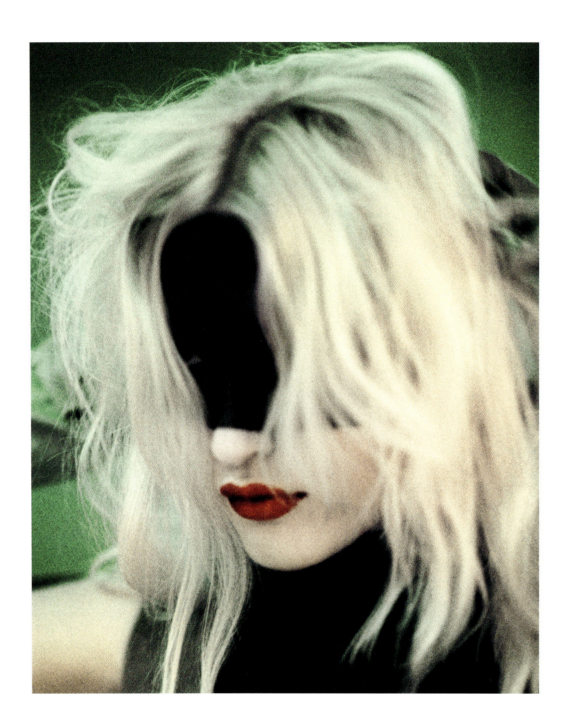

Inge Grognard make-up for Maison Martin Margiela Autumn-Winter 1996-1997.

Walter Van Beirendonck, Autumn-Winter 2023-2024.

KAAT DEBO

Director MoMu - Fashion Museum Antwerp

With the exhibition *Masquerade, Make-up & Ensor*, MoMu – Fashion Museum Antwerp is taking part in an ambitious city festival in the autumn of 2024. With 'Ensor 2024', no fewer than four museums are putting the work of avant-garde Belgian painter and printmaker James Ensor (1860-1949) centre stage: MoMu, the Royal Museum of Fine Arts Antwerp (KMSKA), the Plantin-Moretus Museum, and FOMU – Photo Museum Antwerp. That Ensor's oeuvre is being illuminated not only from a fine arts perspective, but also from that of applied arts such as fashion and photography, is in line with a transdisciplinary exhibition approach that MoMu has been exploring for some time.

In *Masquerade, Make-up & Ensor*, we examine how Ensor's ideas on masquerade, (false) coquetry, seduction, deception, the artificial and the ephemeral can resonate with a contemporary audience more than a century after his time. Our exploration leads us to universal human themes, from the fear of visible ageing to the pursuit of unattainable beauty ideals. The ambiguous masked beings in Ensor's work can be read as a sharp indictment of the hypocrisy of the bourgeoisie in his day. These beings expose insecurities as well as the opportunism and increasing consumerism of his contemporaries. Even today, make-up and cosmetics are carriers of very ambiguous narratives. They are masks behind which humans anxiously hide their transience and insecurity, but they are also an inexhaustible source of self-expression and artistic inventiveness.

The exhibition and accompanying publication celebrate the painters of fashion: the make-up and hair artists who leave an unmistakable mark on the image of fashion and the beauty ideals of their time, artists who often operate in the shadow of the designer or creative director of a fashion house. Light, colour, material and tactility are, as with Ensor, the ingredients for both artistic experimentation and social commentary.

9

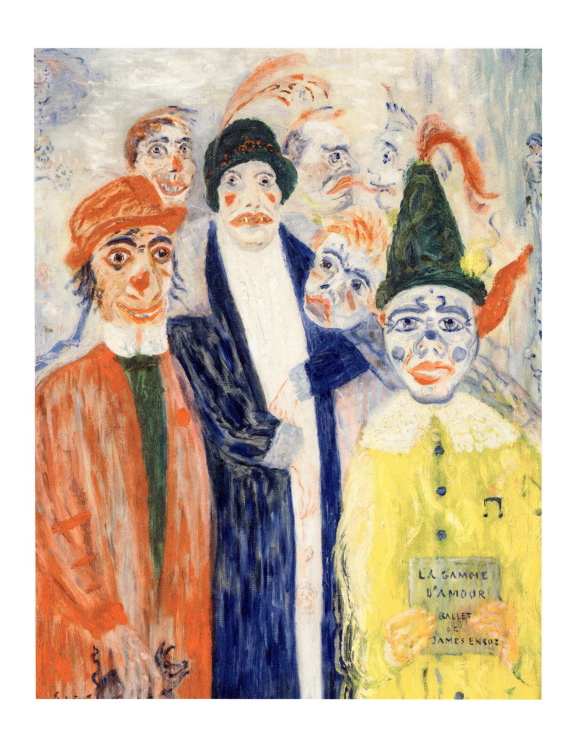

James Ensor, *La gamme d'amour*, 1921.

MoMu invited a selection of make-up and hair artists to engage in dialogue with a number of themes from Ensor's oeuvre. We entered into a partnership with *Beauty Papers*, a magazine and creative platform focusing exclusively on the culture and art of beauty. Founded in 2015, *Beauty Papers* was born out of frustration with the lack of diversity and creativity in the beauty industry. *Beauty Papers* aspires to create a cultural shift in our perception and representation of beauty, taking 'the beauty of possibilities' as its mantra. Founders and artistic directors Maxine Leonard and Valerie Wickes invited make-up and hair artists Lucy Bridge, Éamonn Freel, Inge Grognard and Eugene Souleiman, and directors Arnaud Lajeunie and Casper Sejersen to collaborate on three new video installations.

We are particularly proud of the many unique, artistic collaborations that came about for this exhibition. Our thanks go to Thomas de Kluyver, Julien d'Ys, Genieve Figgis, Inge Grognard, Cyndia Harvey, Christian Lacroix, Martin Margiela, Peter Philips and Walter Van Beirendonck.

Our sincere thanks to all the artists, designers, photographers, graphic designers, authors and lenders, especially KMSKA, who contributed to this exhibition and publication. A special thanks to the curators of this exhibition, Elisa De Wyngaert for the contemporary curation, Romy Cockx for the Ensor contributions, and Janice Li for the curatorial interventions. The scenography of this exhibition was in the capable hands of Janina Pedan. For the graphic design, we were able to call on the creativity of Studio M, in collaboration with Paul Bergés and Frédéric Jaman. As always, we could also count on the unconditional commitment of the entire MoMu team. Lastly, for their valued support for this exhibition and publication, we wish to thank the City of Antwerp, EventFlanders, the Flemish Community and the National Lottery.

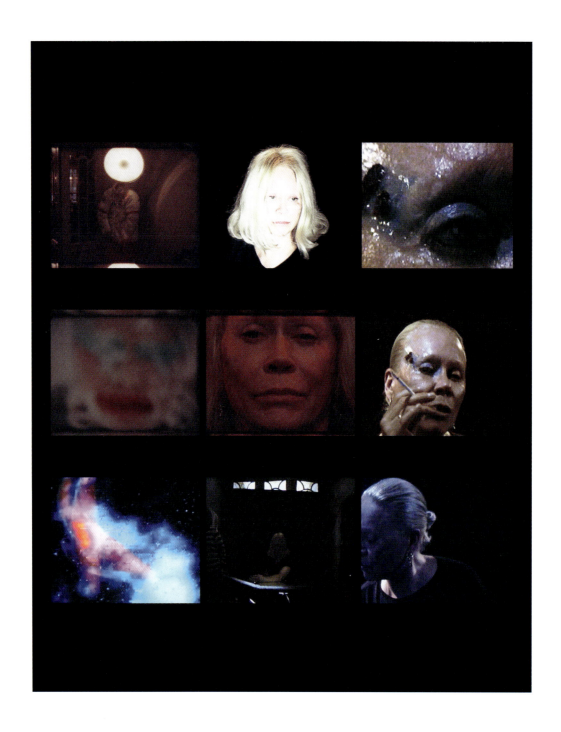

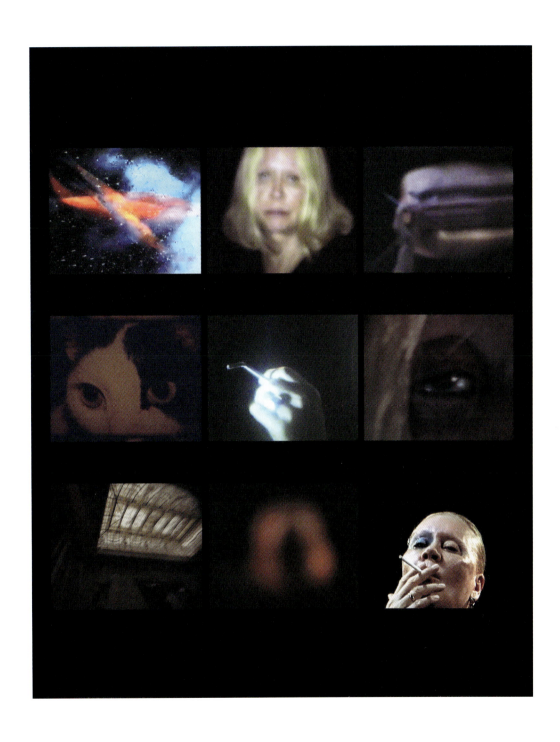

Inge Grognard. Captured and directed by Casper Sejersen, 2024.
A film commissioned by MoMu – Fashion Museum Antwerp, artistic direction by *Beauty Papers*.

Masking, Janice Li

Masking in the most traditional sense could be understood as applying an additional layer to cover one's face. In James Ensor's world, it is expressive and full of colour. While masking, it is simultaneously concealing, disguising and altering how one's original features might be perceived.

Make-up is similar. There is of course full-face make-up that resembles more closely the act of wearing a mask. Complexion make-up in the form of foundation, face paint and concealer has long served as a tool to achieve similar effects to masking. However, the discussion of whiteness and colourism has warranted a revolution in complexion make-up as anti-racist and inclusive efforts pervaded the cosmetic sector. Though the preference for the product to match the user's own skin has never been universal.

In India and Japan, for example, precolonial ideals regarding light skin were linked to ideas about status and/or spiritual purity. In many other cultures, such as in Nigeria, privileging light skin arrived with European domination via slavery, colonialism and globalisation. Wearing a foundation that appears white is one quick and easy way for people to achieve a pale complexion. It is paramount to note, however, that racialised whiteness is about more than complexion alone.

Most area-focused cosmetic additions, on the other hand, capture the magic that lies between deception and expression. Here I am referring to physical add-ons that are used to enhance, conceal and/or alter. For context, around 50 per cent of Asian people are born without a visible eyelid crease above their lash line. In 1896, Japanese surgeon Kotaro Mikamo developed 'blepharoplasty', a procedure to create the double eyelid he believed to be of true nature. Eyelid procedures remain the most commonly requested surgery in Asia. Instead of opting for permanent plastic surgery, false eyelashes, eyelid crease stickers and, to a certain extent, mascara can perform these functions as masking.

Another phenomenon in the world of cosmetic add-ons is acne patches: a product that has become increasingly popular in youth culture in recent years, driven by a strong presence in social media and young celebrity wearers. They are essentially

sticky hydrocolloid patches that shrink pimples. This might appear to fit into the skincare category, but the Gen Z version comes in bright colours such as yellow, pink or black, and in the shapes of stars, crescent moons, butterflies and hearts. Rather than hiding them with the application of concealer as close to one's skin tone as possible – which was the make-up advice that had been given for a long time – young people are not only accepting their blemishes, but also going a step further to embellish them with colours, shapes and glitter. Marketing imagery of the product is often full of joy and with an affirming air of empowerment.

Aesthetically, they take after the age-old beauty patches, or mouches (French for 'flies'). While the practice of wearing beauty patches can be traced as far back as ancient Egypt, they were commonly worn by men and women in Europe by the 1640s. Originally, they strategically covered smallpox or syphilis scars. Sex workers also wore them to attract clientele. By the late seventeen century and into the eighteenth, they had become elite fashion accessories, worn to enhance the radiance and whiteness of the skin. There were social codes: where you wore your mouche could suggest anything from flirtation to political allegiance.

The fashion for beauty patches waned with the invention of the smallpox vaccine in 1796, returning in the early twentieth century as a popular fancy-dress accessory.

Here are but a few small examples of masking in the form of everyday make-up. If examined under the lens of moral judgement, they might all be criticised for their ridiculousness. Yet studied in comparison, we see a complex range of motivations behind one's choice to mask: to conceal, hide, exaggerate, disguise, deceive, enhance, express, celebrate, or all of these at once.

SUSAN M. CANNING

INTO THE THEATRE OF ARTIFICE:
JAMES ENSOR, MAKE-UP, MASKS AND MASQUERADE

James Ensor's paintings invite us into a theatre of artifice where masquerade and performance hold sway. Masking, make-up and arrangements of masks and skulls, skeletons and puppets, and costumed figures promote the disruptive and transgressive subterfuge of artifice and the satirical exchange of the artist's performative masquerade.

From an early age Ensor was aware of the expressive potential of masquerade. He recalled in an 1898 letter his grandmother dressing him and a pet monkey in strange costumes and a time when she stood by his bed in peasant garb wearing a terrifying mask. His home environment, and especially the strange and fantastic assortment of seashells, masks, stuffed fish and ornamental vases in the Ensor family's souvenir shop in Ostend, stimulated his imagination, encouraging revelry and the creative potential of fantastic invention: 'There can be no doubt that these exceptional surroundings helped to develop my artistic faculties or that my grandmother was my great inspiration.'[1] The annual festivities of Carnival and Mardi Gras introduced Ensor to a broader, more public performance of masquerade, one that inverted social codes while celebrating travesty, deception and excessive bodies. Ensor also enjoyed the irreverent and bawdry narratives of burlesque theatre and the puppet performances of the Toone Theatre in Brussels, as well as the satirical and often sarcastic parodies performed at artist cabarets like the Chat Noir.

Ensor promoted his alliance with artifice and masquerade from the very beginning of his long artistic career. As a student at the Royal Academy of Fine Arts in Brussels, he cheekily added lively pink flesh tones to a white plaster bust of the Roman emperor Octavian, effectively giving it a makeover. Inverting the staid classical tradition of copying, Ensor's bold intervention advanced instead the performative nature of his subjective mark making and the disruptive potential of masking and make-up.

THE MADE-UP SELF AS TRAVESTY
Like his maquillage intervention in academic instruction, Ensor's self-portraits often turned to masking and make-up, disguise and travesty when representing himself to the public. In *Self-Portrait with Flowered Hat* (1883/1888, p.22), Ensor gives himself a makeover, reworking an earlier painting by adding enhancements to create a provocative and striking portrait of himself as a modern Belgian artist. Looking out from a mirror-like oval that suggests the portrait is both a reflection of reality and a contrived artifice, Ensor turns to engage the viewer's eye. Dressed in the dark suit of a bourgeois gentleman, his dress and pose recall Paulus Pontius's engraving after a 1623 self-portrait of the Flemish Baroque master Peter Paul Rubens.[2] Painterly embellishments, such as a stylishly upturned moustache and a rakish hat festooned with a feather and flowers, present a deliberate, even flamboyant self-display, one that simultaneously proclaims Ensor's Flemish artistic heritage and his creative affiliation with masquerade.

1
Letter from Ensor to Louis Delattre dated 4 August 1898 (Archives of Contemporary Art in Belgium, 91660)

2
More than likely Ensor was familiar with Pontius's engraving as it served as the frontispiece for Théophile Silvestre's essay on Rubens in Charles Blanc, et.al., *Histoire des peintures de toutes les écoles: L'Art Flamand* (Paris: Renouard, 1883-84), 10: pp.1-32.

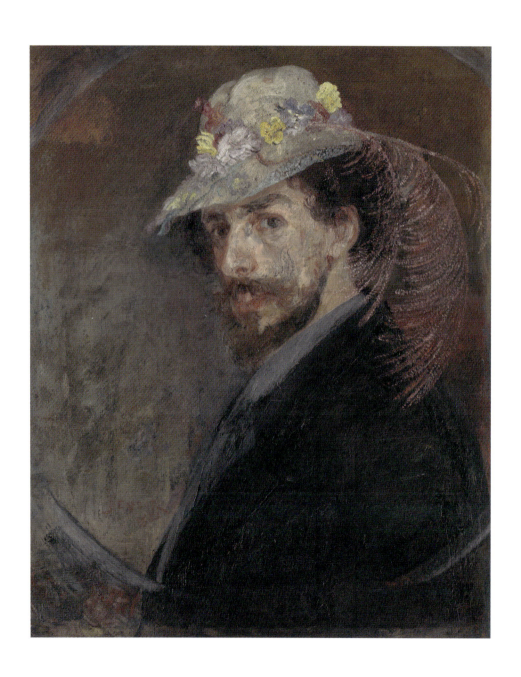

James Ensor, *Self-Portrait with Flowered Hat*, 1883/1888.

Like this painting, Ensor's many self-portraits propose an identity that is public and performative, self-fashioned, mutable and constructed. He often played different roles, allying costumes and dressing up with subversive play and performance and the unruly inversions of Carnival and burlesque theatre. A number of photographs show him dressed in Carnival costumes, dancing and playing the flute or engaging in mock battles holding skeleton bones (p. 24). For one early drawing (1877, Tel Aviv, Fine Arts Museum) he dons a headdress to impersonate an Arab, contorting his face into a wary glance. He appears in drawings and calling cards as a dandy wearing a top hat and coat, his long hair, goatee and tall slender body presented as an almost spectral silhouette. In other works, he becomes a master of disguise, portraying himself as Christ, Pierrot and even a pissing fool.

The studio serves as the stage for Ensor's performance as an artist in *Skeleton Painter* (1896, p. 26). Wearing a smock and surrounded by his work, Ensor, holding a palette, his face masked as a leering and grinning skull, leans forward from his easel to look out at his public. Although based on photographs of the artist in his attic studio (p. 27), Ensor tilted the floor and arranged the paintings salon-style to focus attention on the performance taking place at the centre. All around, skulls, some holding brushes, add humorous, farcical disruptions, as they peer down from an easel and a painting or tip a top hat off a figure in the foreground. Ensor's substitution of a skull for his face alludes to traditional Dance of Death depictions of an artist confronting death, adding a contemplative, moralising note that is offset by the absurdity of skulls cavorting and making trouble with their brushes. With the studio serving as a space for invention and transgression, the droll skeleton artist at the centre sustains his contrary performance as he shows off his wares.

As these paintings make clear, Ensor enjoyed playing the role of artist-provocateur. In *Ensor and Leman Discussing Painting* (1890, p. 28), Ensor stages a mock battle with Gérard Leman filled with masking, travesty and humour. Ensor probably met Leman, a member of the Belgian military and a professor at the Military Academy, at one of the salons at the Brussels home of Ernest Rousseau, who also taught at the Military Academy, and his wife Mariette. The painting alludes to the lively atmosphere and enlightened progressive milieu of the Rousseau circle and to their salons where debates and arguments over science and politics mingled with musical interludes, skits and humorous entertainments. With Mariette Rousseau standing between them, Leman, his head crowned with a laurel wreath and a small plaque with the Freemason symbols of a pair of compasses and a square, fires a toy cannon at Ensor. Ensor counters by poking a large paintbrush at Leman's nose while at the same time thrusting his bulging red phallus-like palette towards the military man and blocking the cannon with his finger. With his head festooned with feathers and his long neck thrust forwards, Ensor resembles an aroused and aggressive cock as he thwarts Lehman's misfire with his own potent and transgressive performance. Tilting her head and rolling her eyes, Mariette acts as a bemused mediator in this amusement whose artifice is signalled by flatly painted figures, exaggerated posturing and mocking ribald humour.

Monsieur and Madame Rousseau Speaking with Sophie Yoteko (1892, p. 28) follows a similar strategy, combining caricatural exaggeration and masking to present the painting as a place of theatre and artifice, with the artist taking on the dual roles of both producer and performer in this travesty.

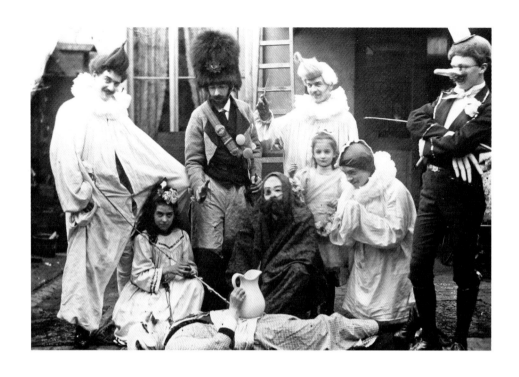

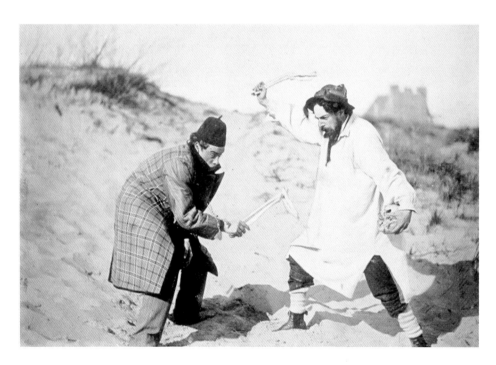

James Ensor with members of the Rousseau and Nahrath families, photographed by Ernest Rousseau Jr. (?), c. 1891. *(Top)*
Ernest Rousseau Jr. and James Ensor in the dunes, photographed by Eugène La Barre, 1892. *(Bottom)*

3
On Sofia Ioteiko (1866–1928), also known as
Józefa Joteyko, see Patrick Florizoone, entry
for 'Mr. and Mrs. Rousseau Speaking with
Sophie Yoteko', in I. Pfeiffer and M. Hollein (eds),
James Ensor, exh. cat., Schirn Kunsthalle, Frankfurt,
2005–6 (Ostfildern: Hatje Cantz, 2005), p. 222.

Set against a plain background that underscores the parodic nature of the scene, a bearded Ensor cross-dressed as a working-class woman and Mariette attired in fashionable dress and hat and wearing a ribbon around her neck offer flowers to a befuddled Ernest Rousseau placed between them. Ensor, on the left, assumes the role of Sophie Yoteko, a name he borrowed from Sofia Ioteiko,[3] a psychology student at the Free University (ULB) where Rousseau also taught. The absurd and ironic rivalry between these two 'women' competing for Ernest's attention is underscored by Ernest's crossed eyes and Ensor's cross-dressing. Cross-dressing, a common practice during Carnival time and often part of comedic sideshow acts and burlesque parodies like those written by Mariette's brother Théo Hannon, accented deception and the satirical potential of disguise. While evident and transgressive, Ensor's performative masquerade in this painting blurs his own gendered identity to offer both Ernest and the public a comparison of two types of modern 'new' women, one humbly clothed, rather masculine and working class and the other a flirtatious well-dressed middle-class lady. Along with the exaggerated poses, awkward presentation of flowers to a man and Ensor's alteration of Ioteiko's name, this mock flirtation subverts conventional notions of gender and bourgeois decorum to offer instead a coded, playful spoof on identity, traditional marriage and the lively progressive milieu of the Rousseau salons.

THE SUBVERSIVE MASK

These images of a disguised Ensor acknowledge his irreverent and transgressive embrace of subterfuge. As he came to value the satirical potential of travesty and masquerade, masks and masking became more prevalent in his work. While most commonly worn during Carnival, masks were also part of everyday Belgian life where they could often be found in caricatures, satirical skits and theatrical burlesques remarking on popular fads, social values and, in particular, the duplicity and deceit of current politics. In Ensor's paintings, masks, masked puppet-like figures and skeletons are brought together with costumes and props in interiors to construct theatres of artifice where the artist can expressively enact his personal and often parodic view of his contemporary milieu.

One of the earliest paintings to include masks, *Scandalized Masks* (1883, p. 30) describes a dramatic encounter between two figures whose identities have been concealed. On the left, a seated man wearing a mask looks up from a table with a bottle on it, while nearby a woman enters through a doorway holding a flute, her face hidden by a large nose, spectacles and a mob cap. Decorated with one hanging oil lamp, the bare corner of the studio suggests a tavern, its masking, strong cast shadows and props accenting the confrontational nature of this meeting where anecdotal description gives way to travesty, alienation and implied violence.

With the studio now serving as a stage, Ensor joined masking and theatrical display with posing and performance to create lively, contrived scenarios and narratives. The setting for *The Astonishment of the Mask Wouse* (1887–9 p. 246) is a sparse interior with a chinoiserie screen hanging as a back curtain. On the raked stage, a pile of costumes, either recently discarded or ready to put on, and masks, musical instruments, and other props lie scattered about. In the foreground, elements such as a doll and skull holding a candle indicate we are witnessing a performance in progress. On either side, figures, some wearing masks and others holding them, look on from the wings as a gloved woman, her head covered with a bonnet and carrying an umbrella, makes her entry.

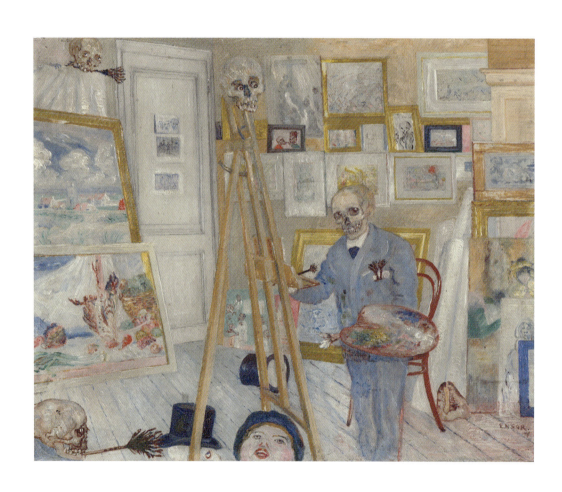

James Ensor, *Skeleton Painter*, 1896.

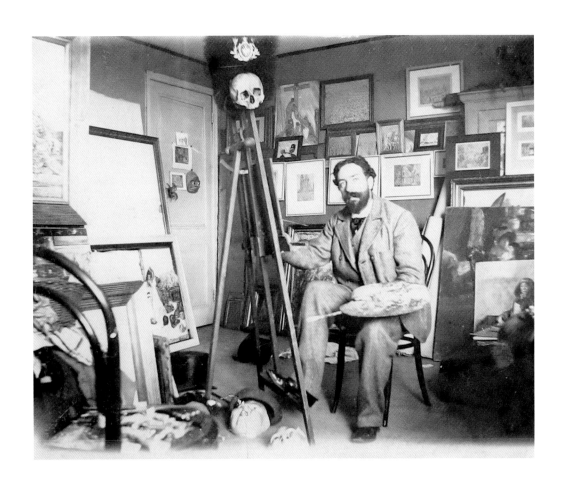

James Ensor in his studio, 1896-1897.

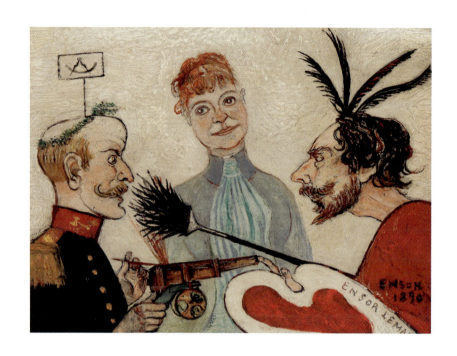

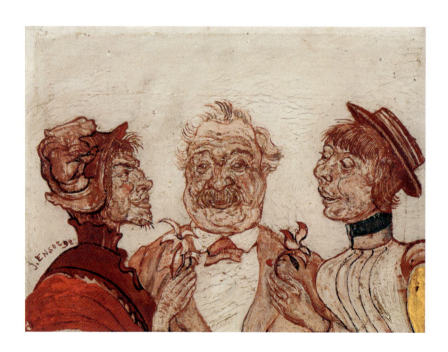

James Ensor, *Ensor and Leman Discussing Painting*, 1890. *(Top)*
James Ensor, *Monsieur and Madame Rousseau Speaking with Sophie Yoteko*, 1892. *(Bottom)*

Presumably a fashionable middle-class woman, but one whose tiny hands, mask-like face and thin almost transparent clothing that undermines the corporeality of her body, reaffirm, as do the masks, costumes and skulls on the floor, that the scene represented here is all artifice, performance and masquerade. Like Henry Fielding's satirical novel *Joseph Andrews* (1742) that Ensor's 'wouse' might reference, this painting confronts its audience with an absurd carnivalesque parody of middle-class propriety and manners.

Skeletons Fighting over the Body of a Hanged Man (1891, p. 33) also takes place on a raked stage now with doorways on either side where masked and costumed characters have gathered. The figures on the stage resemble puppets, with one hanging from the back wall with its characteristic rod holding a sign that reads 'civet' (stew), while another, its rod still attached, is collapsed on the floor. At the centre two puppets appear to spar, each figure made up of a skull head and fashionable hat with bodies constructed from remnants of jackets, skirts and boots. Holding such ludicrous weapons as a curtain pole and broom, their composite bodies frozen in combat, the two simulate the stylised posed violence often seen in Punch and Judy puppet shows of the time.

Improvised on stages in poorer neighbourhoods or in cabarets, puppet shows provided another occasion for performative masquerade. Filled with slang and wordplay, humour and irreverent parody that mocked social pretension and sarcastically commented on current events and politics, these plays performed by awkward, often crude and bumbling rod puppets accentuated the evocative potential of artifice. Inspired by these performances, Symbolist playwrights like Maurice Maeterlinck and Charles van Lerberghe directed actors to imitate marionettes and use hieratic gestures, static poses, and mime along with off-stage narrators to heighten the expressive and symbolic nature of their plays.

In a similar fashion, *Skeletons Warming Themselves* (1889, p. 31) advances the evocative potential of the interior. In a stage-like space with a screen backdrop and figures entering from the wings, two puppet-like figures with skull heads, one wearing a top hat and the other a shawl, stand near a pot-bellied stove impersonating a bourgeois couple. Another composite figure costumed with a yellow jacket lies on the floor with its skull head propped up against a coal bin. The musical instruments, palette and brushes, and skulls scattered about, allude to social status, creativity and the arts. The painting, filled with ironic ruse and contrary play, reminds the beholder that they are attending a performance, a travesty where costumes, props and the painting's jewel-like colours combine with the absurd premise of skeletons searching for warmth to present Ensor's reflection on the challenges of artistic creation, the desires of the bourgeoisie and the transitory nature of life.

THE ARTIFICE OF MAKE-UP

Ensor's use of masks and make-up/maquillage also engaged with contemporary discussions circulating around women, fashion and appearances, as well as debates over painting's role in modern experience. By Ensor's time, the cosmetic art of maquillage and oil painting were viewed by some writers and critics as analogous.[4] Each was understood as a decorative arrangement of appearances that could serve as a vehicle for self-fashioning that covered over social class and gender distinctions to present identity as both fluid and performed.

4
The art theorist Roger de Piles made the conceptual analogy equating paint with cosmetics, writing in 1708: "It is true that this is makeup (*un fard*), but we should wish that all current paintings were made up in this way. We already know that all painting is only makeup, that it is part of its essence to deceive, and that the greatest deceiver in this art is the greatest painter." *Cours de peinture par principes* (1708; reprint, Nimes: Jacqueline Chambon, 1990), p. 159 (trans. M Hyde). Melissa Hyde discusses this association of paint with make-up and the way artifice and social constructions of the feminine were joined with performative self-fashioning in her essay on François Boucher's 1758 portrait of Jeanne-Antoinette Poisson, Marquise de Pompadour (Cambridge, Mass., Fogg Art Museum, Bequest of Charles E. Dunlap) ("The "Makeup" of the Marquise: Boucher's Portrait of Pompadour at Her Toilette" *The Art Bulletin* 82, No. 3 (Sept., 2000); pp. 453-475. These debates and associations continued into the 19th century, most notably in Charles Baudelaire's consideration of the ties between cosmetics, artifice and feminine deceit in his essays "Woman" and "In Praise of Cosmetics" in the *Painter of Modern Life*. (*The Painter of Modern Life and Other Essays*, edited by and translated by Jonathan Mayne, London: Phaidon, 1964; reprinted 2005, pp. 29-34)

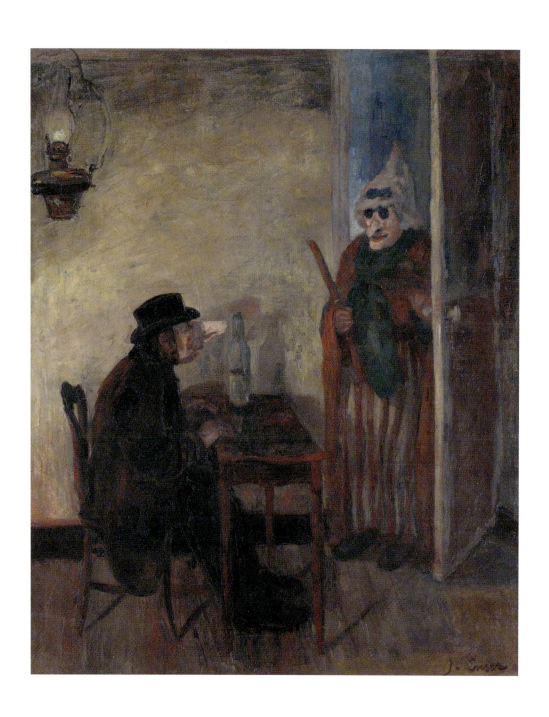

James Ensor, *Scandalized masks*, 1883.

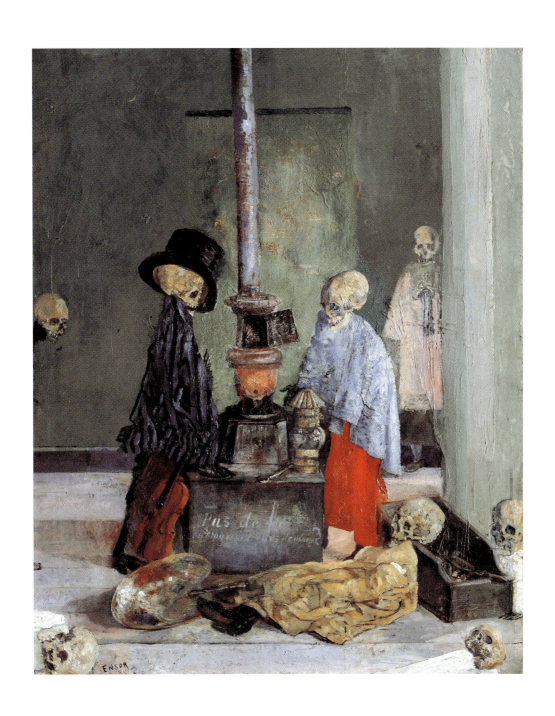

James Ensor, *Skeletons Warming Themselves*, 1889.

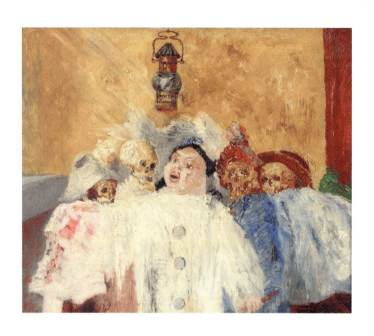

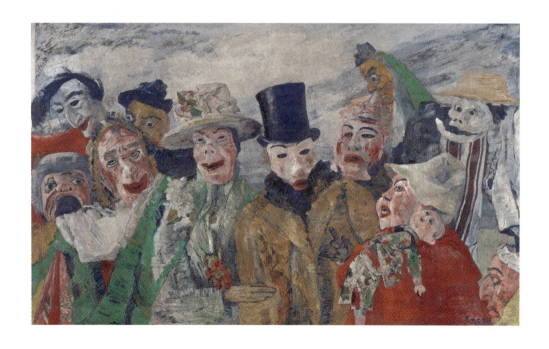

James Ensor, *Pierrot and Skeletons*, 1905. *(Top)*
James Ensor, *The Intrigue*, 1890. *(Bottom)*

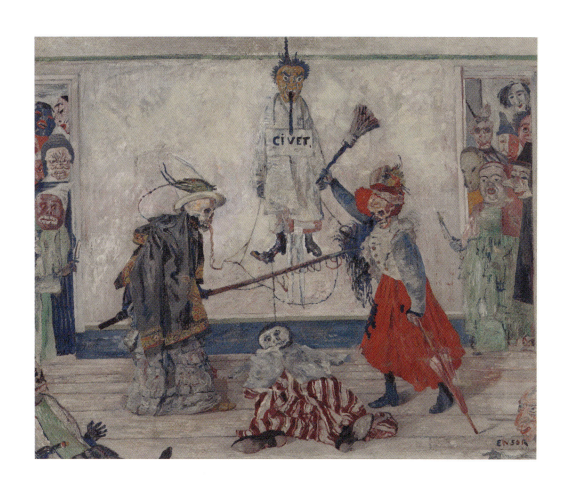

James Ensor, *Skeletons Fighting over the Body of a Hanged Man*, 1891.

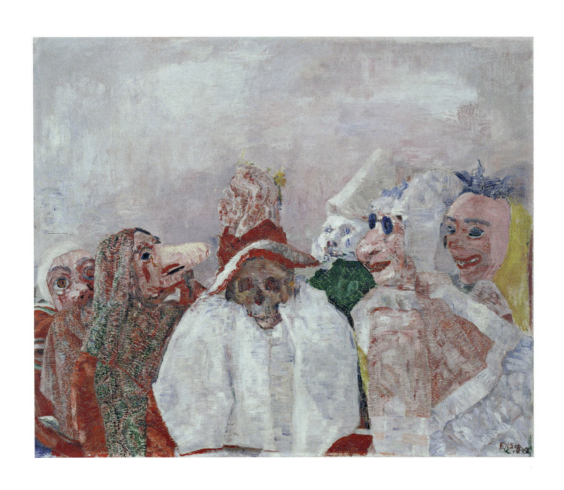

James Ensor, *Masks Confronting Death*, 1888.

Like Charles Baudelaire in his 1863 essay on cosmetics, Ensor associated make-up with modernity, beauty, fashion and display. Paintings from the 1880s like *Lady with the Fan* (1880, p. 90) or *Lady with a Red Parasol* (1880, p. 88) focus attention on the public appearance of the modern middle-class woman while also showing off Ensor's ability to make visible the sensual materiality of contemporary experience. In *Old Lady with Masks* (also known as *Theatre of Masks* or *Bouquet d'Artifice*) (1889, p. 240) he engaged with current discourse on make-up and its potential for disguise, deception and aggrandisement. In this work an older woman with a wrinkled brow, her head crowned with flowers and wearing earrings, looks out as if seeing herself from her reflection in a mirror. Her face, a pastiche of white make-up, rouged lips, two beauty marks and facial hair, is surrounded by large and small masks, several Carnival figures and a skull. Comparing contrived and grotesque forms and faces, Ensor accented the painting's underlying artifice with masks and the cosmetic enhancements of maquillage fashioning a portrait that conceals identity even as it tempers any ideal of beauty with the variances of time and ageing.

In other works, Ensor laid out these same accoutrements of the well-dressed woman – hats and shawls, fashionable dresses and jackets, umbrellas and fans – as still-life arrangements that focus attention on the allure and travesty of material culture. In *Masks Confronting Death* (1888, p. 34) a skull wrapped in a white cloth and wearing a fashionable hat grins from its central position where it is surrounded by masks cloaked with shawls and pieces of cloth, or adorned with blue leaf-like trim or hats. Nearby, another figure with a masked or made-up face, clothed in a peignoir and nightcap and wearing blue glasses, looks towards the skull. Gathered together, this ensemble of skulls, masks, clothing and hats demonstrates Ensor's ability to describe tactile patterns and surfaces with ease and to model form in natural light. Set against a mirror-like background that suggests a deep hazy atmospheric space, Ensor's painterly evocation confronts the public with a display of the fashionable things of commodity culture which reproduce in their arrangements the pleasure of looking, the desire for status and a contemplation on life's ephemerality.

In *Pierrot and Skeletons* (1905, p. 32) Ensor again turned the allure of commodity display into a travesty. Fashion accessories laid out in natural light are combined with skulls and masks associated with artifice, decadence and display, both inviting and subverting the desire to look and acquire. Clothing and hats might adorn the body but, like make-up, they also seduce. In Ensor's painted arrangements, clothes, fabric, masks and skulls ally the embellishments and seductions of the feminine with the ruse of the body immersed in the modern material world in all its tempting array.

Ensor's staging of fashion and spectacle as a burlesque satire carries on in *The Intrigue* (1890, p. 32), where a stylishly dressed woman wearing a large brimmed hat decorated with flowers promenades with a man dressed in a yellow jacket and wearing a top hat. The woman's face is either covered with a mask or cosmetically enhanced with thick white theatre make-up, her red mouth frozen in a grimace that, along with her turned-up nose and eyes rolling upwards, suggests snobby pretension or disdain. Her companion's face is covered with a Noh mask, like those found in the Ensor family shop, its slanted eyes and whiteness accenting further the artifice of his appearance and position. Even though this

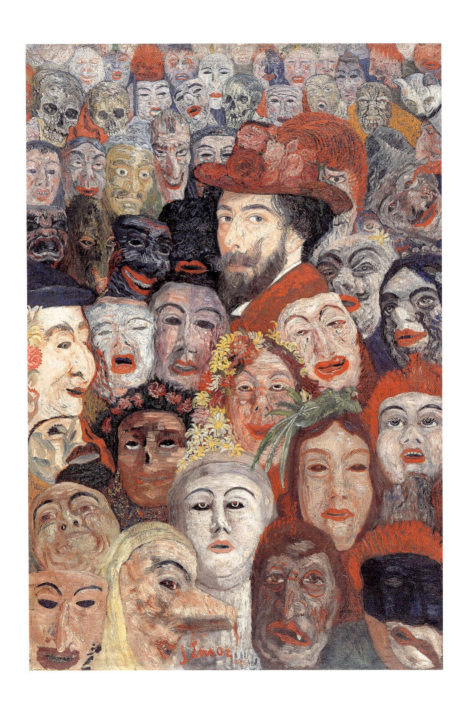

James Ensor, *Self-portrait with Masks*, 1899.

couple is joined together through the woman's embrace of the man's arm, they appear to move in different directions, their bodies and dress articulating their separate spatial and social spheres. On either side, a grotesque crowd consisting mainly of women assembles, their faces obscuring the distinction between mask and maquillage. With bulging eyes, hooked noses and exaggerated and contorted expressions, these figures bring to mind contemporary images of drunks, social miscreants and those suffering from mental disorders. Processing forwards from the background that again resembles a mirror, this preening ensemble confronts the viewer with its absurd and satirical display of modern fashion, make-up and social disguise.

Ensor's strategic use of masking, make-up and performative masquerade continues on a grand scale in *Christ's Entry into Brussels in 1889* (1888, p. 38). Disguise and deception prevail as a crowd of raucous bourgeois, representatives of the Church and Parliament, and a military band, that is, Belgium's ruling class, marches forwards, their masked, made-up and skeletal faces, grinning mouths and swollen bellies forming into a ludicrous chorus line of conformity, deceit and hypocrisy. Intermingling religious narrative with the cacophonous discourse of the street and Carnival, and overlaying references to contemporary politics and social concerns with coarse satirical humour, Ensor transformed the scene from a march or celebration into a parody of social propriety, one that immerses the public in spectacle and artifice. At the centre, Ensor seated on a donkey, performing now in his self-fashioned role as Christ, proclaims his position as the 'social one'[5] as he asserts the primacy of his anarchistic individualism and satiric social critique.

Portraying himself in the same pose and hat as in his *Self-Portrait with Flowered Hat* painted about 15 years earlier, in *Self-Portrait with Masks* (1899, p. 36) Ensor looks out from a Carnival crowd. Some of the faces are masked, others are real but camouflaged and yet others have exaggerated features or wear heavy make-up, making them hard to distinguish from their masked counterparts. At the top of the painting a number of skulls add a sombre note to the scene, while nearby and behind Ensor faces with blackface make-up or blackened masks with red lips can be seen, their features similar to contemporary caricatures of African peoples. Painted with scintillating colour and careful modelling, the masked and painted faces become more grotesque, stifling and oppressive as, jostling and pushing, they press forwards into the pictorial frame.

As doll-like faces and eyes stare outwards, mouths covered in red lipstick open and empty sockets instead of eyes look on, this seemingly endless crowd of masked and made-up faces, skeletons and one cat provides a chilling backdrop to Ensor's carefully posed, even cryptic, self-portrait. Reprising the role seen in other self-portraits, that is as both master of disguise and the intermediary between observation and subjective interpretation, Ensor provocatively invites us to compare his face with those surrounding him. Acting then as an advertisement for his starring role in this theatre of artifice, the portrait presents Ensor's completely contrived and self-fashioned public self, affirming through strategies of subterfuge and performance, masking, make-up and masquerade his central place in the carnivalesque spectacle of modern life.

5
The use of the phrase "the social one" is an interpretation of the words "Vive la Sociale" Ensor inscribed on a banner in *Christ's Entry into Brussels in 1889* and in his large drawing *Christ's Entry into Jerusalem* (1885), part of his series *Visions. The Halos of Christ or the Sensibitlities of Light*, (Ghent, MSK). The wording of this phrase is difficult to translate as the word "sociale" is an adjective without a noun modifier. In the later 19th century "sociale", a Proudhon term for urban industrial workers, regularly appeared on banners at demonstrations and in illustrations, both with or without a noun, promoting a range of political groups and causes. Ensor originally planned to exhibit *Christ's Entry* at Les XX in 1889, the same year as the hundredth anniversary of the French Revolution and the meeting of the Second International in Paris with the Belgian Worker's Party in attendance. This proclamation, prominently displayed in this painting on a red banner hanging across a broad boulevard where a large Mardi-Gras crowd is marching and where directly below Ensor as Christ enters Brussels (site of the Les XX salons) riding a donkey, holds both personal and political meaning. The phrase can be read as "Long Live the Social" or "Long Live that which is done in a social (that is, collective) manner" joining together the individual and the communal in common cause to become the "social (one)". Even after Ensor later painted over many of the signs that had been originally included in the painting (with the exception of the placard near Christ/ Ensor that states "Doctrinaire Fanfares Always Succeed", a reference to orthodoxy and the conservative wing of the Belgian Liberal Party), he retained the red banner allied with socialist and anarchist causes with its declaration "Vive la Sociale" –"Long Live the Social One"– announcing to all the powerful alliance of the social and the individual and Ensor's central role as artist, social critic, and saviour.

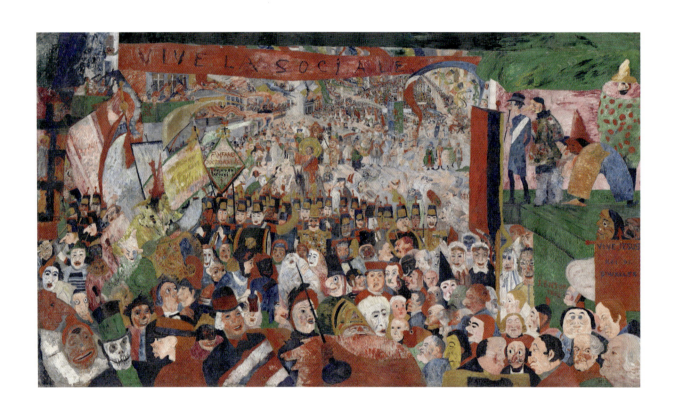

James Ensor, *Christ's Entry into Brussels in 1889*, 1888.

WHAT THE MASK MEANS TO ME:
FIVE MAKE-UP ARTISTS, FIVE WAYS

Make-up practitioners are the artists of contemporary fashion. While they may be the ones backstage at the fashion show who continue to work with pencils and brushes, the creation of an artwork is not the end point. The canvas in front of them is remarkably consistent: a line of model heads (mainly white, mostly the same height – even though diversity is effecting change), transformed in relation to the collection looks they are intended to wear, but only from the neck up. The unchanging brief is to bring new visual coherence to the garments, by extending the designer's aesthetic framework into a means of framing the face, aided by the consideration of hair and accessories, as expressive and directional. They may seem to paint faces, but their work is more calibrated. They are not concerned with the expression of human likeness, as a portraitist might be, but how they might anticipate a fashionable appearance. In having to apply this across a set of models walking in a show, it produces a kind of uniformity that only adds to the sense that, rather than painting faces, they are fashioning a kind of mask.

It is for this reason that this project brings the work of contemporary make-up artists into dialogue with the works of the Belgian artist James Ensor: to illuminate that the artist's preoccupations – the masks worn to grease polite society, and the masks worn to be released from its strictures – are not dissimilar from their own. In 1931 Ensor wrote, 'The mask means to me: freshness of colour, sumptuous decoration, wild unexpected gestures, very shrill expressions, exquisite turbulence.'[1]

His description is rich and strange, not unlike the range of masks encountered in his paintings, or those he lived with in his Ostend home. But the period was also marked by the return of the mask to modern life in Europe and America, worn as well as carried (like some kind of *objet* or handbag) for masquerade parties, modern theatre, dance performance and fashion photography. Photographer Edward Steichen's editorial for American *Vogue* on 15 July 1926 depicts leading fashion models Marion Morehouse and Helen Lyons wearing the latest fashions complemented by masks made by Polish illustrator and painter W.T. (Władysław Teodor) Benda. Benda called his more believable, less stylised masks, 'false faces'[2], but many *Vogue* readers failed to even notice that the models were wearing masks painted in the fashionable make-up of the day. As this example proves, much fashion make-up evades serious scrutiny when in the service of an all-over image of fashion. And yet, as the Benda masks demonstrate, make-up can be appreciated as creative sculpture for the face. It is this idea of fashion make-up as a mask that I would like to pay attention to.

Using Ensor's five-point description for the mask, I will direct it to the work of five contemporary fashion make-up artists, to demonstrate that the mask is a crucial interface between the real and the ideal – between the model's face and the make-up artist's hands full of brushes and pencils. But beyond ideals, masks are also a means of dealing with otherness. According to Susan B. Kaiser, a mask 'can reveal a moment of reflexivity about the otherness within and beyond ourselves'[3]. So, just as a mask can represent falsity, it also holds the potential to transform how we appear by what it discloses about what lies beyond us. Stephen D. Seely has written about fashion being something more than a device to enhance, adorn or make ourselves more attractive:

1
James Ensor, 'Discours au Kursaal d'Ostende'(1931), in *Mes écrits: ou, Les suffisances matamoresques*, (*Bruxelles*: Labor, 1999), p.180.

2
Ronald Naversen, 'The Benda Mask', *Theatre Design & Technology*, Fall 2010, p.38.

3
Susan B. Kaiser, 'Foreword', in Efrat Tseëlon (ed.), *Masquerade and Identities: Essays on Gender, Sexuality and Marginality*, (London: Taylor & Francis, 2003), p. xiv.

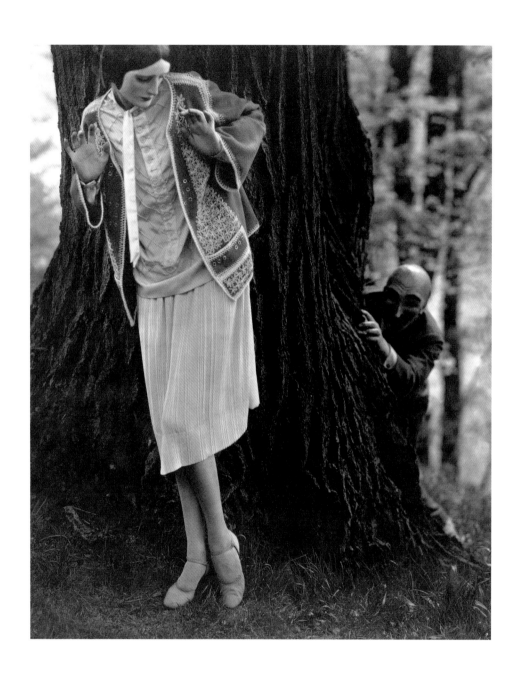

Edward Steichen, *Vogue U.S.*, July 1926.

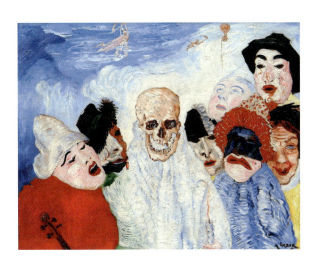

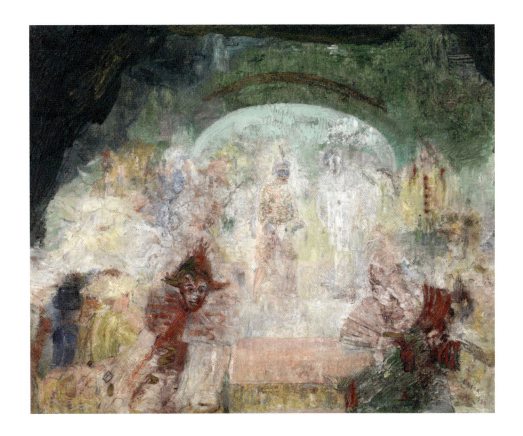

James Ensor, *Death and the Masks*, 1897. *(Top)*
James Ensor, *Masquerade*, 1889. *(Bottom)*

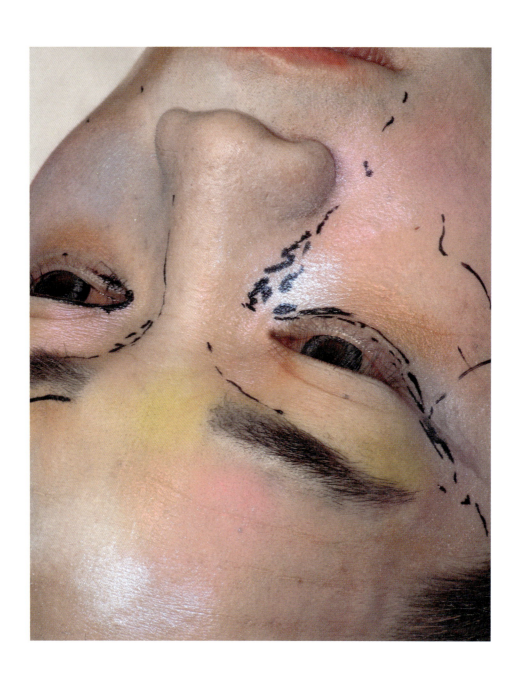

Thomas de Kluyver and Harley Weir, *All I Want to Be*, 2019.

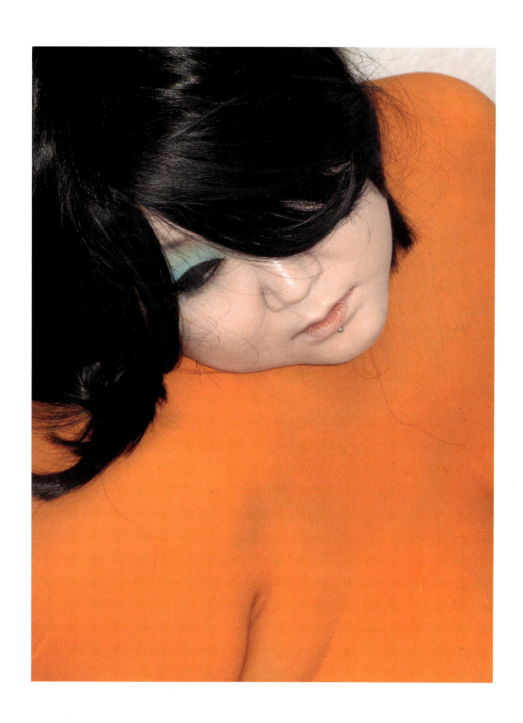

Thomas de Kluyver and Harley Weir, *Shibuya*, in *All I Want to Be*, 2019.

Roche looks for David Bowie as Aladdin Sane. De Kluyver also acknowledges the power that colour bestows on the wearer, not a mask per se but something more transformative: 'I don't think it leaves the person hiding behind it; it's more empowering, allowing you to jump in to who you really are.'[10] Full face make-up has returned as a persistent image. In 2020 it was employed for an editorial alongside an interview by fashion critic Susannah Frankel with Rei Kawakubo, the strands of glitter on the face sourced from AliExpress.

Runway make-up offers de Kluyver the chance to move away from work that is detailed, towards a style that moves or shines in more ambient ways. His work with Simone Rocha over more than seven years has evolved into a collaborative approach, 'where the make-up is an integral part of the collection, it's almost like a fashion accessory'[11]. De Kluyver had been using bows on the faces of young men for some time, as expressive of gender tension, before he thought it might work for Rocha. It was a year later that they decided they had the right collection to work on, and this brought further distillation to the look: instead of multiple ribbon bow ties, it was refined down to a single thin ribbon with a long tie under each eye. The image of the bow face went viral on social media, but what was important for Rocha and de Kluyver was that the static image was a poor substitute for the way the bows moved on the models' faces when they walked, a detail that is hard to see even on show videos. And it is here, in the idea of make-up as an emotional detail that can only be read by those in the room, that makes it such a unique part of a fashion show, as expressive of how creatives work together collaboratively to secure a vision.

PAT MCGRATH/SUMPTUOUS DECORATION

Pat McGrath is a make-up artist and creative director of her own make-up brand, Pat McGrath Labs. She has worked as a make-up artist for fashion shows, as well as editorials and advertising for brands such as Prada, Miu Miu, Jil Sander and Giorgio Armani. McGrath is a long-term collaborator of fashion photographer Steven Meisel, she has been Beauty Editor at Large for British *Vogue* since 2017, and is the first make-up artist to be made a Dame Commander of the British Empire. Much of Dame Pat's most celebrated work has been as part of a long-standing, ongoing collaboration with John Galliano, with his own brand, in his work for Christian Dior and currently for Maison Margiela. The make-up design for Maison Margiela Artisanal Spring-Summer 2024 is a unique example of McGrath's work and its broader cultural impact. The reaction to the show, considered to be a return to form for Galliano, was greatly extended by curiosity on social media as to how the porcelain-like skin was achieved with make-up. This is also a good example of how social media plays an increasingly central role in the dissemination of make-up know-how between artists and makers, producers and consumers.

Staged under the ornate bridge Pont Alexandre III in Paris, the show recreated a louche bar – both inside and out – inspired by the demi-monde documented in Brassaï's illicit photographs of Paris by night, taken in the 1930s but not published until 1976 due to the revealing nature of the imagery. Brassaï famously said that, 'Night does not show things, it suggests them,'[12] and the lighting for the fashion show coaxed models out of the shadows revealing them through spotlights and dry ice before returning them to the enveloping darkness. It meant that the make-up could not be seen in plain sight, but only disclosed itself as a sheened surface from a strange night, like the glowing sweat of a sex worker or the varnished skin of a mannequin doll. Further lustres and transparencies could be traced in sheer layers of latex dress fabric with corsetry beneath, and glazed white leather neck collars appeared like porcelain. Fashion critic Cathy Horyn

12
Brassaï, *Paris de Nuit*: an exhibition of original photographs by Brassai from the book by Paul Morand, (London: B.T. Batsford Ltd, 1933), n.p.

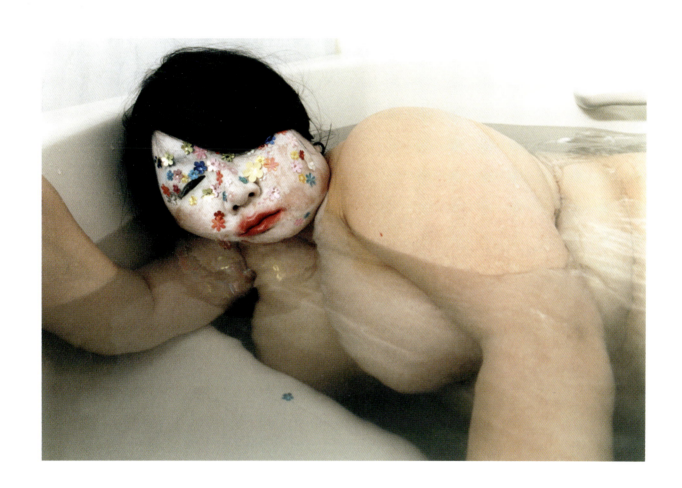

Thomas de Kluyver and Harley Weir, *Shibuya*, in *All I Want to Be*, 2019.

4
Stephen D. Seely, 'How Do You Dress
a Body Without Organs? Affective Fashion
and Nonhuman Becoming', *Women's
Studies Quarterly*, Vol. 41, No. 1/2, Fashion
(Spring-Summer 2012), p. 263.

5
Thomas de Kluyver, in interview
with the author, 28 March 2024.

6, 7, 8, 9, 10, 11
Ibid.

'Rather, fashion can be that "something else" that leads to our
own becoming-otherwise, that actualizes the virtual capacities that
we were not even aware of, that puts us in touch with what is least human
in us, that opens our bodies to a virtual field of limitless creativity,
intensity, sensation, and transformation.'[4]

And it is make-up, in the interface between clothing and the body, applied to
the skin, that signals becoming-otherwise more than fashion garments can alone.

THOMAS DE KLUYVER/FRESHNESS OF COLOUR

Thomas de Kluyver is a self-taught make-up artist, although his theatre director
mother ensured he was exposed to theatrical productions and make-up from an
early age. 'I remember seeing full face make-up for the first time and being super
excited about it because I'd never seen it before and I thought, "Well, maybe
this could be something that could be interesting for me?"'[5] His teenage years
were spent experimenting on friends, and much of his work is rooted in nuanced
expressions of identity, gender and sexuality. Colour is a significant driver in de
Kluyver's work, as 'through the palette I can emotionally connect with the viewer'[6].

De Kluyver has built long-standing working relationships with fashion designers
such as Simone Rocha, Alessandro Michele and Charlotte Knowles, and pro-
ducing catwalk make-up and campaign imagery. He also works closely with
fashion photographers including Harley Weir, Zoë Ghertner, Mert+Marcus and
Glen Luchford. De Kluyver is a contributing editor for *Dazed* magazine and in
2019 was appointed Global Makeup Artist for Gucci. He has produced mono-
graphs of his work, his first being *All I Want to Be* (2019).

Much of de Kluyver's approach to colour is rooted in observation in cities as
well as in the outback or beyond (he grew up in Australia and is now based
in London). 'I'm fascinated by the artificial as much as I like nature: It's the
juxtaposition of these two things that I often find very interesting and it inspires
my work. I use a lot of found objects alongside traditional make-up, as well
as paint, pigments and this sort of jumble of things.'[7] He keeps sketchbooks
in which he notes his ongoing ideas, and records colour in the world around
him using a Pantone app on his smartphone. So, while this all sounds studied
and rehearsed, de Kluyver is actually quite instinctive when working. Much of
this has arisen out of his collaboration with Harley Weir, who is more engaged
with documenting the creative process of de Kluyver's make-up than building
towards a final, resolved image.

For *Shibuya* (2019), de Kluyver and Weir visited Tokyo for two weeks, casting
models and responding to the textures of the city ('neon signage and pastel colours
everywhere'[8]), viewing the films of Shuji Terayama, and spending time with
friends such as Japanese photographer and artist, Fumiko Imano. The portfolio is
a portrayal of non-conformative bodies and minds, gloriously resisting orthodoxy
through the adoption of colour – a mixture of traditional Japanese make-up for
geisha and kabuki from Kyoto repurposed:

> I had the idea of doing a glitter face, and then when I had executed it, it
> looked too done. So, then I started to put paint over the glitter to make
> it less perfect and that's where you get the difference in textures,
> and the yellow colour really brought it to life.[9]

The images recall the make-up styles that Kansai Yamamoto designed for his
fashion shows in the 1970s and their influence on make-up artist Pierre La

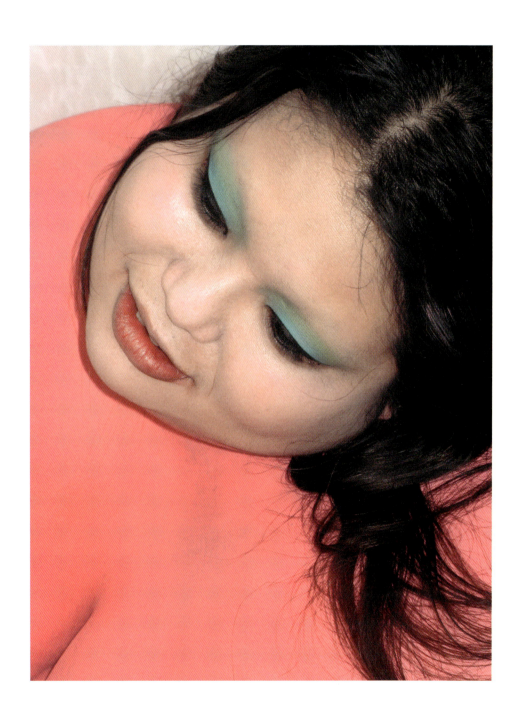

Thomas de Kluyver and Harley Weir, *Shibuya*, in *All I Want to Be*, 2019.

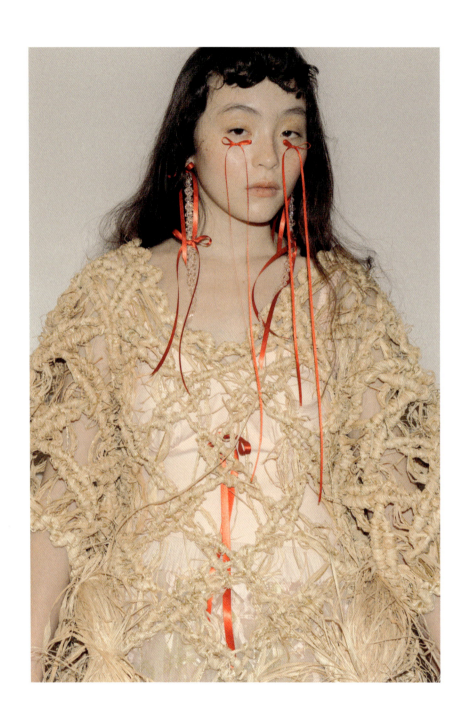

Thomas de Kluyver make-up for Simone Rocha Autumn-Winter 2023-2024.

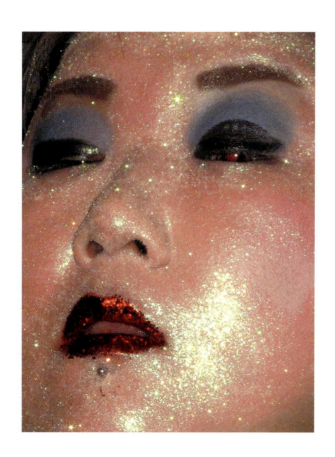

Thomas de Kluyver and Harley Weir, *Shibuya*, in *All I Want to Be*, 2019.

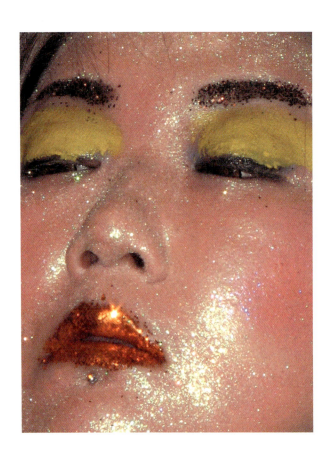

Thomas de Kluyver and Harley Weir, *Shibuya*, in *All I Want to Be*, 2019.

Pat McGrath make-up for Maison Margiela Artisanal Spring-Summer 2024.

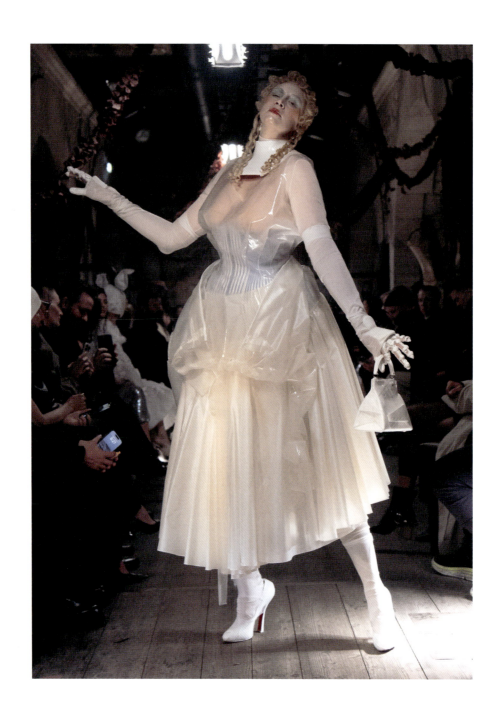

Pat McGrath make-up for Maison Margiela Artisanal Spring-Summer 2024.

13
Cathy Horyn, 'Maison Margiela's Couture Collection Will Go Down in Fashion History', *The Cut*, 26 January 2024, https://www.thecut.com/2024/01/couture-review-margiela.html, accessed 1 April 2024.

14
Pat McGrath quoted in Bridget March, 'Pat McGrath Revealed the 'Porcelain Skin' Products Used for the Viral Maison Margiela Look, 5 February 2024, https://www.harpers bazaar.com/uk/beauty/make-up-nails/a4657 9949/pat-mcgrath-maison-margiela-skin-product/, accessed 1 April 2024.

15
Pat McGrath, in interview with the author, 10 May 2024.

16,17
Ibid.

noted that, 'Galliano is a master at finding beauty in the misbegotten and the disreputable,'[13] but it was the gleam of the skin supplied by McGrath that gave such a potent visual cue across a spectrum of skin tones.

The technique took her studio three years to develop, with McGrath explaining that 'skin is coated in a hyper-shiny glaze, mimicking the smooth, reflective quality of glass and completing the models' unbelievable metamorphosis.'[14] To achieve the right consistency, a mixture of four different peel-off masks diluted with distilled water was applied in eight layers using an airbrush and drying with a hairdryer between coats, before finishing with a clear gloss first developed for the film *A.I.* (2001). Once blush and lip colour had been added, water-based glue was applied to key areas of the face (such as the corners of the mouth and under the nostrils) to fix the 'skin' at weak spots. The final layer was a foundation with touches of white Kryolan face paint to give a ghostly effect.

What is novel about the technique is the way it uses a mask product that targets and lifts impurities from the skin by being peeled away after application, to create a mask effect of porcelain-like skin tone. It takes a behind-closed-doors skin preparation and repurposes it as the principal effect on the skin's surface as a final look. For McGrath, it honours her approach, which addresses the skin first: 'I consider every look I've created to be sumptuously decorated because, even when the make-up is very minimal, it always starts with a base of beautiful, luxuriously perfected skin. For every single runway show I've ever done, the complexion looks radiant, sublime and, to your point, sumptuous, and that's before you add anything on top of it.'[15]

For the Margiela show, what was added was applied layer by layer, creating an elaborate shellac-like carapace for the face, but, crucially, it was a mask that also allowed the facial features a degree of movement. McGrath comments:

> I don't think of make-up as a mask in terms of *concealing* who you are, but more of a tool to *amplify* your true self, celebrating individuality and the multifaceted nature of beauty. However, you can definitely use make-up as a *transformative* medium, much like a mask, that allows for the exploration of identity, fantasy and emotion.[16]

What is surprising about the time-intensive nature of achieving the look is how it has been storyboarded by legions of make-up devotees on Instagram, and how these have been reposted by McGrath herself in support of an online community of make-up fans invested in creating the look for themselves. According to McGrath:

> We live in an age of digitally empowered beauty that allows the make-up-obsessed to instantly share their inspirations and obsessions – make-up is truly a movement. Social media has not only connected the make-up artistry community in amazing ways, but it's also opened up the community to all beauty lovers, letting them see the creative side of make-up that goes beyond just lengthening lashes and covering dark circles. It's supposed to be fun, experimental and creative and I'm so happy more and more people are seeing that.[17]

McGrath's technique therefore signals a labour-intensive, dedicated devotion to make-up, a form of sumptuous decoration that gilds the lily and disseminates the methods of making in new ways.

Sketchbook Julien d'Ys for Comme des Garçons Spring–Summer 1999.

57

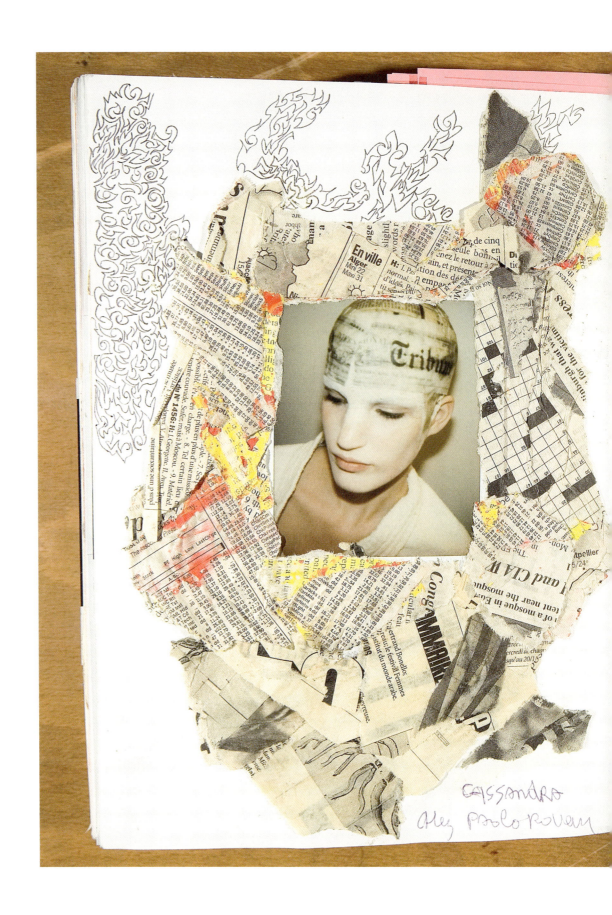

CASSANDRA
chez paolo roversi

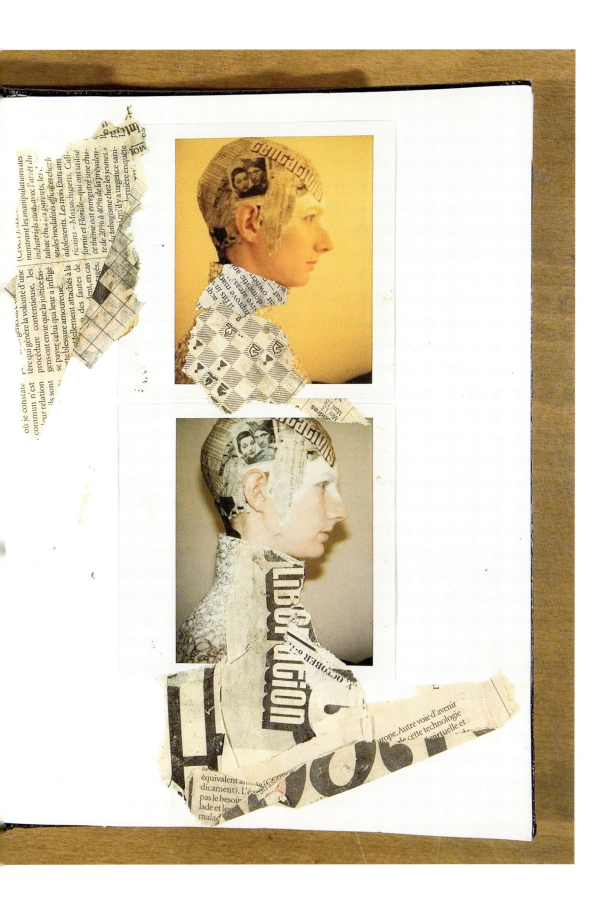

Sketchbook Julien d'Ys for Comme des Garçons Spring-Summer 2002.

Sketchbook Julien d'Ys for Comme des Garçons Spring–Summer 2002.

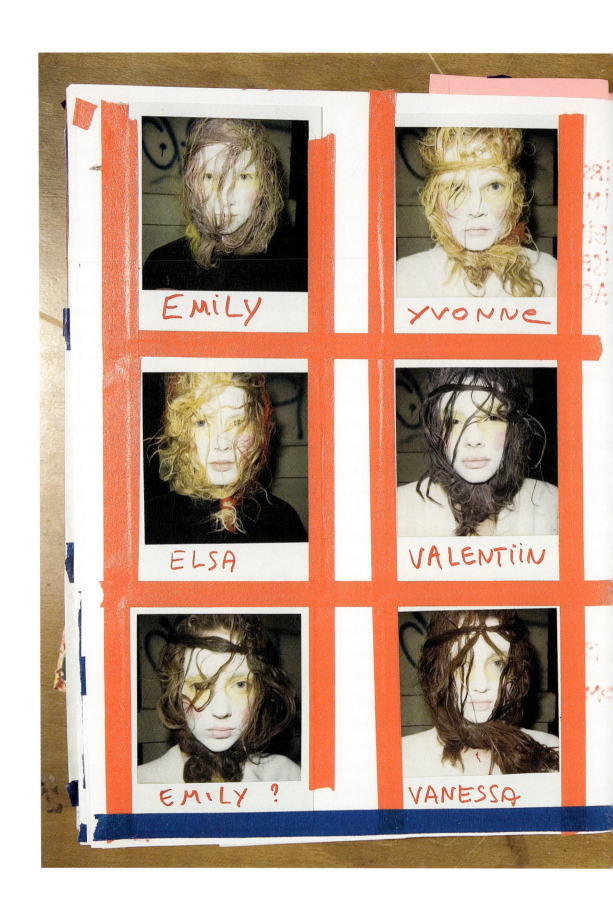

62

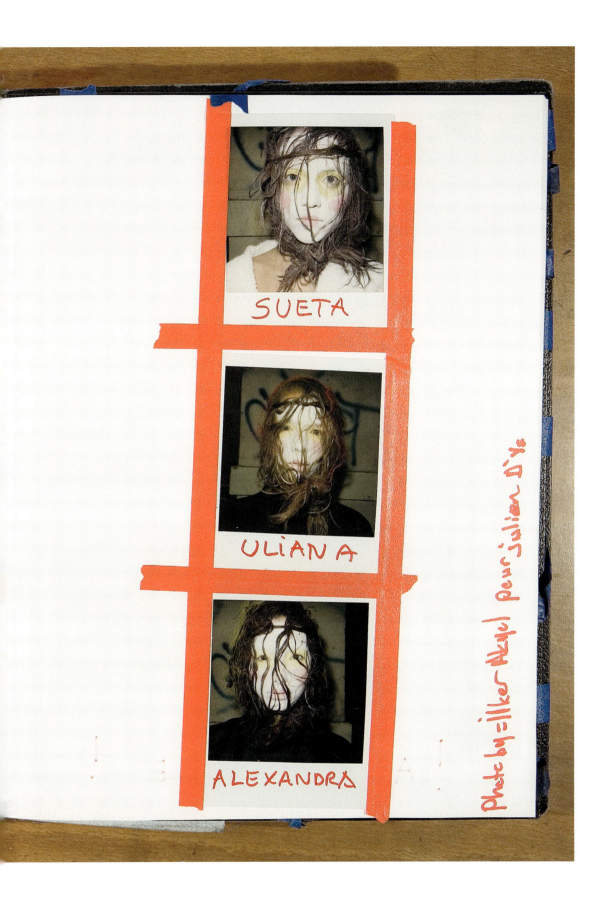

SUETA

ULIANA

ALEXANDRA

Photo by: Ilker Akyol Pour Julien D'Ys

Sketchbook Julien d'Ys for Comme des Garçons Spring–Summer 2008.

Sketchbook Julien d'Ys for Comme des Garçons Autumn–Winter 2009–2010 *Tomorrow's Black*.

66

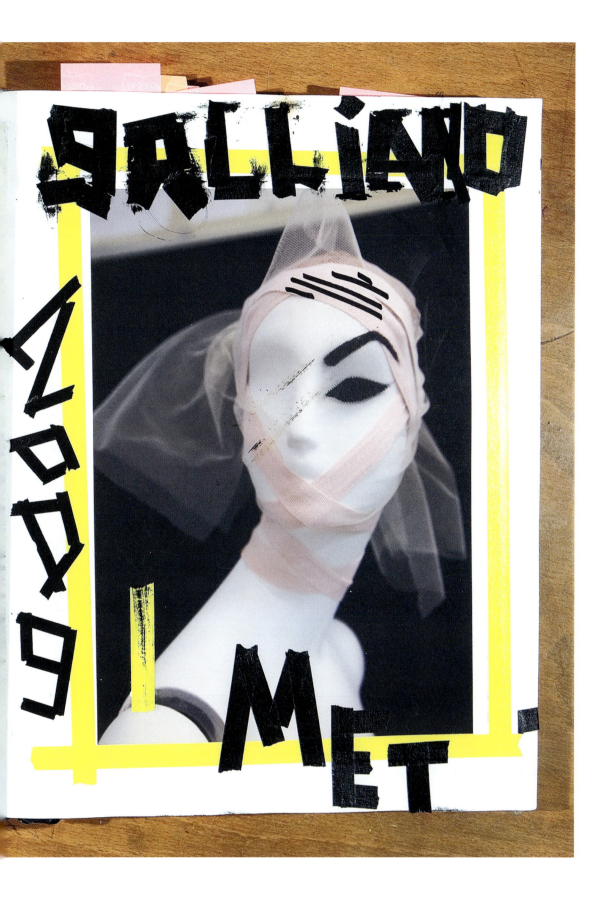

GALLIANO MODO 09 MET

Sketchbook Julien d'Ys for *The Model As Muse: Embodying Fashion* exhibition at The Metropolitan Museum of Art, 2009.

Hi Rei
PERFect HAIR wis
color . PiNK . Violet
Real HAiRDo !!
And ScARF wis Mouse
Print over the Face
DiFFérent PLACE
i Hope you LiKE
Lots oF love .
Julien
New WAy For ScARF !

Sketchbook Julien d'Ys for Comme des Garçons Autumn-Winter 2009-2010 *Tomorrow's Black*.

Julien d'Ys is an artist who has had two commercial careers: first a hair stylist; second a reluctant, perhaps even reticent, make-up artist. He has worked for more than 30 years on fashion editorial, particularly with Grace Coddington and Phyllis Posnick at American *Vogue*, and with fashion photographers Paolo Roversi, Richard Avedon and Annie Leibovitz. He has also produced hair for fashion shows in New York and Paris, for Stephen Sprouse, Karl Lagerfeld and Yohji Yamamoto. But it is his long-standing relationship with Rei Kawakubo for Comme des Garçons – from the mid-1980s until the hiatus of the 2020 Covid pandemic – that forced his hand in make-up.

D'Ys recalls, 'when Rei Kawakubo asked me to do the hair and make-up, I would always say I am not a make-up artist; she would say that is why I like to do it with you – because it's more like working with an artist or a painter.'[18] Kawakubo's direction would be a single word sent from Tokyo, which d'Ys would work on independently until a few days before the show in Paris, 'and we communicate by drawing, not by speaking or writing, as Rei doesn't like to speak too much, as she is so visual.'[19] As a formally trained artist, d'Ys uses drawing to develop his ideas visually and for each Comme des Garçons show he created a sketchbook. He takes the word and produces a visual frieze of hieroglyphs, of drawn heads in profile – necks long, hair high – delineated by handwriting in marker pen, or Polaroids of decorated faces and dyed hair taped down and titled with paintbrushed capital letters.

D'Ys has said of his work for Comme des Garçons: 'What I do for the heads is to give balance.'[20] But this is to perhaps undervalue the significance of the contribution, as it is the balance with the collection that makes the head appear totemic of that original word of inspiration. He recalls:

> You know, CDG is more of a vision rather than just clothes. When you watch either the women's or the men's show, those 15 to 20 minutes, for me, work exactly like a photo-flash where I want the audience to leave the room with an image stuck in their memory forever.[21]

For Autumn-Winter 2009, d'Ys was sent a piece of CDG tulle fabric, the colour of champagne (which would be used predominantly for the opening and closing looks in the collection). At this point, he was only producing the hair and was working with a 1940s victory roll hairstyle sprayed a deep pink. His idea for the tulle was to apply it to the face as a veil, in contrast to the more obvious historical reference of a triangulated silk scarf worn to protect the curled and set hairstyle from the elements. The veil looked more eighteenth century than mid-twentieth, and the historical mismatch was taken further by d'Ys creating lips applied to the veil, set to the side of the face rather than at the mouth, like a beauty spot or eighteenth-century beauty patch. Reviewing the show, *New York Times* critic Cathy Horyn wrote about its powerful sensibility, 'the models' faces covered by strips of tulle embroidered with a single red sequin smudge, as if from a kiss'[22]. In fact, the technique for the appliquéd lips was 'acrylic paint – it was not embroidery – as I painted directly on the tulle, and I put the glitter on top when the acrylic was not dry; that's why it gave a texture almost like jewellery'[23].

In not being directly applied to the face, the make-up design is rather like a soft mask. D'Ys was openly inspired by the stage costume designs of Jean Cocteau and his Surrealist plays on the displacement of facial features and body parts, as

18
Julien d'Ys, in interview with the author,
28 February 2024.

19
Ibid.

20
Julien d'Ys interviewed by
Filep Motwary, 12 February 2018,
https://www.filepmotwary.com/
julien-dys/, accessed 1 April 2024.

21
Ibid.

22
Cathy Horyn, 'Comme des Garçons: Magic Act',
The New York Times, 7 March 2009.

23
Julien d'Ys, in interview with the author,
28 February 2024.

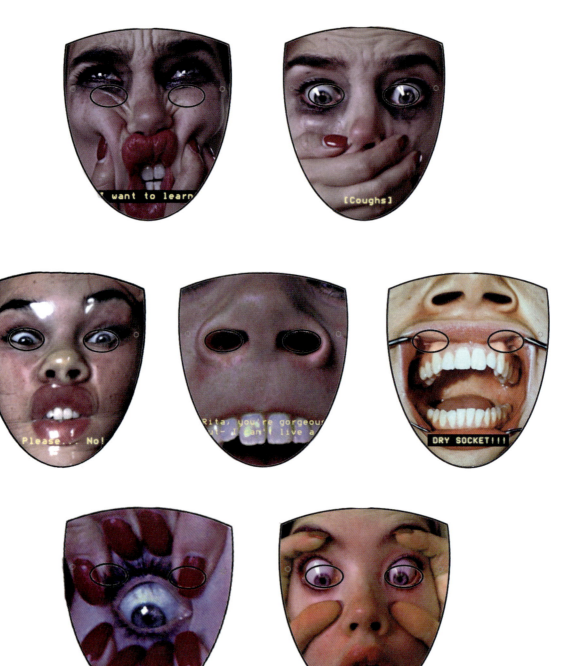

Isamaya Ffrench, *A Beautiful Darkness*, showstudio.com, 2015.

24, 25, 26
Ibid.

if the model's lips had floated sidewards revealing a Cubist profile. And yet, the inspiration for the lips was not Mae West (as in the Surrealist idiom in a shade of shocking pink), but Marilyn Monroe in all-American fire-engine red. Again, it is the mismatch that creates the visual frisson, as d'Ys confirms: 'Red mouth and pink was fantastic.'[24]

Straight after the Paris show, d'Ys returned to New York to work on the mannequins for an exhibition at the Costume Institute, *Model as Muse: Embodying Fashion*, where he reworked the tulle technique in the exhibition installation that restaged key twentieth-century fashion photographs as tableaux. So, Cecil Beaton's 1948 picture of Charles James evening gowns in jewel tones redeployed the red lips on tulle, but this time appropriately placed on the mouth; while for the recreation of Loomis Dean's 1957 picture of Dior haute couture, the tulle carried an eyebrow and an eye with eyeliner. According to d'Ys: 'For the Metropolitan, it was the Galliano and Dior section and John always really liked the underneath of the wigs and bonnets, so that's why I took the idea of the eyebrow and my inspiration was from Irving Penn's photograph of Lisa Fonssagrives, which I drew.'[25] In this context, the technique provided a perfect counterpoint to Galliano's studied historicism of the structural underpinnings of the New Look in his work for Dior at the time.

The make-up design was employed again for an editorial by Steven Klein for American *Vogue*, modelled by Karlie Kloss. The closely detailed crop picture reveals the precision of the placement of the veil's eye and brow on the head, and how the tulle frames the face and wig cap while complementing the white powdered skin – part mannequin, part living doll. D'Ys explains:

> When you put the tulle on the
> face of the girl and you put the eyebrow
> on, it looks completely 3-D – as if it's 3-D
> make-up – and it gave a lot of character. It was fantas-
> tic to find this way to paint the face of the girl for the picture.
> Rightaway, it became like a painting, from two-second make-up.[26]

What is so ingenious about the technique is how d'Ys is able to conjure wild, unexpected and stylised expressions on the face with the most economical of artistic means.

ISAMAYA FFRENCH/VERY SHRILL EXPRESSIONS

Prior to her career as a make-up artist, Isamaya Ffrench had a background in dance and theatre, most notably as a member of the Theo Adams Company, the multidisciplinary theatre group based in London which creates large-scale, immersive performances that blend art, music and fashion. Her dual credit as performer and beauty director for the company is a good example of how she now operates as a make-up artist and beauty brand today, where she performs her looks and products (as model, as spokesperson) as much as she designs and engineers them. This duality is also a factor in her education: while studying for a Product and Industrial Design course at Central Saint Martins, she was earning money at the weekend doing face-painting on children at society birthday parties. It lends her work an unusual blend of pragmatism and subversive fantasy that always has the customer in mind.

The decision to use herself arose out of a conversation with fashion photographer David Sims, at a time when she was trying to gain work as a professional make-up artist for fashion, 'and I remember complaining to him that nobody

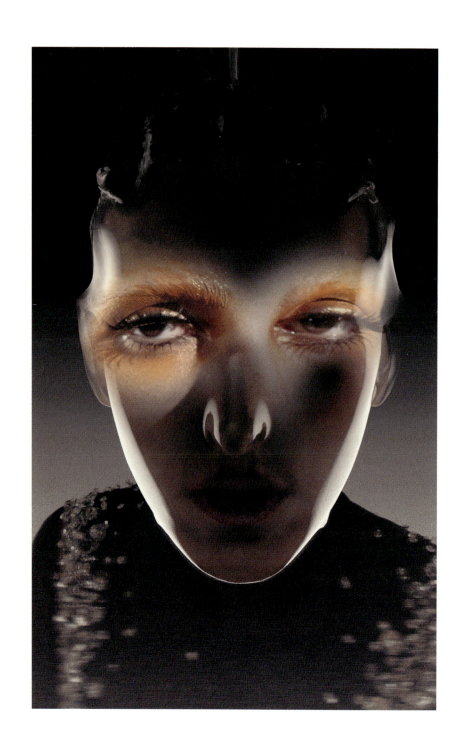

Till Janz and Isamaya Ffrench, *Portrait Nr. 6, Interview Magazine*, 2020.

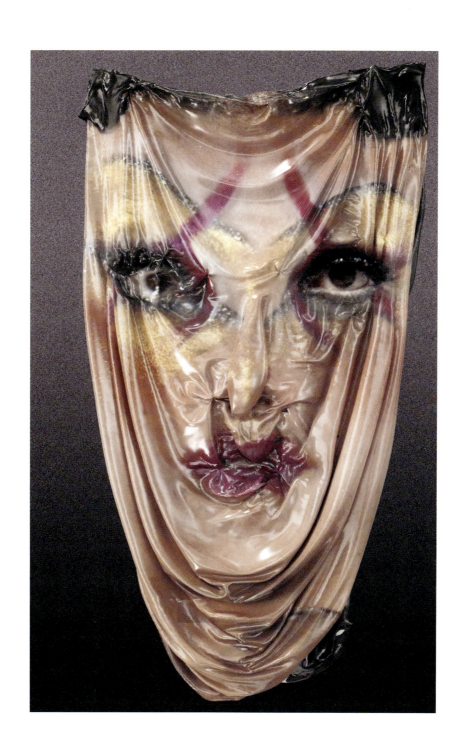

Till Janz and Isamaya Ffrench, *Portrait Nr. 6, Interview Magazine*, 2020.

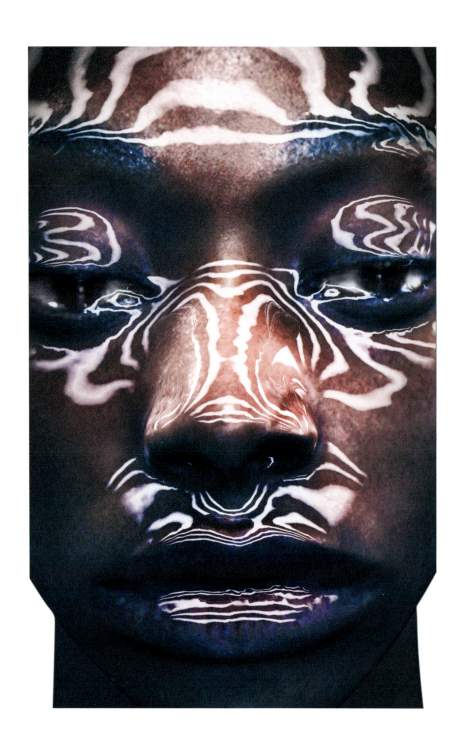

Till Janz and Isamaya Ffrench, *Portrait Nr. 6, Interview Magazine*, 2020.

27
Isamaya Ffrench, in interview with the author, 22 February 2024.

28, 29, 30
Ibid.

wanted to do my weird ideas, and he looked at me like I was an idiot and said, "Well, just shoot it yourself". And it hadn't really occurred to me. A lot of the time, you wait for the opportunity.'[27] An early project for SHOWstudio, *A Beautiful Darkness* (2015) commissioned Ffrench to make downloadable fright masks for Halloween (the fashion website has a tradition of downloadable projects such as paper patterns, T-shirt designs, posters and audio). Using pictures of her own face at different scales, with cutout holes for eyes and provocative subtitles printed over them, the masks raised the idea of horror in the everyday (Ffrench recently had a wisdom tooth extracted). 'At the time I felt very inspired by how you could express an idea or an emotion on the face and I was inspired by films with subtitles to help add another layer of storytelling into the project.'[28] One mask show's Ffrench's face contorted behind a clear Perspex mask, her compressed bloated lips next to a subtitle reading, 'Please… No!'. Ffrench's interest in narrative found voice in her role as beauty editor at *i-D* magazine from 2014, and as creative director of *Dazed Beauty* from its launch in 2018.

In addition to editorial work, Ffrench has also been a make-up artist for fashion shows for more than a decade, for the likes of Iris van Herpen, Thom Browne, Junya Watanabe, and Andreas Kronthaler for Vivienne Westwood. Ffrench is refreshingly pragmatic in her view of this aspect of her work, seeing it as 'less of a creative opportunity' and more of a 'problem-solving activity' that is time poor. 'It's super constrained and that's what many people don't realise, that big decisions might be made due to the fact that we've only got three hours and fifty models in the chair – it's an eye or a lip and you can't have both.'[29] Such creative constraints can also offer more concentrated looks, such as Chet Lo Autumn-Winter 2023, which included fragments of fake eyelash and dyed tongues: short-form make-up in staccato.

For Spring-Summer 2024, the season following the death of Vivienne Westwood, Ffrench created make-up looks for the show based on how Westwood herself wore make-up in her lifetime:

> It was a very sentimental show for everyone, and a number of the clothes in the show were from Vivienne's personal wardrobe, and mixed some of the vintage pieces with the new pieces tailored by Andreas. And I guess they wanted to do something similar across the board. Her make-up repertoire is vast and she had so many mad and iconic looks, so we went about bringing out some of those hero looks – the pencil eyebrow or the smeared cheek – it was really a homage to her fashion and beauty choices to make the show feel very personal.[30]

Andreas Kronthaler and stylist Sabina Schreder provided references including personal photographs of Westwood, the exception being a hooded look sported by model Tim Piglowski, with a pair of dark shades worn over the face covering, which was imprinted with Ffrench's own lips: a shrill expression and a gesture of love combined in a single kiss.

INGE GROGNARD/EXQUISITE TURBULENCE

Inge Grognard is a make-up artist who works against the grain of convention. Her collaborations – with Maison Martin Margiela from the late 1980's until the 2000s, and Balenciaga in the 2020s – interrogated beauty conventions with conceptual rigour, creating lasting images. Grognard is invested in 'the dark side of human beings', which sets her apart from most of her peers, lending her work

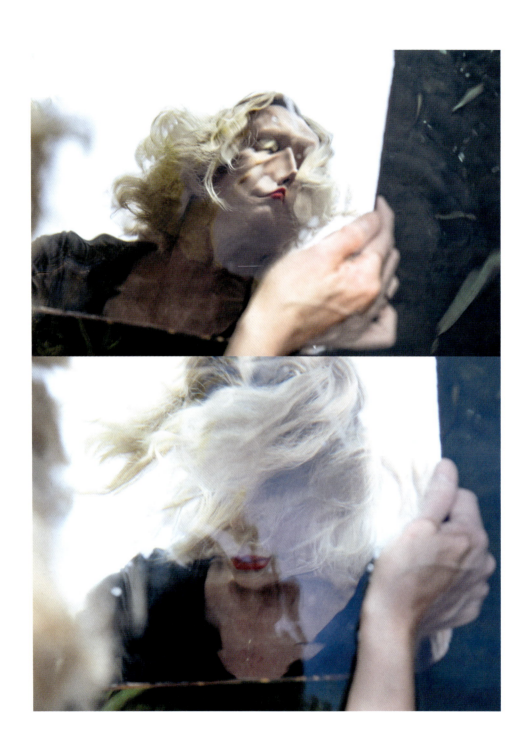

Inge Grognard and Ronald Stoops, *Vanity*, *Beauty Papers*, 2021.

31
Inge Grognard, in interview with
the author, 19 February 2024.

32, 33, 34
Ibid.

an unanswerable, ritualistic quality. Her approach is not to decorate the face, 'as my canvas is skin',[31] and much of her work centres on imprinting visual traces to disrupt how a face appears.

Such minimal interventions can look stark, but it is the conscious resistance to a total look: 'What I don't like is when I have to go all over the face and cover it.'[32] As such, Grognard's work shares an affinity with the mask, partly informed by her awareness of Ensor's work, which she first saw as a teenager growing up in Belgium. 'With Ensor, he wasn't using a mask to cover the face; it was to bring out the not so beautiful parts of people.' And Grognard uses the term to describe her own practice: 'do you use a mask to cover or do you use it to bring out that dark side?'[33]

For Margiela's Autumn-Winter 1996 fashion show (p. 6), the staging involved a number of male technicians carrying a large umbrella containing spotlights that illuminated the models from behind and cast a shadow. The concept was inspired by Impressionist paintings (such as Claude Monet's *The Beach at Trouville*, 1870) depicting the shadow lines cast on a woman's face sheltering from the sun under a parasol. Grognard extended the idea, creating a cabin backstage with a brimmed hat hanging above a stool with a lamp strung above it, so that each model could sit and have a real shadow line painted across their face, filling in the upper half of the head with a dark brown. This was offset with alabaster skin, bright red lips and teeth painted with white varnish (an outdated silent-movie technique to make teeth shine more) beneath. It produced a *trompe-l'oeil* of a shadow on the faces of the models, but the horizontal line also harked back to the mask of Harlequin, the character from the Italian commedia dell'arte, which can be traced back further to the Old French term for a mischievous devil. It is a mask that can also be seen in Ensor's painting, *Death and the Masks* (1897), worn under the frilly brim of a clown's spotted cone hat, the black horizontal line of the mask framing downturned rouged lips beneath.

Beyond the catwalk, Grognard regularly collaborates with her partner, photographer Ronald Stoops, to realise their ideas as editorials in magazines such as *V, NoA* and *Beauty Papers*. *Hibernia* (2003) depicts a group of young people watching a movie in a cinema, each wearing a chin mask that covers the mouth. The mask has a moulded pair of lips, across which, strung between two holes, is a red cord like the kind you might use to fasten a mask to the head. Visually, it turns the lips into a false smile but it also refers to a much more sinister smile, known as the Chelsea smile, a torture technique where the sides of the mouth are cut to leave the permanent scar of a rictus grin. It is a chilling commentary on the societal fears around young people watching horror movies, and the visual simplicity of the chin mask they all wear is what makes it such an unsettling picture. In 2021 Grognard and Stoops produced a beguiling double portrait of Grognard that was published in *Beauty Papers*, titled *Vanity*. From a mirrored pane held under water at the edge of a stream, Grognard's distorted portrait is thrown back, destabilising the fixed nature of appearance. The exquisite turbulence it raises shows us something finely crafted and ravishing to look at, but also shifting and distracting. The picture points to the fact that beauty is not necessarily just in the subjective eye of the beholder, but that it is the product of a restless vanity guided by the hand holding the mirror. Grognard told me, 'My thing is I do everything by hand, that is my signature.'[34] What this suggests, beyond the practicality of using her hands to apply make-up, is that her role – as a make-up artist for fashion – is also one that tilts and directs the vision of contemporary beauty.

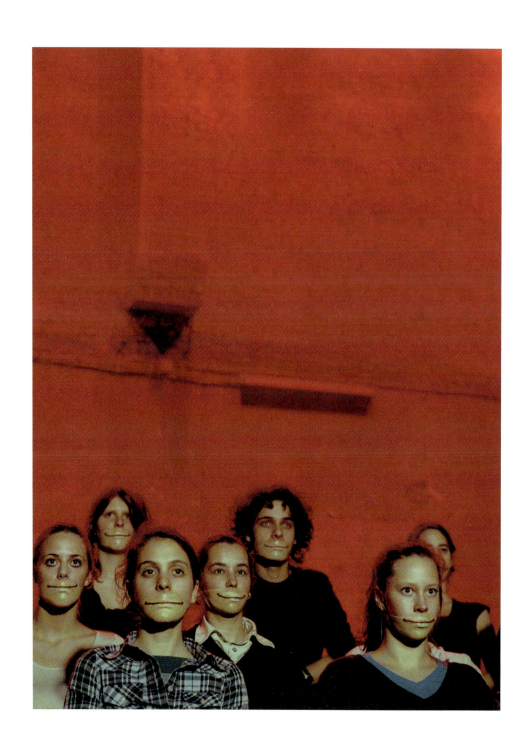

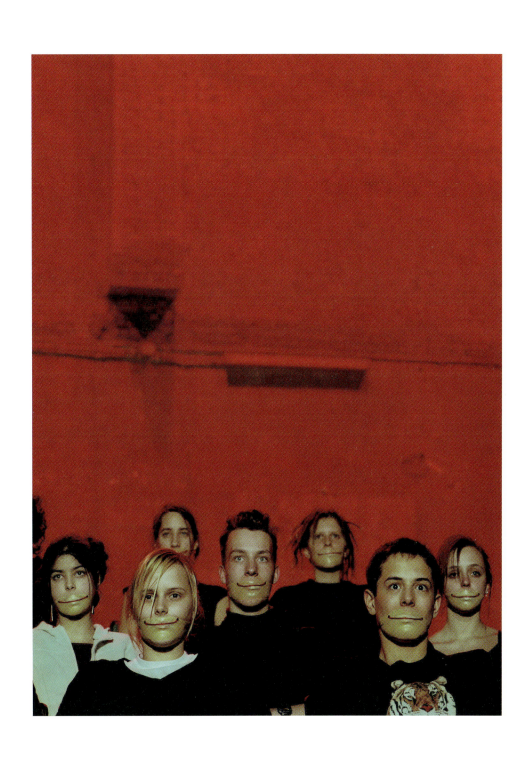

Inge Grognard and Ronald Stoops, *Hibernia*, 2003.

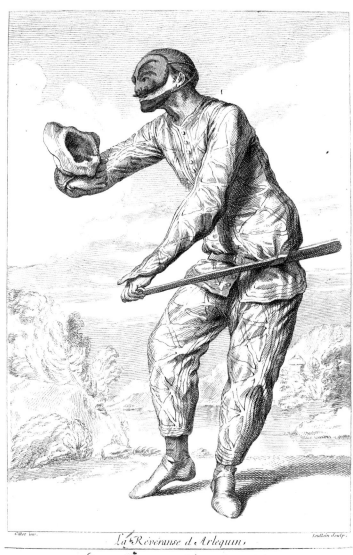

François Joullain after Claude Gillot, *La Révéranse d'Arlequin*, c. 1730.

MAKE-UP IN ENSOR'S TIME:
FROM TABOO TO ART FORM

1
Max Beerbohm, *A Defence of Cosmetics*
(1894) (New York: Dodd, Mead and
Company, 1922), p. 68.

'Artifice is the strength of the world, and that same
mask of paint and powder, shadowed with vermeil tinct
and most trimly pencilled, is woman's strength.'

Max Beerbohm, *A Defence of Cosmetics*, 1894[1]

2
Caroline de Broutelles, *La Mode Pratique*,
6 July 1895, p. 212.

'The majority of the public is convinced that, over time,
face powder withers the skin and causes premature wrinkles;
husbands disapprove of its use; people who pride themselves
on austerity liken it to make-up and judge severely those who resort
to this means of self-beautification; almost all the women who
use it are even afraid of shortening the time of their freshness through
its use, reproach themselves somewhat for sacrificing the future
to the present and hide from this weakness.'

Caroline de Broutelles, in *La Mode Pratique*, 6 July 1895[2]

For centuries, cosmetics have served to approach prevailing ideals of beauty. In the nineteenth century, the striking, highly artificial make-up of the eighteenth century made way for subtle means that besmirched the ideal of natural beauty as little as possible. Visible make-up was unacceptable for almost a hundred years, although this changed towards the end of the century, with opinions divided as a result. Maquillage was then regularly described as a mask of paint. The Belgian painter James Ensor depicted make-up in various ways.

3
Aileen Ribeiro, *Facing Beauty:
Painted Women & Cosmetic Art* (New Haven,
CT: Yale University Press, 2011), p. 224.

4
In his 'Éloge du maquillage',
published in *Le Peintre de la vie moderne*
(Le Figaro, Paris, 1863), he praised
artificiality even when it was clearly visible.

A MASK OF PAINT

Around the mid-nineteenth century, make-up was associated with deception, excessive luxury and overt sexuality.[3] Women were expected to be beautiful without showing a hint of artifice, although French writer Charles Baudelaire thought otherwise.[4] The taboo around artificial aids encouraged charlatans. The notorious 'Madame Rachel', for instance, used to blackmail her embarrassed clients before being convicted of fraud in 1868.[5] (p. 88) All kinds of bleaching agents, ranging from lemon-based lotions to arsenic steeped in water, were secretly employed to achieve an even complexion. Women continued to use mixtures of lead and mercury despite the many warnings about the dangers to their health:

5
Sarah Jane Downing, *Beauty and Cosmetics
1550–1950* (London: Shire Books, 2012), p. 38;
Ribeiro 2011, p. 255. She sold beauty
products worth £1,000 to one Mrs Borradaile
and extorted the same sum from her again
with the promise of a titled noble husband. In today's
money, that would amount to £90,000.

6
Drs D.G. Brinton and Geo. N. Napheys,
Personal Beauty (1870), quoted in
Richard Corson, *Fashions in Makeup:
From Ancient to Modern Times* (New York:
Universe Books, 1972), p. 353.

The so-called method of 'enamelling' is simply painting the face, and for this purpose the artists always prefer the poisonous salts of lead, as they yield much more striking effects. Practice often gives these persons a decided skill in their speciality, but their customers pay for it doubly, first in money and then in health.[6]

Anonymous, 'A Stall at Vanity Fair', *Echoes from the Clubs*, 29 July 1868.

7
Ribeiro 2011, pp. 224, 249.

8
Max Beerbohm 1922, p. 4.

9
The Woman's World (1888), quoted in Ribeiro 2011, p. 267.

10
A Professional Beauty, *Beauty and How to Keep It* (1889), quoted in Corson 1972, p. 361.

11
Corson 1972, p. 167.

12
Ribeiro 2011, p. 273.

13
Emile Verhaeren, *James Ensor* (Brussels: G. Van Oest & Cie, 1908), p. 107. The French title *L'amie de l'artiste* can refer to friend or to girlfriend.

14
Such as *The Lady in Grey* (1881; Royal Museums of Fine Arts of Belgium, Brussels) and *The Sombre Lady* (1881; Royal Museums of Fine Arts of Belgium, Brussels).

15
Susan M. Canning, *The Social Context of James Ensor's Art Practices: 'Vive la Sociale!'* (New York: Bloomsbury, 2022), p. 168.

Around 1870, the discreet use of powders, salves and rouge for a splash of colour was gradually accepted, as long as it was applied in moderation. If the make-up was applied too thickly, the lady in question would be seen as being of easy virtue or as belonging to the demi-monde.[7] For the *Petit journal pour rire* (1866, p. 86), for instance, Alfred Grévin sketched a heavily made-up woman in a box at the theatre with two men judging her in the background. The woman's 'possessor' asks his friend what he thinks of 'his little woman', to which the latter replies: 'Gosh, I don't know, I'm not a connoisseur of paintings.'

If we are to believe essayist and cosmetics enthusiast Max Beerbohm, the use of make-up was widespread by the end of the nineteenth century: 'And now that the use of pigments is becoming general, and most women are not so young as they are painted, it may be asked curiously how the prejudice ever came into being'.[8] In 1888 the magazine *The Woman's World*, edited by Oscar Wilde, lauded the possibilities in poetic terms:

> In the present day a woman of the world enhances her charms not only with clothes, but with washes and pigments… Crème Simon, and powder made of Russian or San Remo violets. Her cheeks blush with rouge made only of Provence roses, and her rosy lips owe their colour to Baume de Thé; while a cleverly applied pencil renders her eyebrows shapely, and 'puts fire in each eye.[9]

But not everyone was equally enthusiastic. One 'professional beauty' warned her readers not to ridicule themselves with a mask of paint:

> The use of rouge and pearl powder seems to have become more fashionable now than it has been for many years… It would be so much better to try to correct the faults of the face with a little care and art without covering the whole of it with a mask of paint. I have seen some hideous specimens lately of painted women who think they are objects of beauty, instead of which they have made themselves objects of ridicule.[10]

Ensor seemed to hold the same opinion at the time, as he mocked an excessively made-up lady by surrounding her with equally colourful masks with thick layers of paint. He even provides his *Old Lady with Masks* (1889, p. 240) with some artificial beauty spots, popular in the seventeenth century to emphasise the whiteness of powdered skin. During the reign of Louis XIV, the shape of the spot and its location on the face conveyed all kinds of messages, providing an inexhaustible source of satire.[11] Like the old lady's outmoded hat, these beauty spots experienced a brief revival around 1860.[12] Ensor made grateful use of them to underline the ephemeral nature of fashion and beauty.

The portrait contrasts sharply with the female image he had painted ten years earlier. At the age of 19, he produced *Girl with Upturned Nose* (1879, p. 87), previously titled *The Artist's Friend*.[13] The girl looks fresh with a slight blush on her cheeks, nothing but natural youthfulness. Distracted, she averts her gaze. In several of the domestic portraits Ensor painted between 1880 and 1881, the women are also mostly lost in thought or carrying out mundane activities.[14] The postures and unpretentious clothing and surroundings of these women from the 'petite bourgeoisie' evoke respect for their dignity and social status.[15]

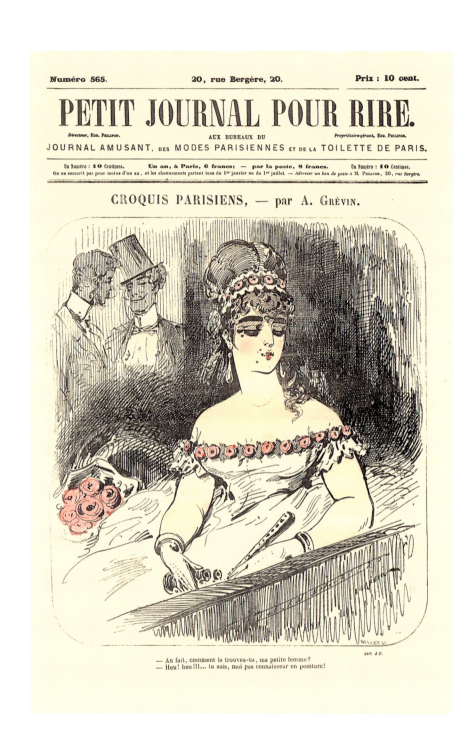

Alfred Grévin, *Croquis Parisiens, Petit journal pour rire*, No. 565, 14 February 1866.

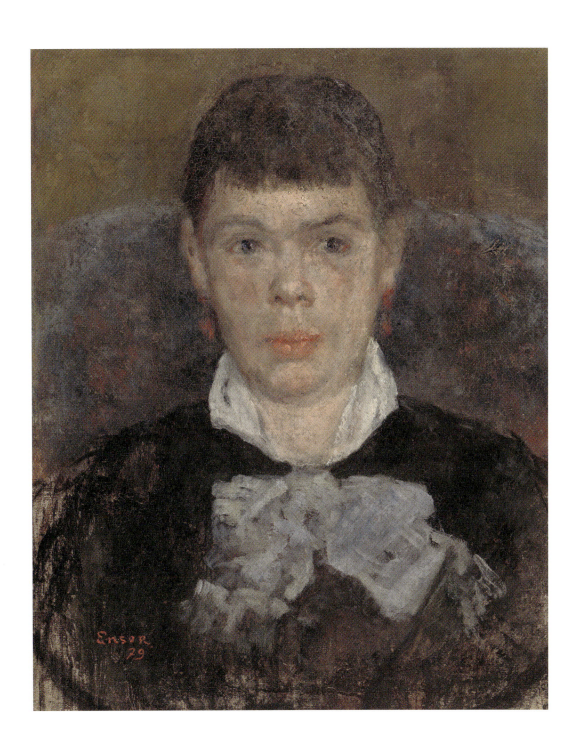

James Ensor, *Girl with Upturned Nose*, 1879.

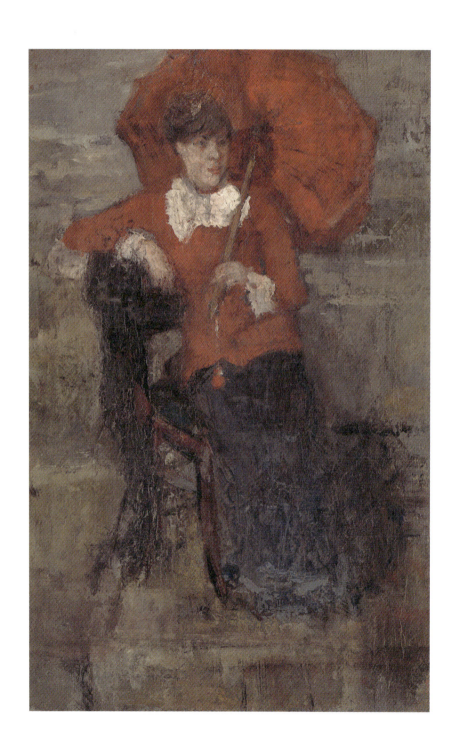

James Ensor, *Lady with a Red Parasol*, 1880.

16
Corson 1972, p. 380.

17
Speed Art Museum, Louisville, Kentucky.

18
Canning 2022, p. 169.

19
See Valerie Steele, '*Femme Fatale*: Fashion
and Visual Culture in Fin-de-Siècle Paris',
Fashion Theory, Vol. 8, No. 3, 2004,
pp. 316–18.

20
James Ensor, quoted in Saskia de Bodt et
al. (eds), *Alfred Stevens 1823–1906:
Brussel–Parijs* (Brussels and Amsterdam:
Royal Museum of Fine Arts of Belgium
and Van Gogh Museum, 2009), pp. 55–6.

Two works from this period have a more pronounced fashionable component in that, in addition to the posing woman, her accessory plays a leading role. In *Lady with a Red Parasol* (1880, p. 88), the red lips of Ensor's sister Mitche connect the colour of her parasol with that of her jacket. When he depicted her as *Lady with the Fan* (1880/1, p. 90), by way of an exception, she looks straight at him. Her coral-red lips stand out. 'Rouge' was less acceptable for the mouth than for the cheeks at the time, but both were available.[16] However, it was presumably the artist's choice to highlight Mitche's lips in this way.

The painterly genre of women in domestic interiors was also the trademark of Ensor's fellow countryman and contemporary, Alfred Stevens (1823–1906). His depiction of Parisian bourgeois women dressed in the latest fashions amid luxurious interiors maintained a nineteenth-century feminine ideal that was associated with fashion, shopping and amusement within a consumer culture that relied on possession and desire. Susan M. Canning has aptly illustrated how Ensor and Stevens, using the same ingredients, achieved very different effects. She compared Ensor's *Lady with the Fan* with Stevens's *Young Woman with a Japanese Screen*,[17] also dated 1880. Although both women, surrounded by the comforts of tangible materials, look at their beholder, Stevens's model conjures the illusion of possession while Ensor's model deflects any hint of acquisition or desire through her gaze, posture and clothing.[18] Both paintings bear witness to the various, often conflicting, expectations that were projected onto women and which can be found in crystallised form in the discourse on make-up, even though Ensor and Stevens briefly seem to agree on that very point. Like Ensor, but one or two years later, Stevens painted a woman with similar coral-red lips holding a fan and gracefully resting her arm (*Fedora*, 1882, p. 91). This was none other than French actress Sarah Bernhardt, who became a role model for fashion and make-up during the fin-de-siècle. Pictures of her circulated widely and she appeared several times on stage in Brussels and Ostend from 1895 onwards. She was considered the embodiment of the femme fatale, blurring the boundaries between different female types.[19] By the 1890s, high-society ladies were copying the theatrical cosmetics of actresses, including eye shadow and rouge to emphasise cheekbones.

Ensor was no fan of Stevens's work and social environment. He wrote in the Brussels avant-garde magazine *Le Coq rouge* in 1896:

> His paintings amount to nothing, his colouring is a mishmash. His works neither arouse elevated feelings nor make you think. They are of a debauched mediocrity that is willing to concede everything: from lack of quality and false stylishness to the low strokes of a cunning slyboots. His work appeals to red-faced stock-market speculators, obnoxious Semites. Drain covers on the decline, sheepish countrymen, inconsequent snobs, greedy financiers and pushy greenies like flâneurs, absinthe drinkers and seamstresses… Mr Stevens' cunning foxiness, his currant juice and pistachio colours, his refined affectation, his paintings that gleam like the table of a café covered in splashes of diluted liqueur, the glassy flesh colours of his pallid *Parisiennes*, these are not the work of a Fleming.[20]

By then, Ensor himself had traded in his decent middle-class ladies and sober colours for grotesque masks in a pronounced colour palette.

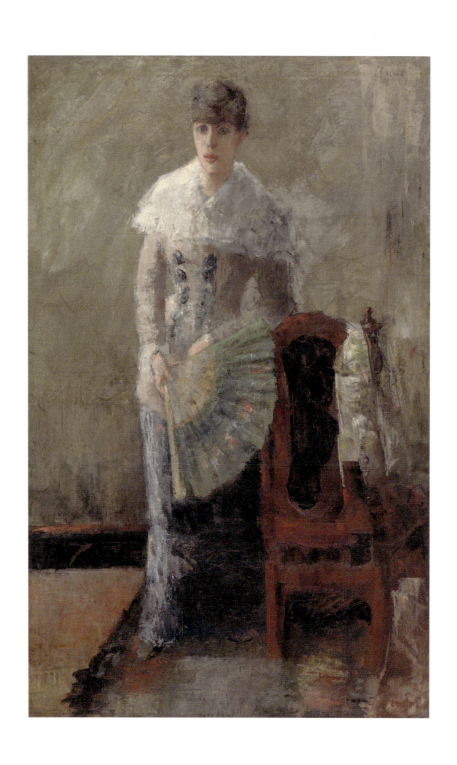

James Ensor, *Lady with the Fan,* 1880 or 1881.

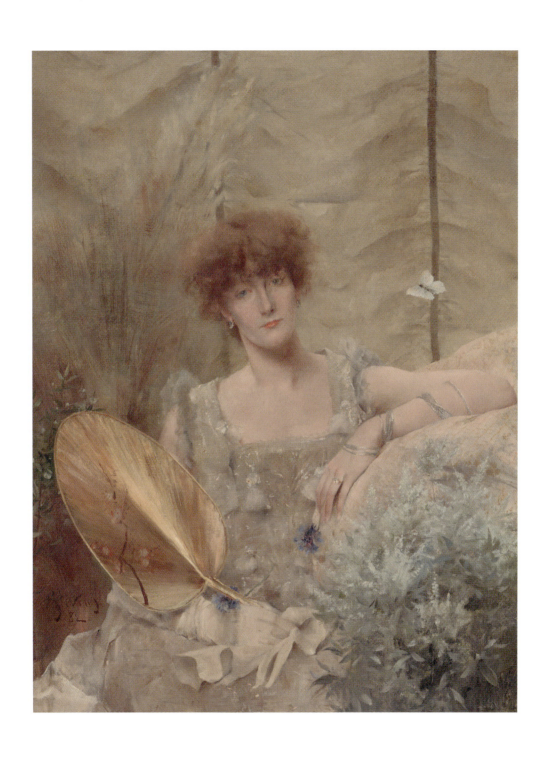

Alfred Stevens, *Fedora (portrait of Sarah Bernhardt)*, 1882.

James Ensor, *Our Two Portraits*, 1905.

21
Canning 2022, p. 195.

22
Francine-Claire Legrand claims she was 'probably his mistress', while also commenting that their correspondence lacks a romantic undertone: *Ensor, la mort et le charme: Un autre Ensor* (Antwerp: Mercatorfonds, 1993), pp. 45–6. Susan M. Canning points out that Ensor kept his sexuality hidden and his relationships discreet. According to her, several elements of *Our Two Portraits* suggest a clandestine encounter: the fleeting exchange of glances, the mirror reflection, and the setting that alludes to an unusual relationship. See Canning 2022, p. 212.

23
La Mode Pratique, 9 May 1903, p. 223.

24
La Mode Pratique, 11 February 1905, p. 104.

25
Ensor named Boogaerts 'la Sirène', a word used for women considered attractive but also dangerous (see https://dictionary.cambridge.org/dictionary/english/siren).

26
La Mode Pratique, 23 May 1914, p. 318.

27
Ribeiro 2011, p. 298.

28
Ibid., p. 305.

In such masquerades as *Masks Confronting Death* (1888, p. 34) and *The Astonishment of the Mask Wouse* (1889, p. 246), Ensor transformed the lure of fashion, accessories and make-up into satire.[21]

THE WOMAN BEHIND THE MASK

From the early twentieth century, Ensor again painted a number of domestic portraits of women from his immediate environment. In *Our Two Portraits* (c. 1905, p. 92), he depicted himself in the company of Augusta Boogaerts (1870–1951), the daughter of an Ostend hotel manager with whom he had been friends since 1888. Their lifelong friendship and unmarried status suggest they were lovers.[22] Boogaerts is dressed in a dark walking suit that contrasts wonderfully with the luminous, rosy complexion Ensor gives her. She looks somewhat shyly, but also slightly seductively, out of the window, aware that he is watching her. Her eyelashes and eyebrows have been darkened. From 1900 onwards, *La Mode Pratique*, a French women's magazine that was also distributed in Belgium, regularly praised 'Sourcilium' and 'Sève sourcilaire', products that darkened, thickened and lengthened lashes and eyebrows, which was a change in tone from a few years earlier. In 1896, under the heading 'Carnet de la maîtresse de maison' (The housewife's notebook), readers were given advice on how to preserve their eyelashes and eyebrows, given the 'charm' they lend to a woman's gaze. The magazine recommended petroleum oil to encourage growth or an extract called 'Cruspinera'. By 1903 the beauty section was clearly named as 'Petits conseils de beauté' (Beauty tips) and dark lashes were described as 'irrésistiblement charmeurs' (irresistibly charming).[23] The word 'seduction' was now a regular part of the discourse and the use of artificial aids was a must by now, though the trick lay in creating the opposite impression:

> The real art lies not only in producing a pleasing ensemble using make-up and powders, but above all in giving an impression of reality. A woman who truly cares about her beauty will only be completely satisfied if she can hide the artifice she has used from the best trained eye.[24]

The way Ensor rendered his 'siren'[25] seems to meet this requirement. Whether Boogaerts was actually using make-up at the time is hard to say. A portrait photograph from the early twentieth century does not give that impression. (p. 94) She was dressed and coiffed according to the fashion of the time, and her face betrays no hint of unnaturalness. It is possible that she had mastered the art described above.

A portrait photograph taken around 1925 shows a different picture. Boogaerts looks fashionable in a knee-length dress with sequins and a long string of pearls. A short haircut *à la garçonne* and made-up eyes complete her look. From 1910 onwards, *La Mode Pratique* featured a growing number of colours for rice powder. In 1914 there was talk of 'mauve, ocre, bise, rosée et naturelle' (mauve, ochre, greyish-brown, pink and natural) and by 1917 women could choose from 13 colours, including turquoise and violet, according to their hair colour and the occasion.[26] The increase in the number of colours and in their vibrancy was inspired by Fauvism and the costumes and maquillage of the Ballets Russes.[27] Kees van Dongen aptly rendered this focus on the eyes and lips in his female portraits. In 1920 he depicted a woman applying mascara with a little brush (p. 96), a novelty made possible by the American brand Maybelline in 1917.[28]

Augusta Boogaerts, c. 1905.

Augusta Boogaerts and Alexandra Daveluy in Ostend, c. 1925.

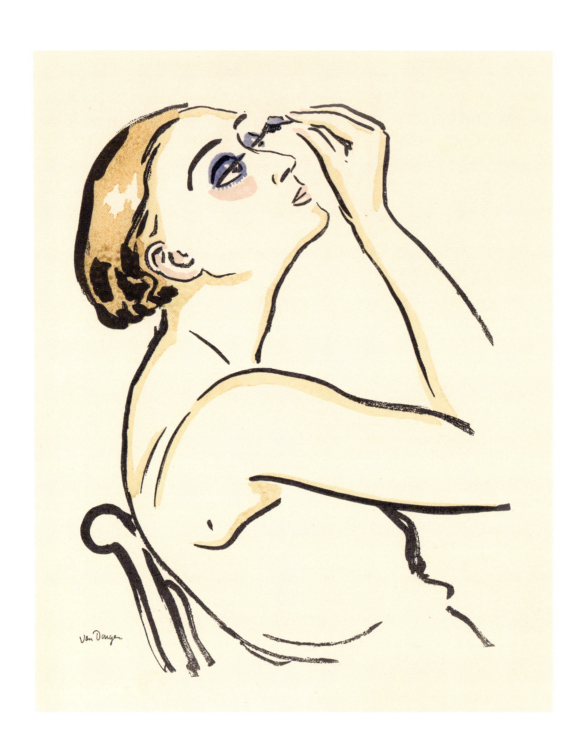

Kees van Dongen, *The Rimmel*, c. 1920.

29
'Le soin de soi-même: faut-il mettre du rouge?', *La Mode Pratique*, 10 January 1920, p.13.

30
See the letter from James Ensor to Emma Lambotte, 13 October 1908, quoted in Legrand 1993, p.53.

31
Canning 2022, p.209.

32
Their extensive correspondence was cordial and mainly concerned their health and her role as an intermediary, but from Ensor's reactions it sometimes appears that Boogaerts used to reproach him. See Legrand 1993, pp.46–7.

33
The full text that was addressed to the film-maker Henri Storck was published in: Paul Haesaerts, *James Ensor* (London: Thames & Hudson, 1957), p.360 and in Legrand 1993, p.43. According to Canning, Storck was disillusioned by his relationships with women. The anti-woman sentiment of the text can therefore be understood in this context too.

34
On this, see Canning 2022, p.210.

35
The painting is entitled *Woman Through the Ages* in: Xavier Tricot, James Ensor: Catalogue raisonné des peintures, (Antwerp: Pandora: 1992), No. 588 but in a letter to Irma Caers on 12 July 1925 James Ensor refers to the painting as *Les femmes à la mode*.

Make-up was more prominent not only on account of the use of colour, but also because women were gradually beginning to apply it in public. While the stylish fashion magazine *Gazette du Bon Ton* hailed it as a 'charming habit' in 1920 (p.98), it remained a bridge too far for some. *La Mode Pratique* tried to convince the last doubters to use rouge for their cheeks and lips that same year. What used to be considered 'mauvais genre' (tarty) became retroactively acceptable:

> From a moral point of view, I would say that after all, this concession does not seem to me to have as much importance as you seem to think: our most virtuous foremothers did not hesitate to put on a lot of red when fashion dictated, and this did not harm their fidelity or their devotion as mothers and wives.[29]

A second photograph from around 1925 shows Boogaerts wearing eye make-up in Ostend. Next to her is Alexandra Daveluy, Ensor's niece, in a sleeveless, sparkling dress. (p.95) Ensor portrayed her in a 1927 painting in a similar dress (p.103), but replaced her pearl necklace with one with a jade stone. Some decorative objects also allude to her Asian origins, such as the Chinese silk draped on her lap and the Chinese vase on the chest of drawers. Behind her hangs a grimacing Japanese mask that appears in several Ensor paintings. Daveluy's complexion is even and pale, her eyes and mouth finely painted, without much colour. She holds a marionette in her hands and a fan lies on the floor. Does her disregard for this female accessory in favour of the male puppet refer to her marriage at the age of 15? In Ensor's eyes, it was a dishonourable decision that he very much held against her and his sister Mitche.[30]

Around 1930, he also painted Boogaerts in an interior that emphasises her respectable, middle-class status. (p.102) She holds a fan in her hand and wears a high-necked, lace blouse. Her greying hair shows that she is getting on in age, although Ensor does not reveal that she is now 66. He gives her the same pink blush as 30 years earlier. The paintings in the background evoke his presence and allude to her supporting role as a promoter of his work.[31] As in the portrait of his niece, a mask hangs on the wall: a sad face with red lips and rouge on the cheeks. Does the choice of mask in both portraits say something about Ensor's feelings for the woman in question? Do they symbolise the less pleasant side of the person portrayed? Daveluy as a tormentor on account of her teenage marriage that weighed on him and Boogaerts frozen in disappointment because of a wedding that never took place?[32] A misogynistic text in which he describes women generally as hypocritical creatures, full of lies and deceit, a 'masque constant et sourire sans fin' (constantly wearing a mask and always smiling), makes it tempting to interpret the straight-faced likenesses as masks concealing the true nature of the women portrayed:[33] a subtle, prudent form of criticism because both played an important role in his life, as did his mother, sister and aunt. His relationship with women was without doubt complex and ambivalent.[34]

FASHIONABLE WOMEN

In 1928 Ensor painted *Fashionable Women* (p.104) for the art-and-fashion-loving Antwerp hat maker Irma Caers.[35] Three women dominate the picture: the first is dressed in an imagined blend of eighteenth- and nineteenth-century fashion; the middle one wears a flapper dress and cloche hat from the 1920s; and the third woman's clothes evoke early twentieth-century styles. Their faces feature subtle make-up applied with fine brushstrokes.

Elles *se* maquillent,
Elles ont raison,

car

si le bon ton jadis l'ordonnait, si plus tard il l'interdisait, aujourd'hui il le recommande presque. Liberté, égalité. Toutes les femmes de toutes les conditions se fardent et elles ont joliment raison, puisque le fard les embellit. Elles ne se donnent même plus la peine de dissimuler. Regardez-les, au dancing entre un tango et un fox-trott, au restaurant à la fin du repas... La belle prend la petite glace et se regarde sévèrement, passe la houpette sur son nez, le bâton de rouge sur ses lèvres, un doigt mouillé sur ses cils et d'un index précis consolide une mouche de velours ; personne n'y fait attention puisque chaque table voit le même manège.

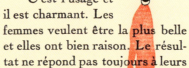

C'est l'usage et il est charmant. Les femmes veulent être la plus belle et elles ont bien raison. Le résultat ne répond pas toujours à leurs

désirs, mais l'intention est louable et ne peut que flatter ceux qui les contemplent. Ils auraient tort, ceux-là, de dénigrer le maquillage. Adroitement employé, il rectifie le visâge, diminue la joue, agrandit l'œil, fait briller la dent blanche sur la lèvre rouge. Il rend plus jolie la jolie, charmante la médiocre, et grâce à lui la laide transforme sa disgrâce en originalité, piquant, ou drôlerie. Un visage irrégulier artistiquement arrangé acquiert très souvent un style, un cachet plus attrayant que la simple beauté. Le maquillage est un art car il consiste non seulement à colorer ou aviver le teint ou les traits, mais surtout à les accentuer dans le caractère où ils ont été créés. Il est aussi une science. Ce qui embellit l'une, enlaidit l'autre. Certains rouges qui donnent à la joue mate des brunes l'aspect du brugnon en fleur, noircissent la peau bleutée des blondes ; une prunelle très claire prend facilement une expression féroce quand elle est encadrée de kohl ; et si l'œil est agrandi par l'estompe ou le crayon brun, un trait noir trop appuyé le

87

Sylviac, 'Elles se maquillent, elles ont raison', illustrated by Maggie Salzedo, *Gazette du Bon Ton*, No. 3, April 1920.

rapetisse et lui donne un regard vulgaire.

Comme toutes choses de ce monde le maquillage a une mode.

Il y a quelques années, s'enduire la figure de crême semblait indispensable : on était pâle comme un clair de lune.

Les fortes créatures d'autrefois prenaient toutes un aspect anémique et mourant, celles d'aujourd'hui, si minces, si frêles, sont actives, robustes, ne veulent être ni souffrantes, ni malades, aussi ne le sont-elles jamais.

Ce souci de paraître fortes, ce désir de vouloir être belles ennoblit le maquillage. Le geste de la femme qui se farde ne fait plus aujourd'hui sourire personne. Sans peut-être se l'expliquer, on a compris que non seulement il n'est pas puéril mais que, bien au contraire, il a la force d'un symbole.

SYLVIAC.

88

Sylviac, 'Elles se maquillent, elles ont raison', illustrated by Maggie Salzedo,
Gazette du Bon Ton, No. 3, April 1920.

They are surrounded by women's faces depicted more coarsely, showing envious and bored expressions, and adorned with a medley of hats. Both scathing and tender representations of women come together here, along with fashion and make-up. The painting seems to express compassion for the woman who follows fashion and moves with the times.

Images of fashion and women changed considerably in Ensor's time: the fashionable woman transformed from a pale, constricted 'angel in the house' to a seductive femme fatale to a self-confident *garçonne* in short skirts. Make-up was an important part of this transformation, evolving from a taboo to a commercialised form of self-expression. The paintings discussed show Ensor's sensitivity to fashion, accessories and make-up, but his depiction of them fluctuated: from status-enhancing to satirical, from realistic to fantasised. He highlighted the analogy between make-up and masks, part of the late nineteenth-century discourse on cosmetics. Some of his masquerades can be read as parodying the growing consumer culture. These satirical works contrast with the domestic portraits of women from his own environment in which he subtly but misleadingly depicts their possible use of make-up. Based on the views on maquillage held at the time, it seems unlikely that his sister Mitche, as a respectable middle-class woman from Ostend around 1880, actually used coral-red lip rouge. While his friend Boogaerts opted for expressive eye make-up in the 1920s, he only emphasised her blushing cheeks. In his portraits of married women who were not part of his intimate circle, Ensor seems have held back less. In 1907, for instance, he gave his art-critic friend Emma Lambotte darkened lashes and burgundy lips. In 1927 Mrs Albert Croquez was given a mouth painted red, a pronounced pink blush and red nail polish. It is possible that Ensor's caution was prompted by the continued importance attached to female virtue; he did not take risks when it came to his unmarried friend or his talked-about niece. Both the discourse on make-up and Ensor's works bear witness to complex and conflicting expectations at a time when women were steadily gaining greater freedom of movement and expression.

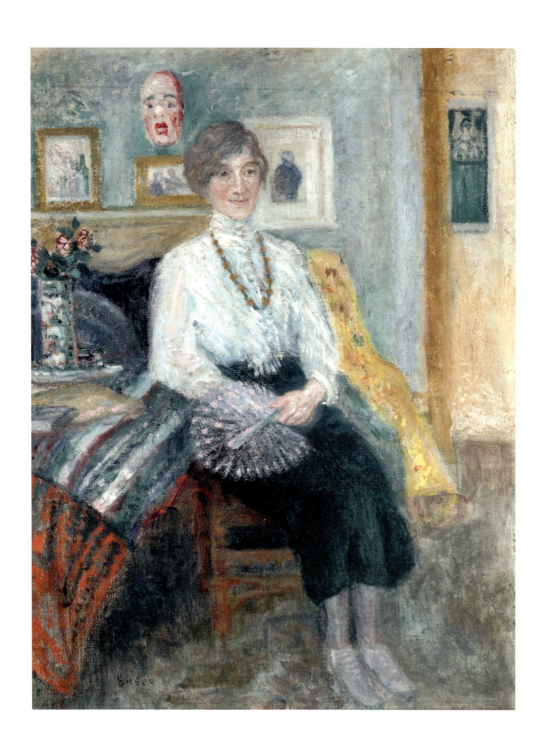

James Ensor, *Portrait of Augusta Boogaerts seated (La Sirène)*, c. 1930.

James Ensor, *Portrait of Alexandra Daveluy*, 1927.

James Ensor, *Fashionable Women*, 1928.

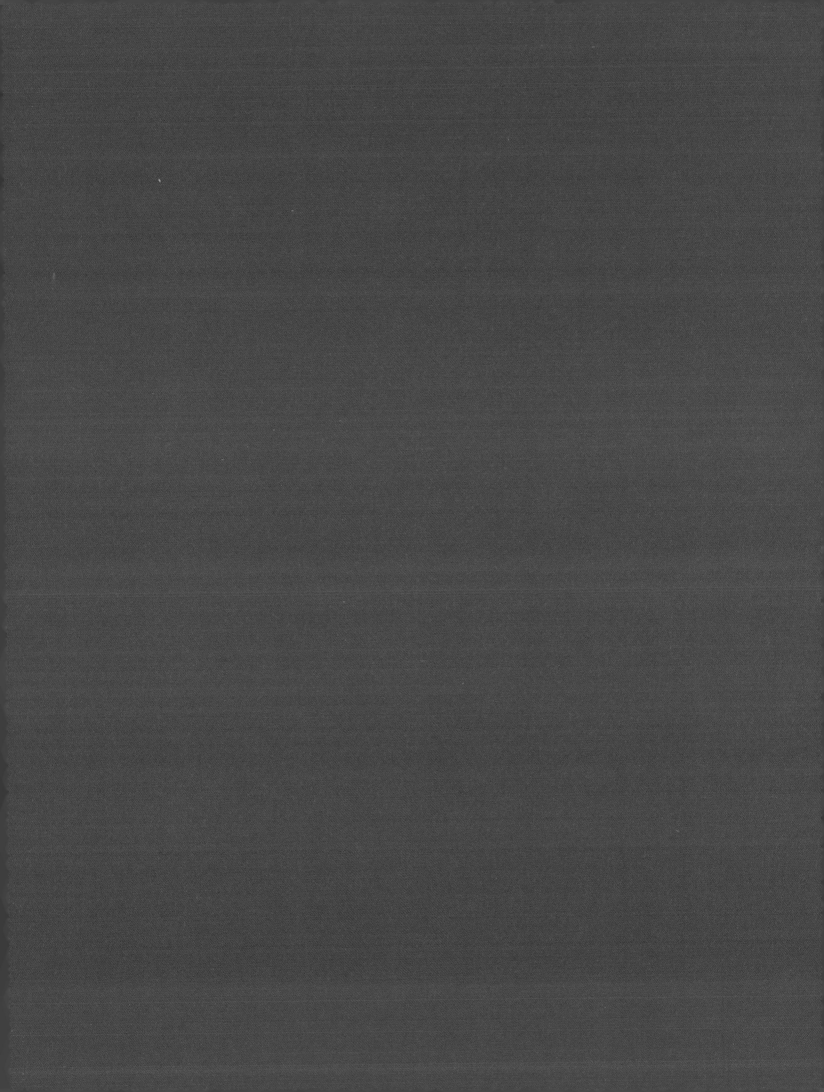

MAKING UP THE GROTESQUE IN CONTEMPORARY FASHION

1
Mikhail Bakhtin, *Rabelais and His World*,
trans. Hélène Iswolsky (Bloomington:
Indiana University Press, 1984), p. 40.

2, 3
Ibid.

4
Peter Stallybrass and Allon White,
'From Carnival to Transgression', in Ken Gelder
and Sarah Thornton (eds), *The Subcultures Reader*
(London: Routledge, 1997), pp. 293–301.

5
Caroline Evans, *Fashion at the Edge:
Spectacle, Modernity, and Deathliness*
(New Haven and London: Yale University
Press, 2003), pp. 3–14.

6
'Make-up', *Oxford English Dictionary*,
https://www.oed.com/dictionary/make-up
_n?tab=meaning_and_use#38239812,
accessed 15 March 2024.

Masks were central to the European Carnival tradition, which, according to the literary scholar Mikhail Bakhtin, found its utmost expression in the Middle Ages. Tracing the history of the Carnival spirit from the Middle Ages to the twentieth century, he writes, 'The mask is connected with the joy of change and reincarnation, with the gay relativity and with the merry negation of uniformity and similarity; it rejects conformity to oneself.'[1] Thus, masks allowed for a playful and ever-shifting relation to one's identity and, together with Carnival costumes, spurred the taking on of different identities and the creation of alternative worlds, where class and other categories could be, however temporarily, upended. Or as Bakhtin aptly puts it, the mask 'contains the playful element of life; it is based on a peculiar interrelation of reality and image, characteristic of the most ancient rituals and spectacles […] It reveals the essence of the grotesque'.[2] He defines the grotesque body as transgressing boundaries, and rules and places it in contrast to the classical body defined by symmetry, proportionality and order.

However, Bakhtin concedes that, particularly as the European Carnivals waned from the Renaissance onwards, the mask lost part of this joyous quality of renewal and transformed itself into something more unsettling: 'the mask hides something, keeps a secret, deceives […] acquires a sombre hue'.[3] And it is this ambivalent mask, alternately comic and terrifying, that characterises much of the oeuvre of the late nineteenth-century's James Ensor, whose work presaged the German Expressionists' ample use of grotesque masks in the early twentieth century.

It is the argument of Bakhtin alongside other theorists such as Peter Stallybrass and Allon White that, as the Carnival lost its central place in European societies and the grotesque expression of the body receded, it reappeared in other forms, one being the European avant-gardes, in a process which they identify following Freudian theories as a return of the repressed.[4] Caroline Evans argues that these returns began occurring in fashion at the end of the twenty-first century.[5]

If we understand much of fashion in its mainstream variety as part of a discourse advancing normative bodies and beauty ideals (or, as Bakhtin would have said, classical bodies), it is no surprise that we witness a counter-discourse generated in the kind of fashion that explores alternative aesthetic parameters. This aesthetic is, to an extent, achieved through the use of masks and through experimental make-up.

Make-up is, in its more traditional application, supposed to *mask* our imperfections, giving a person the appearance of smoother skin and bringing them closer to the idealised beauty *du jour* articulated through various media. An earlier meaning of 'make-up' is that of 'a made-up story, an invention, a fiction'. Or, worse, the word refers to 'a lie'.[6] This double meaning of make-up is even more explicit in other languages.

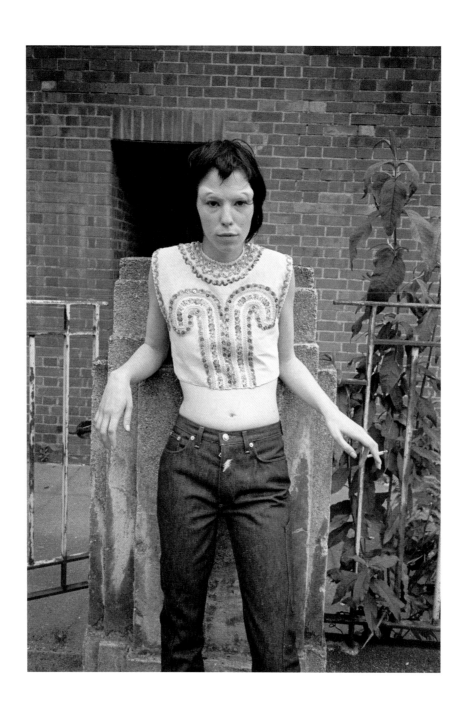

Juergen Teller for Walter Van Beirendonck & Wild and Lethal Trash! (W.&L.T.), *Believe* Autumn-Winter 1998-1999.
Make-up Inge Grognard, prosthetic make-up Geoff Portass and hair by Jean-Claude Gallon.

Juergen Teller for Walter Van Beirendonck & Wild and Lethal Trash! (W.&L.T.), *Believe* Autumn-Winter 1998-1999.
Make-up Inge Grognard, prosthetic make-up Geoff Portass and hair by Jean-Claude Gallon.

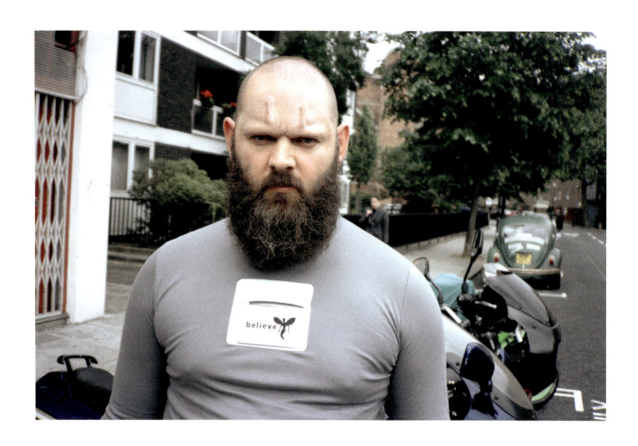

Juergen Teller for Walter Van Beirendonck & Wild and Lethal Trash! (W.&L.T.), *Believe* Autumn-Winter 1998-1999.
Make-up Inge Grognard, prosthetic make-up Geoff Portass and hair by Jean-Claude Gallon.

7
Translation by the author.
See 'Trucco', Vocabolario Treccani,
https://www.treccani.it/vocabolario/trucco/,
accessed 15 March 2024.

In Italian, for instance, the word for make-up, 'trucco', means 'the act of applying cosmetics to one's face to render it more pleasing', but it also means 'a magic trick', and in its most negative iteration 'a deceit, a fraud'.[7] Thus, make-up can bring us closer to an elusive beauty ideal, or like the carnivalesque mask, it can allow for a space of experimentation and playfulness, as well as being a rejection of the classical canon and the imperative of trying to achieve a narrow normative beauty standard.

Among the designers and artists working in the fashion realm who have explored the subversive potential of make-up is the Belgian Inge Grognard, who, since the 1980s, has employed make-up to create unsettling faces. For Martin Margiela, Grognard used make-up as if it were slashes of paint, often producing a black effect around the eyes that seemed a direct challenge to the dictum that make-up is supposed to brighten your eyes and *mask* the appearance of dark circles. In her make-up, the models look defiant rather than pleasing to the eye, as if wearing war paint. Further experimenting with make-up and beauty ideals, Grognard at times traces lines on the models' faces reminiscent of the marks made on people prior to undergoing cosmetic surgery, thus providing a further refusal of accepted beauty ideals. In a particularly poetic photograph, Grognard traces silver thread across a middle-aged model's expression lines: the thread highlights the wrinkles – the woman's life experience – as opposed to hiding them. These wrinkles are traditionally minimised via make-up and/or injectables, rather than emphasised, as Grognard does. The Belgian make-up artist further subverts cosmetic surgery procedures in a diptych portraying a younger and an older woman whose eyelids and cheeks are lifted by transparent tape, a crude reference to facelifts as well as cosmetic tape. The visible tape distorts and stretches the models' faces and, even though harmless, it creates a disquieting effect as it appears to be painful. The tape reminds the viewer of the invasiveness, pain and potential danger of facelift procedures. Another implicit critique of the dictum of optimisation through make-up, cosmetic surgery and injectables can be found in Grognard's more recent collaborations with Balenciaga, and particularly for the Spring-Summer 2020 collections for which she created the impression of extreme fillers on the models' cheeksbones and lips.

These subversions of the tropes of cosmetic surgery have also been explored by the Belgian designer Walter Van Beirendonck, who, as early as 1998, began experimenting with prosthetic make-up by applying customised latex prostheses – which he developed in collaboration with special effect make-up artist Geoff Portass – to models' faces. These facial bumps, mainly placed on the forehead, were inspired by the work of French artist Orlan, whose 'carnal art' involved employing actual plastic surgery against the grain. In surgical operations, which also double as performances, Orlan had implants placed on her forehead, which destabilise the classical beauty ideals and clearly bring to mind the growths of the grotesque canon. Stating her alliance to feminism, Orlan comments on how her work denounces the technologies of beauty: 'My activity consists in denouncing the social pressures exerted on the body. And particularly on the female body.' To which she adds, 'I wanted to be the opposite of the habitual expectation of what it is to be a woman, being beautiful according to masculine criteria. My objective was to turn aesthetic surgery away from its habits of improving people, making them look younger.'[8] In Van Beirendonck's Autumn-Winter 1998-1999 collection, facial prostheses (in the form of make-up) were applied to a range of models of different ages and genders as well as to the designers themselves, thus giving the impression of a race of humans whose faces had morphed into new beauty standards.

8
As quoted in Pascale Renaux, 'artifice',
in Thimo de Duits and Walter Van Beirendonck
[or Walter van Beirendonck & Wild and
Letal Trash!?] (eds), believe, exh. cat.,
Boijmans Van Beuningen Museum, Rotterdam,
1998 (Ostfildern: Hatje Cantz, 1998), n.p.

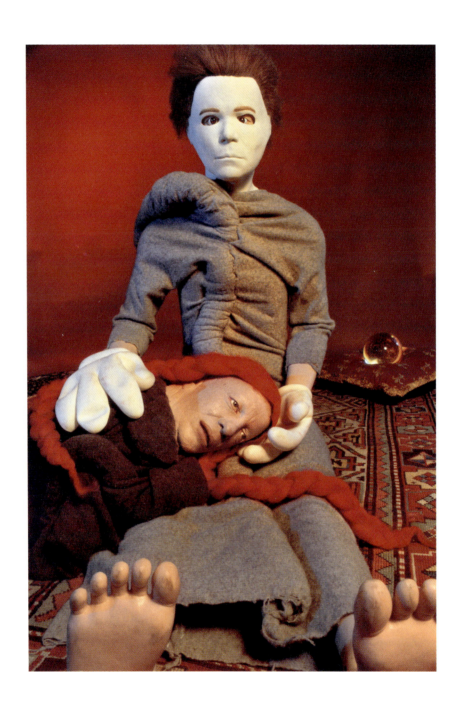

Cindy Sherman, *Untitled #304*, 1994. Comme des Garçons' Metamorphosis campaign
for Autumn-Winter 1994-1995 was conceptualised and photographed by Cindy Sherman.

9
Eva Respini, 'Will the Real Cindy Sherman Please Stand Up?', in Eva Respini (ed.), *Cindy Sherman*, exh. cat., The Museum of Modern Art, New York, 2012; San Francisco Museum of Modern Art, 2012; Walker Art Center, Minneapolis, 2012–13; Dallas Museum of Art, 2013 (New York: MoMA, 2012), p.35.

10
Mary Russo, *The Female Grotesque: Risk, Excess and Modernity* (New York: Routledge, 1994), p.2.

11
Francesca Granata, *Experimental Fashion: Performance Art, Carnival and the Grotesque Body* (London: I.B. Tauris, 2017), p.2.

The uncanny beauty achieved through the prosthetic make-up is further explored in Believe, a publication accompanying the exhibition *Kiss the Future*, held at the Boijmans Van Beuningen Museum, Rotterdam, in 1998. The photographs of the collection, shot by Juergen Teller, depict people tenderly embracing, mothers and children in sweet domestic scenes, a loving dog-owner (in this case a young Alexander McQueen), as well as Van Beirendonck and Orlan themselves. All sport different kinds of facial prostheses while going about their lives in a somewhat banal and conventional city setting, pointing to a utopian post-human reality where new configurations of the body are accepted and ordinary.

It was also in the 1990s that Rei Kawakubo of Comme des Garçons started investigating the grotesque canon. The Japanese designer's explorations of different standards of beauty and her rejection of fashion conventions are perhaps most evident in her entrusting the American artist Cindy Sherman to create images to accompany her Spring-Summer 1994 and Autumn-Winter 1994-1995 collections at a time when the photographer was explicitly employing grotesque imagery. As curator Eva Respini points out, Sherman's fashion work 'marks the beginning of her exploration of the ugly, macabre and grotesque and a trajectory of the physical disintegration of the body'.[9] And as Mary Russo adds, it was during this period that 'Cindy Sherman's literalization of the metaphoric relationship between the female and bodily abjection in the photographs of decaying matter and vomit makes explicit what is merely implied in Sherman's earlier fashion photographs, film stills, and historical masquerades: the uncanny, nonidentical resemblance between female and grotesque.'[10] Thus, Sherman's work appears an obvious match for the experimental fashion of the period and its subversion of fashion's polished façade. As I have argued elsewhere, these explorations were, in part, the result of shifting gender roles and the AIDS crisis.[11]

The majority of Sherman's photographs for the Comme des Garçons campaigns feature, like the rest of her work, disguises for the self. The images employ the use of masks and/or prosthetic make-up to visibly age Sherman's face and render the artist unrecognisable. In one of the portraits, Sherman wears a striped coat and a small ruffled collar which, together with a gold ribbon tied around her long flowing hair, are reminiscent of Renaissance attire. However, the character depicted contradicts the associations of the attire: she is partially balding, her remaining hair is grey and her wrinkled face is frozen in a disturbing grin, which make her closer to a character in a horror film than a young woman in a Renaissance re-enactment or a fashion model.

Another image from the series portrays a person, or possibly a doll, wearing a white mask reminiscent of horror-film lore, especially Michael Myers's mask in the *Halloween* films; in addition to a grey felted dress by Comme des Garçons, the figure wears Mickey Mouse gloves. With the gloves, she is tenderly cradling another figure, visibly aged through prosthetic make-up and wearing a red wig with two long braids. These images predate the more direct investigations of cosmetic surgery and make-up that Sherman pursued as she herself started to age. At the turn of the millennium, she returned to more traditional portraits, but this time, instead of the movie starlets captured in her earlier black-and-white faux film stills, she presented heavily made-up middle-aged women in saturated colour photographs.

Cindy Sherman, *Untitled #298*, 1994 for Comme des Garçons Homme Autumn-Winter 1994-1995.

Inge Grognard make-up for Maison Martin Margiela Autumn-Winter 1989-1990.

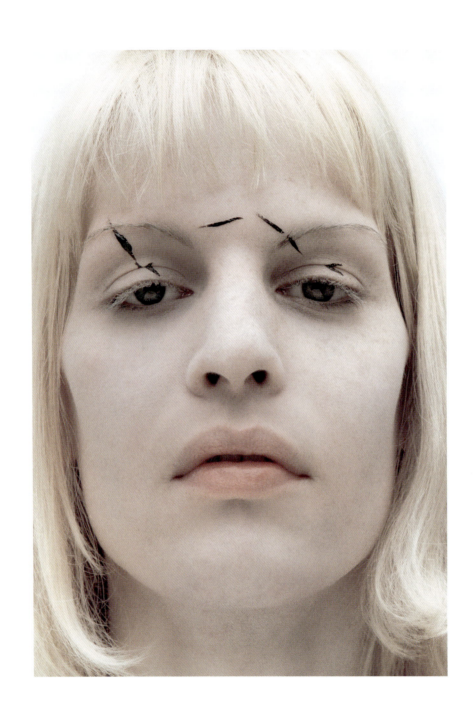

Inge Grognard make-up for Jurgi Persoons Autumn-Winter 1998-1999.

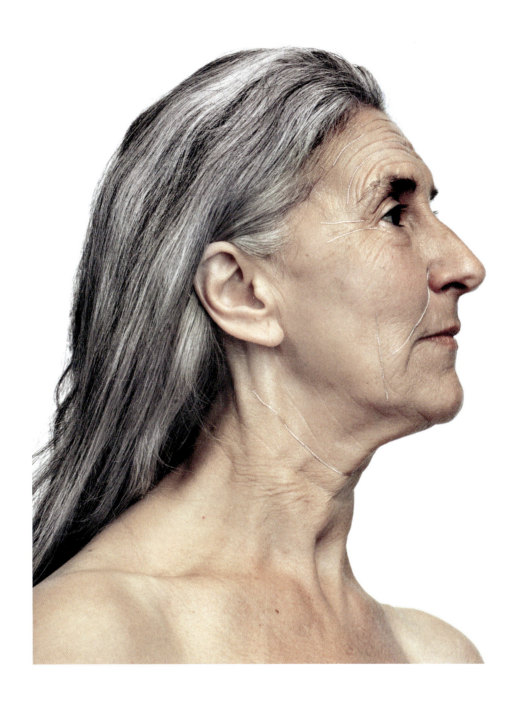

Inge Grognard and Ronald Stoops, *Women*, Vitrine exhibition project, 1998.

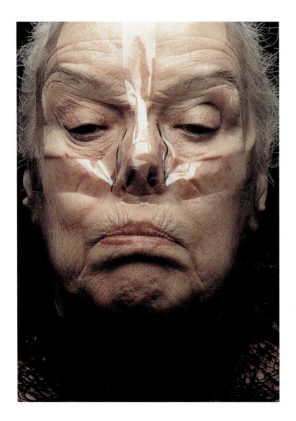
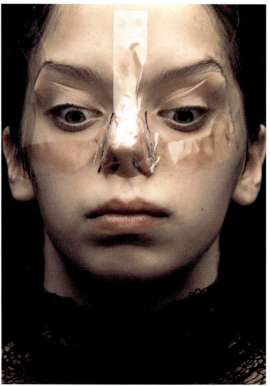

Inge Grognard and Ronald Stoops, *Sputnik*, 1998.

One image in particular depicts a woman, seemingly inspired by Pamela Anderson, with a 'bad' blonde dye job and red lips clearly enhanced by fillers; she wears so much foundation that it drips down her face. This photograph makes reference to the failure of make-up and other techniques of bodily modification to maintain youth and achieve normative beauty ideals, which remain forever out of reach.

Ultimately, the work of Grognard, Van Beirendonck and Sherman interrogates the constant quest for self-optimisation, or what Michel Foucault calls 'technologies of the self',[12] which includes practices of beauty, fitness and health. These intensified from the 1980s onwards, when neoliberalism took stronger hold particularly in the USA and Europe and the model of an enterprising self developed. As the sociologist Nikolas Rose argues, the enterprising self is constantly working on the self. It is 'a self that calculates about itself and that works upon itself in order to better itself'.[13]

Thus, Grognard's, Van Beirendonck's and Sherman's work can be read as a critique of practices of self-betterment achieved, in part, through beauty, fashion and fitness that are employed for the attainment and maintenance of contemporary ideals of beauty and in particular feminine beauty. Foucault describes the process by which, from the end of the twentieth century, the power materialised in the body as 'a new mode of investment' of power in the body. He argues that, towards the end of that century, a new kind of power developed, an economic one 'which presents itself no longer as a form of control by repression, but control by stimulation. "Get undressed – but be slim, good-looking, tanned!"'.[14] These demands have only intensified in the twenty-first century, when self-optimisation achieved through beauty and make-up routines, as well as injectables and cosmetic surgery, has attained new visibility through social media with its endless online tutorials promising the latest glow-up. As Jia Tolentino, in her by now famous essay 'Always Optimizing', writes: 'The ideal woman, in other words, is always optimizing. She takes advantage of technology, both in the way she broadcasts her image and in the meticulous improvement of that image itself.'[15] And as theorist Franziska Bork Petersen, quoting Bernadette Wegenstein, argues, we are now living under:

> the cosmetic gaze 'one through which the act of looking at our bodies and those of others is informed by the techniques, expectations and strategies of bodily modification.' […] Informed by the currently possible techniques of beautifying body modification, the cosmetic gaze facilitates a 'reading' of bodies in terms of their beautified potential: what they are 'not yet', but could be.[16]

It is precisely this all-pervasive beauty culture of constant self-betterment and optimisation that Grognard, Van Beirendonck and Sherman criticise as they employ make-up, prostheses and masks in their exploration of a grotesque canon.

12
Michel Foucault, 'Body/Power', in Michel Foucault, Power/Knowledge: Selected Interviews and Other Writings 1972–1977 (New York: Harvester Press, 1980), p. 57.

13
Nikolas Rose, 'Governing the Enterprising Self', in Paul Heelas and Paul Morris (eds), The Values of the Enterprise Culture: The Moral Debate (London: Routledge, 1992), p. 146.

14
Foucault 1980, p. 57.

15
Jia Tolentino, Trick Mirror: Reflections on Self-Delusion (New York: Penguin Random House, 2019), p. 64.

16
Franziska Bork Petersen, Body Utopianism: Prosthetic Being between Enhancement and Estrangement (New York and London: Palgrave Macmillan, 2022, pp. 188–9.

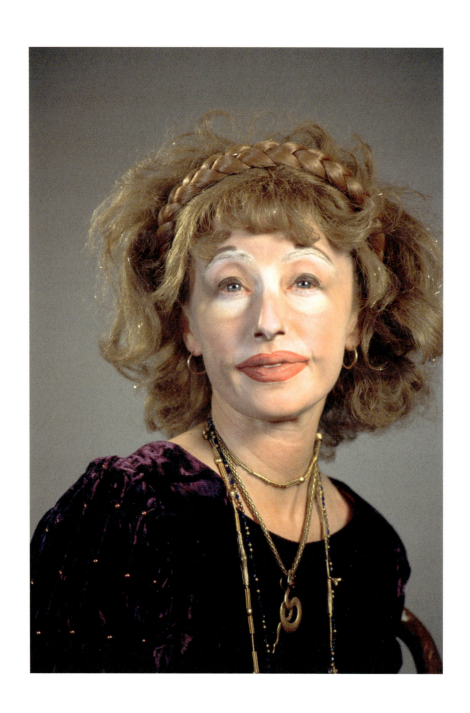

Cindy Sherman, *Untitled #359*, 2000.

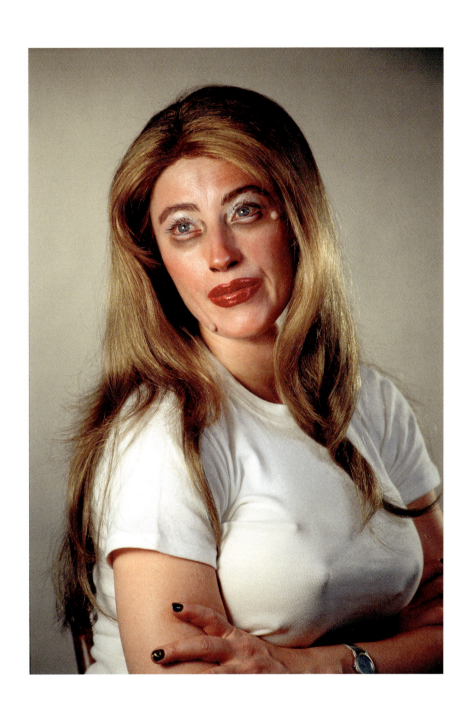

Cindy Sherman, *Untitled #360*, 2000.

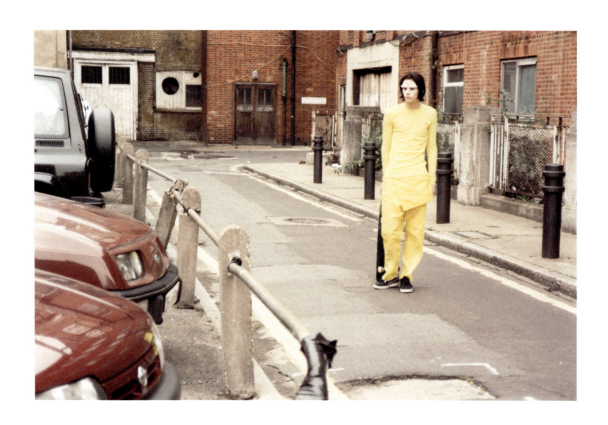

Juergen Teller for Walter Van Beirendonck & Wild and Lethal Trash! (W.&L.T.), *Believe* Autumn-Winter 1998-1999.
Make-up Inge Grognard, prosthetic make-up Geoff Portass and hair by Jean-Claude Gallon.

Colouring, Janice Li

The year 2024 has been unanimously named across beauty media outlets as the year of the blush. To put it in an economic context, US blusher sales in the prestige market alone went up 60 per cent in 2023 to $427 million; in comparison, mascara saw a mere 6 per cent increase. A quick online search reveals a long list of key trends relating to blush: glazed blush, tomato girl, strawberry girl, boyfriend blush, sunset blush and après-ski blush, with application techniques such as draping, sandwiching, lifting and even strolling. New standards around inclusivity set by trailblazers such as Fenty Beauty – a brand initially focused on foundation to match a more diverse range of skin tones – have rippled into product develop- ment in blusher as well. Brands launching new blush products have not only expanded their ranges, but also demonstrated how the same shade appears on a myriad of skin colours with unique undertones. Another great hit of this TikTok era is pH colour-changing blusher, monetising the concept of a universally flattering hue.

Archaeological evidence from ancient civilisations across the world attests to the instinctual and enduring practice of humans of all genders wearing cheek rouge. From seventeenth-century BCE frescoes in Akrotiri on the Aegean island of Thera (today's Santorini) documenting men and women wearing red cheek pigment, to the eighth-century Chinese imperial consort Yang Guifei popularising heavy blush wearing, for millennia humans have crushed mulberries and cochineal, and grounded red ochre and cinnabar, to create a range of scarlet-hued pigments to adorn their cheeks.

While the fashion for blush applications, like all trends in history, has lived through long cycles of evolution, blushed cheeks have always been associated with wider socio- cultural, physiological and economic meanings, which sometimes leads to its popularity and sometimes to its decline. It can be read as a sign of youthfulness and a marker of good health; its most powerful connotation, however, is one associated with our complex internal emotional landscape, so much so that the naturalist Charles Darwin proclaimed blushing to be 'the most peculiar and the most human of all expressions'.[1]

Naturally flushed cheeks are indicative of a flow of oxygenated

blood right beneath the skin. Blushing is an involuntary physical response to emotional states such as excitement, embarrassment, shame and shyness, all of which are socially conditioned. Blushing exists in relation to others and our sense of self, yet it is more honest than our conscious behaviour; it cannot be rushed, hidden or vanished, at least not without make-up. Emotions can change in a second; rouge displays, accentuates and fakes, bending durational responses.

Blush becomes increasingly gendered when we consider the flushed look as a sexual expression. In the second half of the nineteenth century, rouge went out of fashion in a society that favoured 'the virtuous woman' and associated the erotic undertones of blush with prostitution. The essayist and caricaturist Max Beerbohm famously consolidated the blush's degenerate social status in his essay 'The Pervasion of Rouge' published in 1894.[2]

The coquetry of blush application is also seen as a flirtatious strategy, intrinsically linked to the enhancement of one's desirability. Consumerism sells desirability. Rouge's commercial success in the twentieth century owed much to how pop culture monetised the misogynistic Freudian virgin-whore complex, selling the two most desirable traits portrayed in media from films and advertisements to pop songs: innocent youth and provocative sexiness. It is no surprise that Nars's Orgasm was arguably the most famous blusher of the century.

It might be convenient to conclude that adding peachy-pink pigment to our cheeks could make us appear healthier, sun-kissed, youthful, inexperienced with emotional concealment and sexually attractive. What is of particular note, though, is that various artful and skilful pivots on blusher today provide markedly nuanced distinctions. Each technique and trend is specifically created to achieve a certain result and perhaps to evoke certain social interactions. How one might perceive a 'strawberry girl' would be very different from someone wearing 'boyfriend blush'.

Instead of reducing the revival of the blush to old ploys, I am tempted to say that the rapidly evolving make-up trends reflect the society's readiness to embrace bold, creative expressions of our dynamic, ever-changing internal worlds.

1 Charles Darwin, *The Expression of the Emotions in Man and Animals* (London: John Murray, 1872), p. 311.
2 Max Beerbohm, 'The Pervasion of Rouge' in *The Works of Max Beerbohm* (New York: Mead Dodd, 1922), pp. 107-135.

REFLECTIONS

Beauty Papers, Issy Wood, Tschabalala Self,
Harley Weir & Martin Margiela

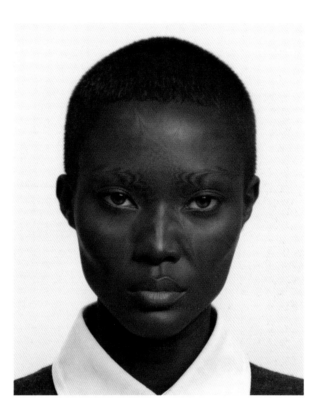

Make-up by Lynski, photography by Éamonn Freel, *Beauty Papers,* issue 11.

miu miu

MAXINE LEONARD
Creative Director and Founder of Beauty Papers

'Frustrated by the lack of diversity in the beauty industry and the dangerous message that one ideal fits all, I felt there was a real need for a different voice. When I was on the last train home from Paris and talking with Valerie Wickes, we found common ground in our obsession and passion for beauty and the idea of *Beauty Papers* was born.'

Make-up by Lynski, photography by Éamonn Freel, *Beauty Papers,* issue 11.

'We live in an increasingly conservative world with many in power politically, culturally, corporately continuing to subvert beauty to serve their own purposes: control, conformity, fear and formula. We want to celebrate art, freedom and the power of individuality to defy those that seek to silence and control us.'

Make-up by Lucy Bridge and hair by Eugene Souleiman, photography by Luis Alberto Rodriguez, *Beauty Papers*, issue 11.

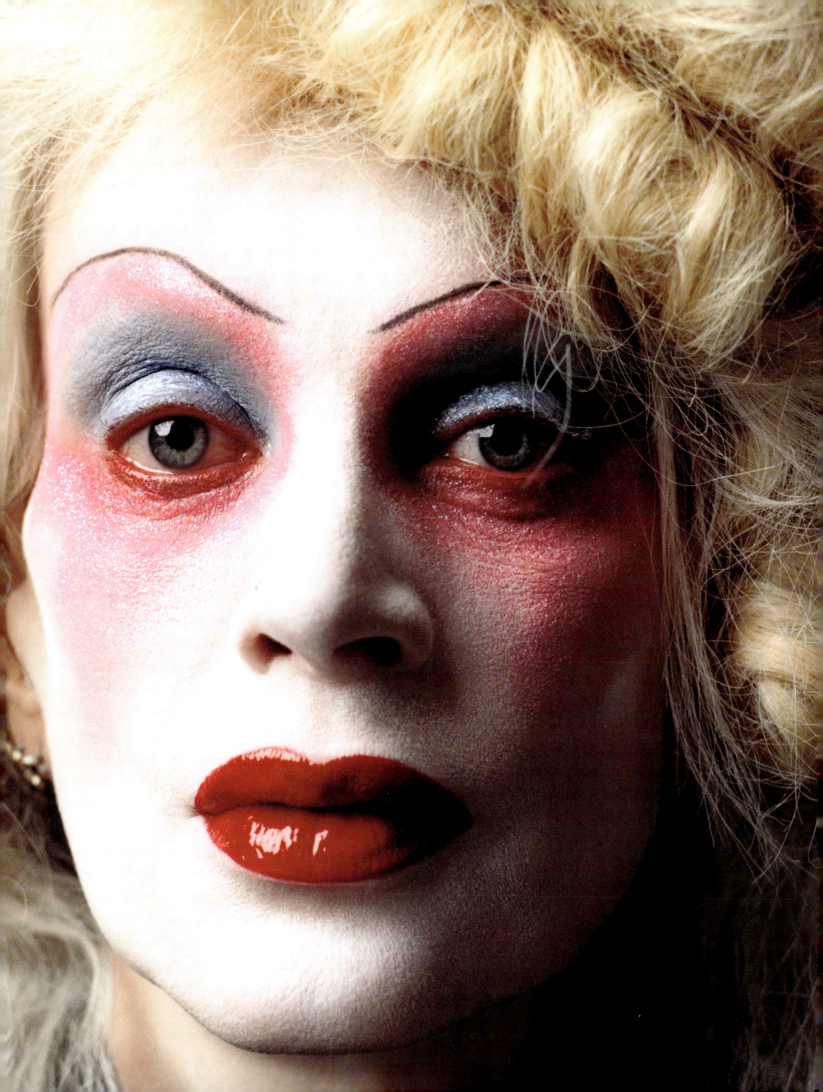

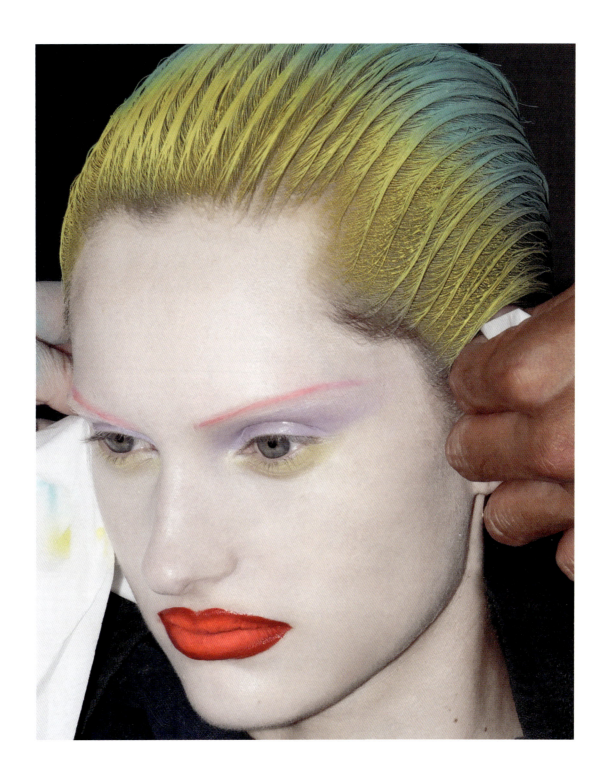

Make-up by Lucy Bridge, hair by Eugene Souleiman,
photography by Jean Marques, *Beauty Papers*, issue 11.

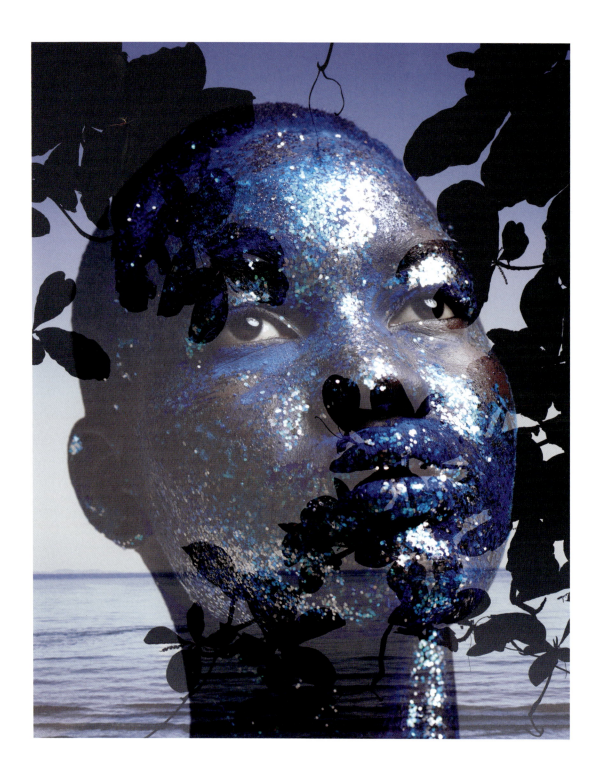

Make-up by Daniel Sallstrom, hair by Gary Gill,
photography by Viviane Sassen, *Beauty Papers*, issue 11.

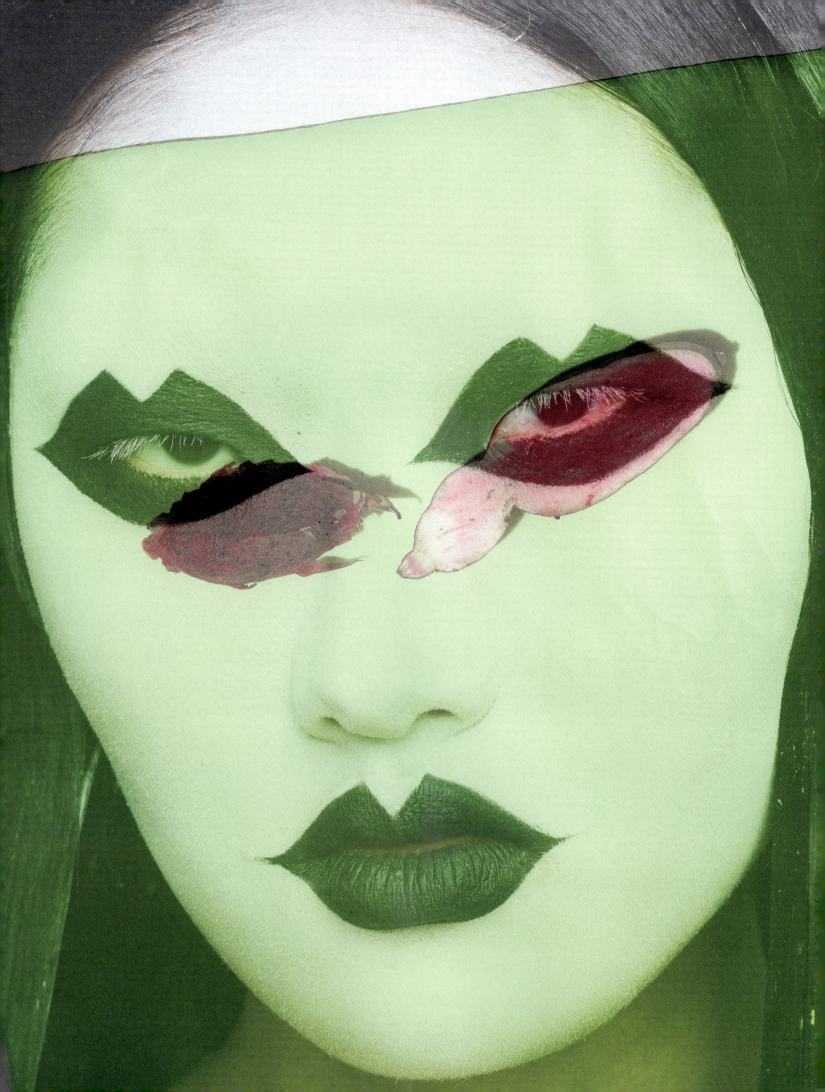

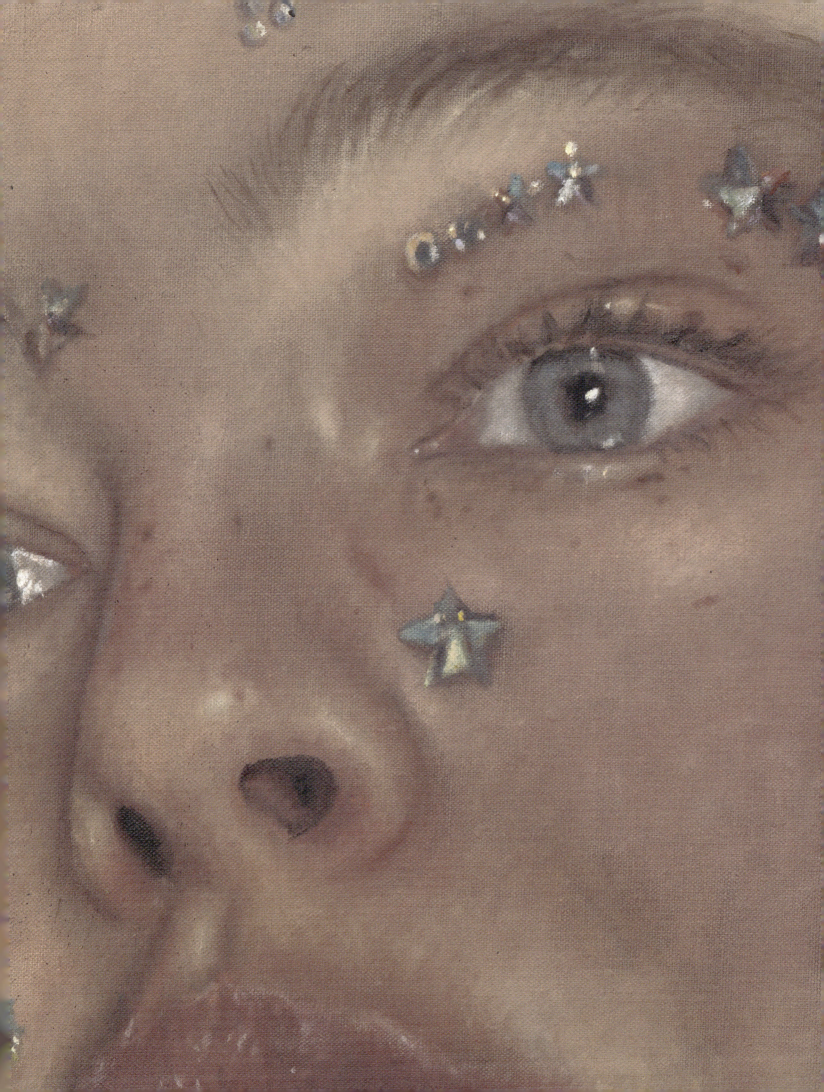

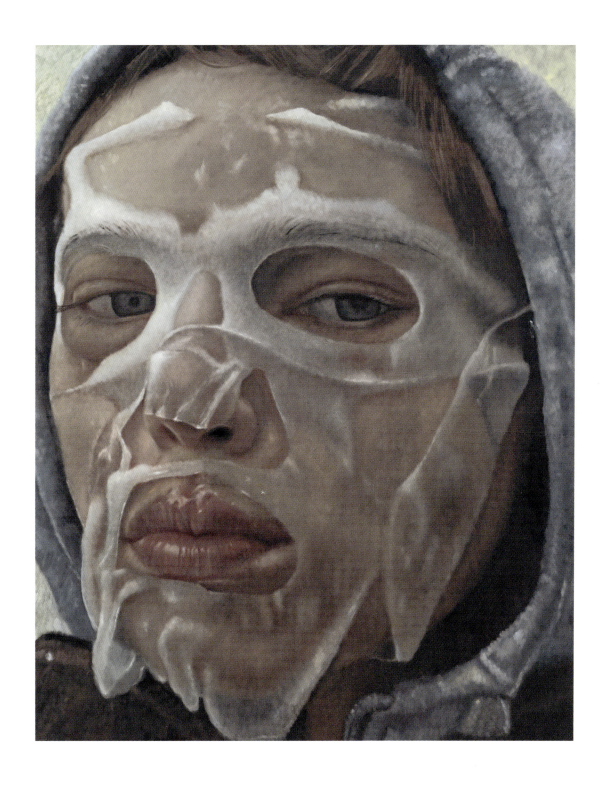

Issy Wood, *Self Portrait 46*, 2023. (*Left*)
Issy Wood, *Self Portrait 32*, 2022. (*Right*)

'This painting is of Carmela Soprano from *The Sopranos*. Her nails always seemed to be the one intact thing when her life was falling apart. It is part of a larger series of film and TV […] Only after making these paintings did I realise that most scenes I chose are ones with people touching each other, characters at their most human and therefore most unsanitary. Everybody talks about *The Sopranos* with a gravity rarely afforded to other TV shows, but I've yet to feel fully gripped by it. Perhaps the eye that looks for painting fodder is too selfish or too detached for full-body immersion in a plot, or perhaps I just can't identify enough with the middle-aged New Jersey father, gangster and protagonist that is Tony Soprano. Nonetheless, film and television feel like the only opportunities to see something outside of a world that has gone from expansive to the size of whichever room I'm smoking in.'

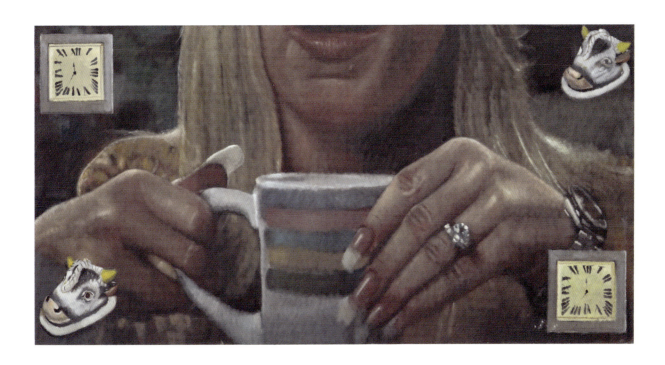

Issy Wood, *Carmela has the tea*, 2022.

Issy Wood

'I do not like to be photographed or captured physically in any way. Unless the circumstances are unavoidable, I am a real asshole about having my photograph taken. The self-portraits were a practical decision so I could send a magazine or a catalogue or whatever a "picture of me" without involving a photographer. They are also a product of how much time I spend with myself. [...] It is a series in its very early stages. While I mostly do not like my face, or looking in the mirror, hating one's face this much is its own kind of vanity.'

Issy Wood, *Self Portrait 52*, 2023.

'I first began this series for a solo show in 2020, *Cotton Mouth*, at Eva Presenhuber Gallery in New York City. In that show, I examined popular culture in relation to Black American identity. Specifically, the significance of Black American pop culture as a vehicle for oral history — oral history being the traditional means of preserving historical information within Africa and the diaspora. The drawings in this series all begin with pencil. I wanted to capture the movement of my hand and my own thinking. Drawing feels analogous to writing, so, in a way, the portraits are like diary entries. There's a certain level of immediacy and intimacy that can only be translated with the kind of mark making available through drawing. The application of make-up is a similar process to drawing. Even the tools and techniques that are used are akin to drawing: for example, lip liner, eyeliner, and all of the shades that are used to accentuate and shadow the face.'

Tschabalala Self, *Black Face with Rose Cheek*, 2020.

'I have various feelings about ageing. I think artists are always thinking about their legacy — thinking about what they will leave behind. Art can have influence so far into the future, further than you'll ever be able to travel in a single lifetime. It's truly inspiring the potential longevity of an individual artwork and the ideas communicated within it. On the other hand, I have a fear of getting older because my work is so tethered to my own physicality, my ability to move, work and construct it. You have to remind yourself that your art is not just a matter of the physical things that you make, it's also a matter of the ideas you produce.'

Tschabalala Self, *Black Face Brown with Blue Hoops,* 2020.

Tschabalala Self

'As a child, both images that were meant to depict beauty and images meant to depict the opposite of beauty impacted me. They had an impact on how I saw and currently see myself, as well as the characters in my paintings. The images that I most associated with beauty were images depicting north-eastern, Black American women from the 1990s. I'm thinking about Nia Long, Lil'Kim (circa 1996), Aaliyah, Garcelle Beauvais and Robin Givens – that is what is in the forefront of my mind when I think of a "beautiful woman". It's probably because their peak fame aligned with my early memories of television and visual media. These early images shaped my first concepts of beauty. I remember aspiring towards these images for many years, likely because there was a familiarity and accessibility to them. They mirrored, to some degree, my own aesthetic and aesthetics of the women in my family and in my community. Because I grew up in a very pro-Black family, I wanted to find beauty that looked like mine to imitate. Beauty standards can be informed by your political mindset. A lot of the time, beauty ideals reflect the politics you want to align yourself with. Unfortunately, many people do not understand this relationship and underestimate the political aspect of beauty and preference.'

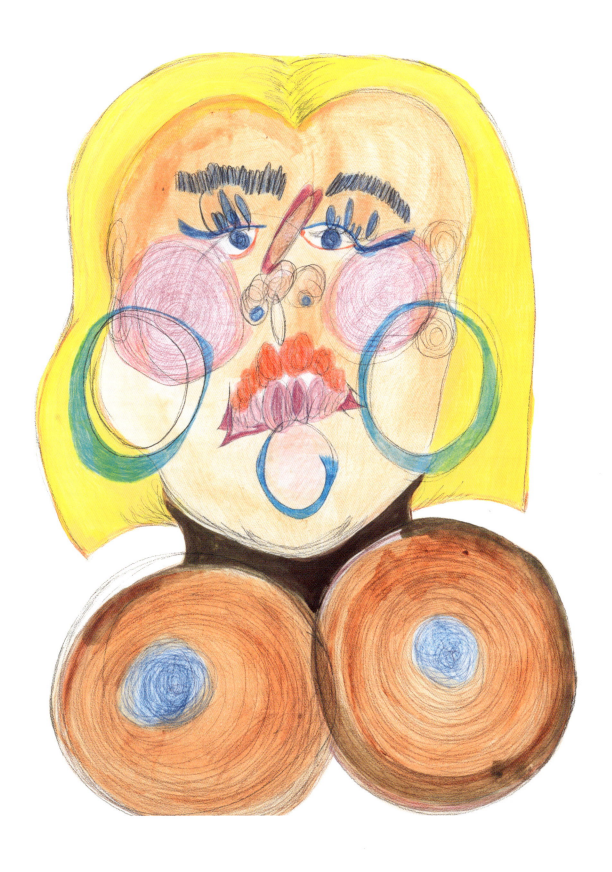

Tschabalala Self, *Black Face Flush with Blonde Wig*, 2022.

Harley Weir for *Beauty Papers*, 2022.
Make-up by Ana Takahashi and hair by Shiori Takahashi.

Harley Weir for *Beauty Papers*, 2022.
Make-up by Ana Takahashi and hair by Shiori Takahashi.

Harley Weir

'I don't agree with the oversexualisation, the overbeautification, and the artificial elements of current day beauty, still it's very hard to move away from those wants and desires, from toxic beauty ideals. It is hard not to compare yourself against this constant stream of images on Instagram. Everyone wants to be desired. In this series, I wanted to question if we really are that attracted to perfection.'

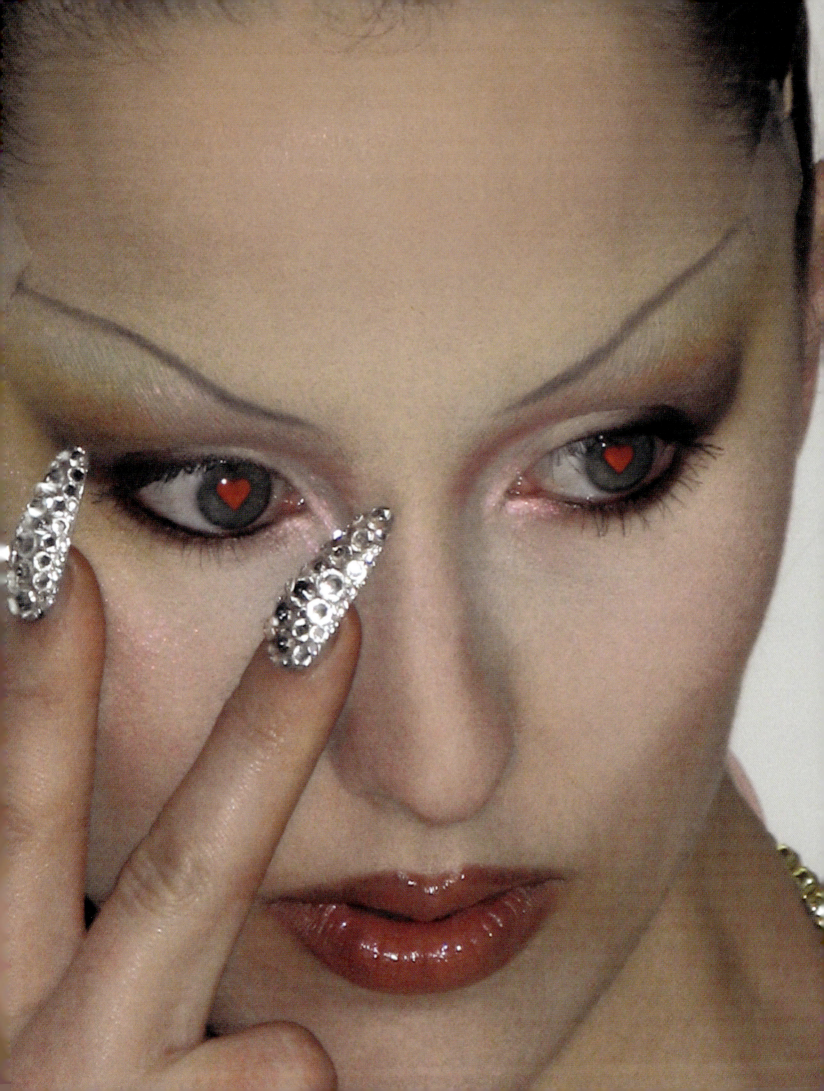

Harley Weir for *Beauty Papers*, 2022.
Make-up by Ana Takahashi and hair by Shiori Takahashi.

Harley Weir

'This self-portrait is from a series dedicated to "All The Dolls In The World." I wanted to reflect on the artificial representation of women (and people) and our universal desire to be desired. This was my first self-portrait series, the first time I turned the camera on myself. I had never wanted people to judge me before they judge my work. I wanted my images to speak for themselves, but these self-portraits allowed me a new kind of freedom without having to worry about hurting someone's identity. It was just mine that was there to play with.'

Harley Weir for *Beauty Papers*, 2022.
Make-up by Ana Takahashi and hair by Shiori Takahashi.

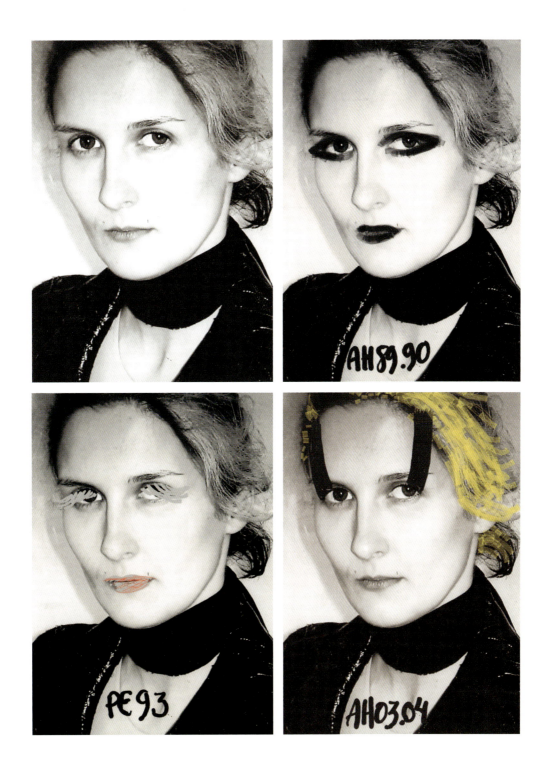

A selection of Maison Martin Margiela make-up looks from 1988 to 2008.
Drawn by Martin Margiela on a portrait of Ania Martchenko using an iPhone app, 2018.

Martin Margiela

'The women in our presentations (1988–2008) had no similar physique or age, but they had in common a certain mentality. The faces we invented were not about glamour, but rather raw expression. The products we used were never sophisticated, nor was the way of applying them. Hair was always left undone, which, together with expressive make-up by Inge Grognard, created an unusual statement back in those days.'

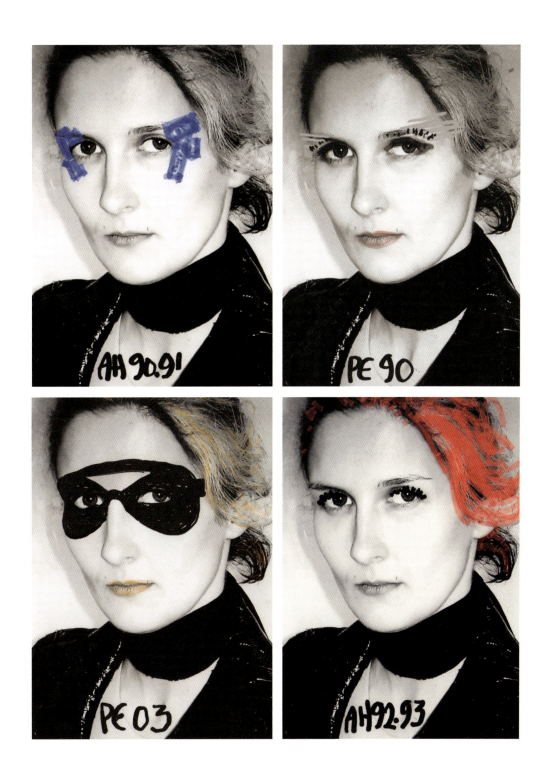

A selection of Maison Martin Margiela make-up looks from 1988 to 2008.
Drawn by Martin Margiela on a portrait of Ania Martchenko using an iPhone app, 2018.

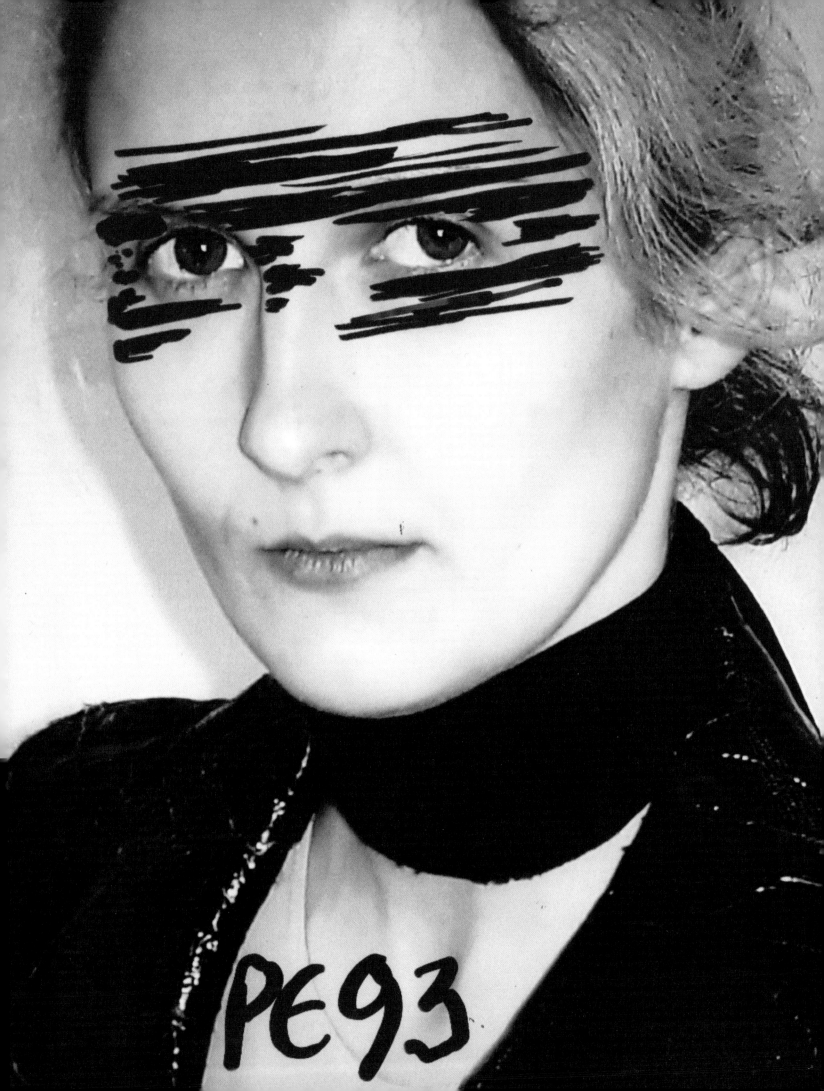

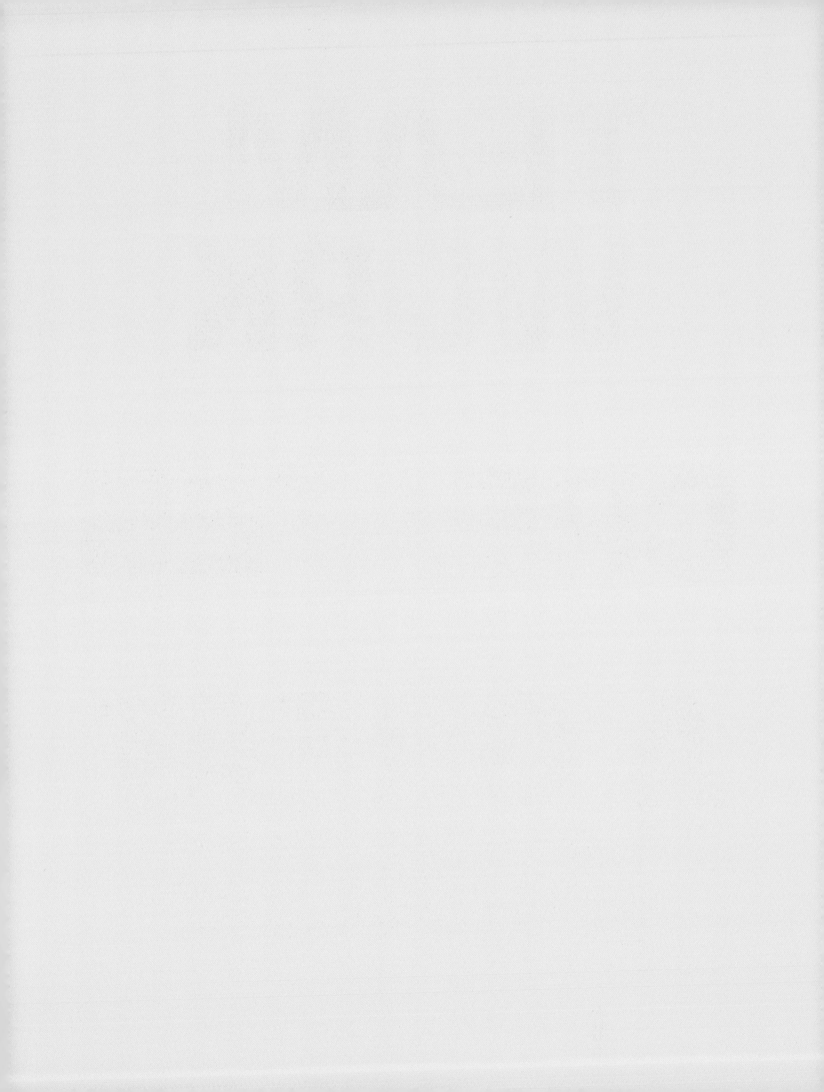

I

TEAM-WORK CREATES A GREAT IMAGE

Peter Philips in conversation with Elisa De Wyngaert & Kaat Debo

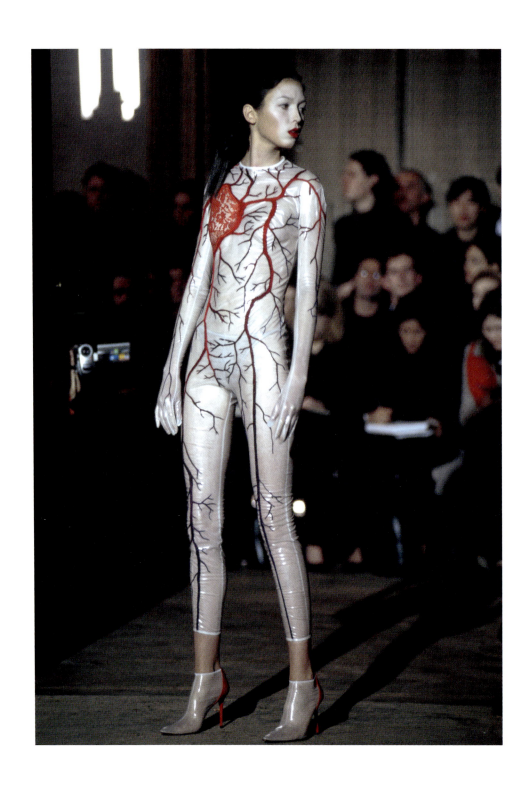

Peter Philips make-up for Olivier Theyskens
Autumn-Winter 1998-1999

Kaat Debo
Let's start at the very beginning.
Do you remember your first interests in fashion
and make-up? Was there already
an attraction when you were a child?

PETER PHILIPS

I always loved flipping through fashion magazines. My grandmother on my mother's side used to make clothes and my grandfather on my father's side was a wholesaler in fabrics. My grandfather was one of the few in Flanders who sold exclusive Italian fabrics. Once a year, he went to Italy to buy fabrics and then I, as a five or six year old, would go with him on tour to sell the fabrics to Belgian tailors. Among these tailors was Linda Loppa's father who was a tailor in Antwerp. I also sat next to my grandmother when she made dresses for my mum or aunt for special occasions. She made things for me and my brother too. Seeing the beautiful fabrics being turned into something wearable was so inspiring. As a teenager I helped my stepfather in his butcher's shop in the Nationalestraat. The Antwerp Academy was somehow already within reach. I remember being fascinated by the fashion students – Ann Demeulemeester with full make-up coming into the shop and Walter Van Beirendonck extraordinarily dressed – and I was always hypnotised by those colourful 'birds of paradise' that you saw around Antwerp.

Elisa De Wyngaert
Was the decision made then and there that you
wanted to study something creative as well?

PETER PHILIPS

I always told my parents I wanted to be a hairdresser but my mum warned me: 'There are already 15 hairdressers in this area, you are never going to make any money.' My father is a painter and as I loved to draw as well, my mother nudged me in the direction of art school. I wanted to go to the Antwerp Academy to study fashion but my parents encouraged me to study graphic design in Brussels first.

Kaat Debo
Somehow, I sense there are still some remains
of your graphic design degree in your work.
Do you see that?

PETER PHILIPS

I studied graphic design before the computer era. I remember one of my teachers saying we would be starting to use an Apple Macintosh: 'There's a new thing, a computer, and computers are going to be big in the future and are going to help us with graphic design.' We learnt to do so much ourselves: the photography, the modelling, the cover design, the layout, we made imaginary advertisements, we would do set design, we would do lighting. To this day, I feel like I benefit from the things I learnt there. I made good friends who studied fashion at La Cambre at the time. I was lucky to get a little taste of the Brussels fashion scene before starting in Antwerp.

Elisa De Wyngaert
From your time studying fashion in Antwerp,
it's also those close friendships that stand out in your story,
friendships that led to great artistic collaborations.
Do you remember when you met your closest friends?

PETER PHILIPS

We met during the entrance exam. On my one side was David Vandewal and on the other was Olivier Rizzo. Upon starting in September, you automatically go back to the people that you know and we've been friends ever since.

Elisa De Wyngaert
It's interesting that you got to know people from
the Brussels and Antwerp scenes so soon. You went on to work
for designers from both 'schools', such as Olivier Theyskens
and Veronique Branquinho.

PETER PHILIPS

The first shows I did were in the same week: Veronique Branquinho and Olivier Theyskens for their Autumn-Winter 1998-1999 collections. It was pure coincidence. I loved working with them and their collections were extraordinary. I loved adapting my make-up skills to match their work.

Kaat Debo
Can you tell me a bit more about
the make-up for these two shows?

PETER PHILIPS

Olivier had more of a Gothic approach but there was still an element of couture. The silhouette that stood out was a catsuit embellished with veins and a heart, and there were amazing tweeds that I was drawn to. I took a piece of tweed and started to take the threads out to create fake eyelashes. They were fluffy. For some of the models I did extreme contouring with a white foundation stick and a darker one on the sides, and a bright red lip. In a way, it was very 1990s. For Veronique's first show in Paris we went for simple, pale faces, poetic with white highlights. For white, I never use any pearlescent or any shiny products, but a painter's white as a highlight. And we did black teeth.

Kaat Debo
Which was very radical.

PETER PHILIPS

The idea was not to show the teeth. The idea was actually inspired by a picture, a retouched photo of a girl where the eyes, I think, were made black and the lips were a bit open but you couldn't see any teeth. There was a depth that felt very ghostly and so we wanted to create that for the show. This beautiful pale face with white painted highlights and the black teeth gave a sense of depth. The models were asked not to laugh on the catwalk but just to separate the lips a little so there would be this void, an empty space, and it gave a fragile, almost ghostly appearance. In the line-up it was a different story because the models were talking and smoking… They looked very scary, like old witches, but on the catwalk they looked really beautiful.

Kaat Debo
Before going on to do those shows in Paris, did you try out
other things? What were your first work experiences like?

PETER PHILIPS

We did a great show in Belgium after we graduated, with Olivier, David, Ingrid Cosemans and me in Limburg. I think it was linked to the Fashion Museum there. Ingrid, David and Olivier went second-hand shopping and dyed all the garments in various skin tones. The concept was genius: people came to see the show and left their coats and bags in the cloakroom. After the speech the show started and the models appeared on the runway wearing different coats, bags and umbrellas belonging to the audience on top of their skin-toned silhouettes. It was funny to see the responses. I did the make-up of every model individually according to their style. Some were done as go-go dancers, some were done with feather lashes, some were punk. When I did the full make-up, I took off half of it as if they had been dipped in a bath of make-up remover. We were a very small team. I still don't

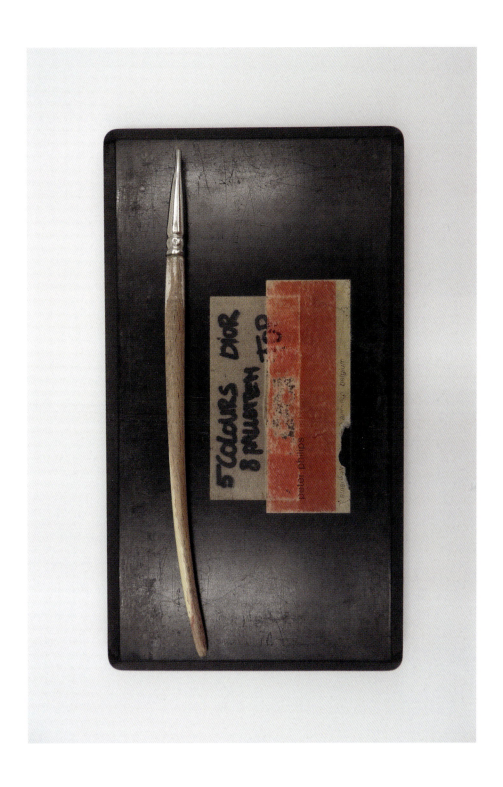

Peter Philips' first make-up brush
Peter Philips make-up, 2001 *(Left)*

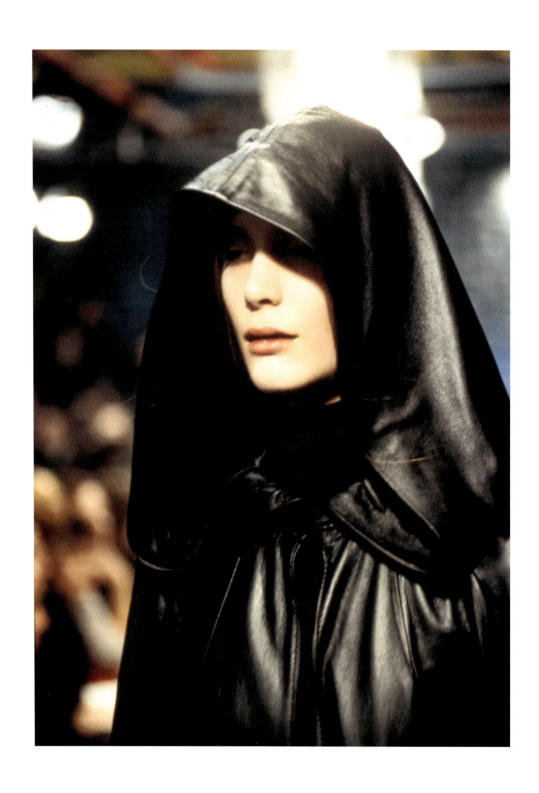

Peter Philips make-up for Veronique Branquinho
Autumn-Winter 1998-1999

understand how we managed to do it in such a such a short time and with so few people, but we did and it was fun.

Kaat Debo
And at that time were there already people that inspired you in the world of make-up or were the inspirations mostly from fashion?

PETER PHILIPS

Make-up wise my inspirations were very graphic, maybe because of my background in graphic design. I love to draw, and I've got a steady hand. In those days my aesthetic was not very delicate because my main motivation came from fashion, and not from a beauty perspective. As a student I went to Paris to help backstage for the Belgian designers and sneaked into the shows by Thierry Mugler, Claude Montana, Jean Paul Gaultier, Helmut Lang or Romeo Gigli. I really admired them. They each have a really defined style but my inspiration did not necessarily come from existing shows. The inspiration came mainly from my background in graphic design, painting, drawing and cartoons. My luck was that when I started working in Belgium with fellow students Willy Vanderperre and Olivier Rizzo they shot a lot of menswear stories. In those days, extreme make-up was mostly done for female shoots so I was lucky to be able to use those men's shoots as my platform for being creative, which made the stories stand out. I think that's maybe why one of the make-up looks that really set the pace for us was the Mickey Mouse that we did on Robbie Snelders. It was initially published in the first issue of *V* magazine and then afterwards Raf Simons used the image on the cover of his book.

Elisa De Wyngaert
How did the transition come about from approaching make-up from a fashion point of view to a new-found intrigue and appreciation for beauty?

PETER PHILIPS

I slowly started appreciating how make-up can be used not to hide but to show yourself. I used to work on many of the 'before and after' photoshoots for *Flair* magazine. We would do a session in a hair salon with a few readers. They would do a hair makeover and I would do some make-up looks. That's where I got to know the impact of make-up on real people. I realised how you can touch people's lives and in fact that's where I started to appreciate the power of beauty products. After that, I started working a lot in New York, where it is more about glamour and commercial beauty than conceptual makeups. For a long time I shot beauty campaigns for Estée Lauder, Givenchy and Armani before I signed with Chanel. Fashion is a fantastic platform for being creative, but it's not my main focus anymore. Most of my colleagues went to beauty school rather than fashion school. They slowly grew into their creative selves. For me, it was the other way around.

Kaat Debo
In the early days, I think the products you had to work with were much more limited than what's available now. Did you experiment so as to fill in the gaps?

PETER PHILIPS

Limitations push you to be more creative, which is, I think, an advantage. The products were not as high quality, but you had lots of possibilities. I did shoots with dark-skinned models when there was hardly any suitably coloured foundation, especially in Belgium. So, you started mixing and matching to come up with a solution. Also, those were the days before digital, with no safety net of retouching. You had to make sure that you could give the illusion of perfect skin. We also could not check on screen what was being shot, so you had to communicate with the photographer. It was teamwork. There was no internet to do research; you had to come up with your own creative ideas. It was a different world, a totally different world.

Elisa De Wyngaert
Your focus today is much more on beauty, but you are still responsible for the runway shows of Dior. How do you collaborate on a look with the creative directors?

PETER PHILIPS

When working with creative directors, my skills are at the service of their vision. My vision is always to make sure that there's a great image; it is teamwork that creates such an image. And sometimes you step back and sometimes you go full on, but you make sure that there's harmony. I've worked with Maria Grazia Chiuri for about seven years. She doesn't really like lipstick or colour, but she likes eye make-up. So, the signature make-up became eyeliners and raw make-up.

Elisa De Wyngaert
You also never operate alone on the beauty looks for a show, as you have to collaborate closely with the hairstylists. Most notably in your career this has been with the extraordinary Guido Palau. How do you both work on one vision? How do the hair and make-up come together?

PETER PHILIPS

One of the first shoots I did with him was a David Sims shoot. I think Guido and I had already worked together for a few years, maybe two years, and it was a two-day shoot with a German model called Luca. She had a little bob, a bit Anna Wintour style. At the end of the first shooting day, Guido said, 'well, I can't come tomorrow, and I need all my assistants. But I think Peter can do the hair. I'm sure he has a good eye, he can manage'. Suddenly it was the next day. I thought, 'okay, Guido trusts me'. But the nerves hit me. I'm not a hairdresser and this magazine would sign it afterwards as 'hair by Guido'. It was a lot of pressure, but at the same time it showed his trust. I managed somehow, but almost completely forgot about the make-up. The strength of Guido is that he loves fashion, and he loves great images. He and David kind of grew up together in the business. When David started out, he began working with Guido and Guido would almost be an art director. Guido is a perfectionist. And you don't mind that with Guido because he has got an amazing eye. When Guido says something about hair, he's right. I've never known him be wrong. For shoots, I think, hair quite often is more important than make-up because it's a shape. It completes a silhouette. And Guido has an extremely good eye for it, so we work really well together. I know that I'm in safe hands. Sometimes, you have to stand up. You have to stand strong. Make sure he doesn't take over. We laugh a lot. And so, with a sense of humour, I can push him aside and say, okay, back off now. It's my turn. He doesn't take it badly, especially after so many years of working together. I've done Alexander McQueen shows with him. I've done Dior shows, Jil Sanders shows, Fendi shows. Plenty of shoots. It's always a pleasure working with him.

Kaat Debo
Together you worked on legendary Alexander McQueen shows. How was your experience working with McQueen?

PETER PHILIPS

Working for Lee McQueen was a very special part of my life and career. It was a rollercoaster, shifting between working with a creative genius and someone very complex.

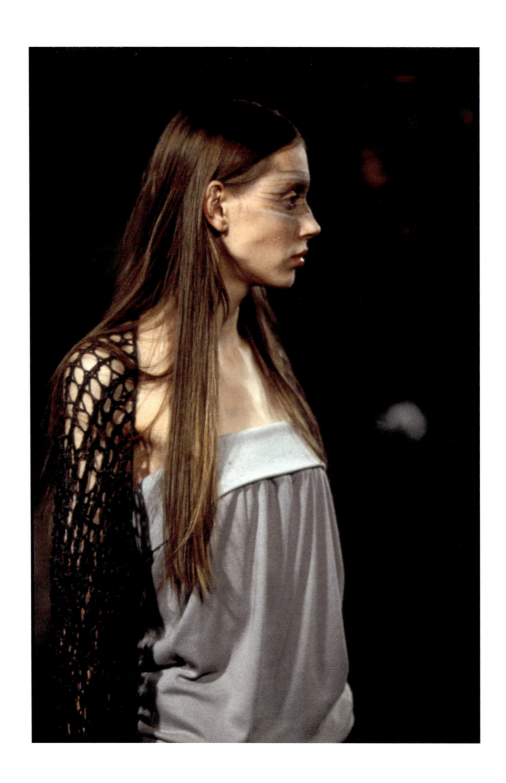

Peter Philips make-up for Veronique Branquinho Spring-Summer 1999
Peter Philips make-up for Alexander McQueen Autumn-Winter 2009-2010 *(Right)*

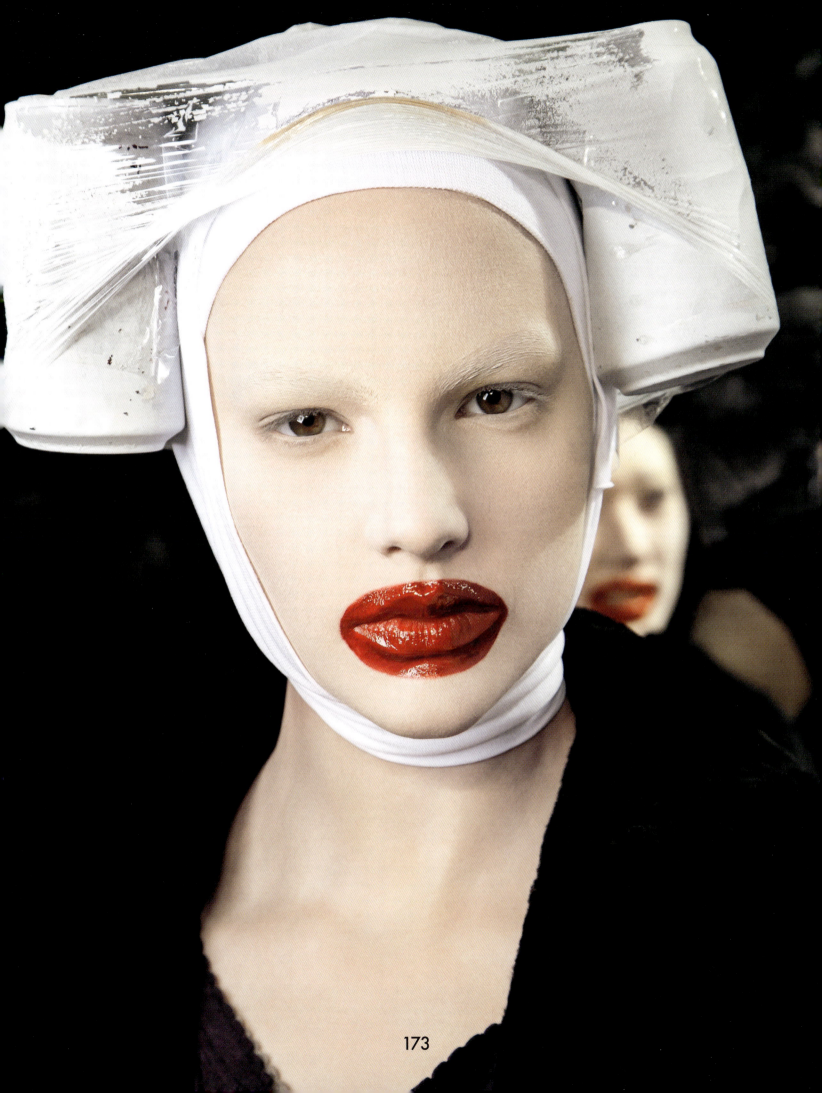

173

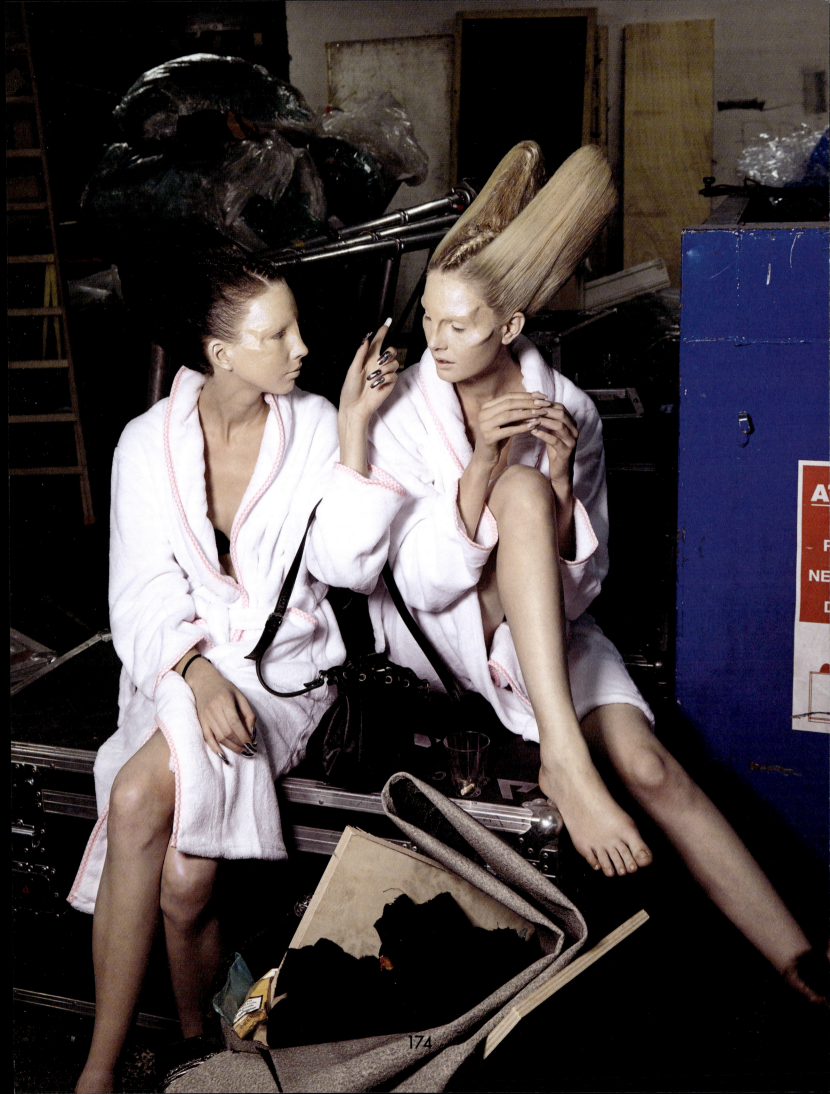

However creative, it could also be kind of draining. But at the same time, he was very open to suggestions from me. We did some memorable shows together and then I skipped a few collections because it was all becoming too hectic during fashion week… too many shows and often only three hours in-between. I did end up returning to McQueen to do his last shows. I had heard from stylist Tabitha Simmons who said: 'it would be really nice to have you back. He is working on a really good collection'. When I returned, Lee was like a new person and it was fantastic to work with him. Before the show, he would send a huge box of books with references so I could prepare, and then we would go to London to do a first test. It was an amazing process. Our last show together was the one with incredible prosthetics, *Plato's Atlantis*, for Spring-Summer 2010. I also did the presentation of the collection he had been working on before he passed away, which was very emotional for everyone involved. It felt like a funeral.

Elisa De Wyngaert
During the last two decades you have been developing new products: first between 2008 and 2013 as creative director of Chanel's make-up and beauty lines, and since 2014 as creative and image director of Christian Dior make-up. What is the most exciting part of this work?

PETER PHILIPS

That people buy them. That's amazing. I don't have a marketing degree, but I'm apparently a very good salesperson. The question with brands like Dior is how do we keep our house and our make-up brand relevant for the younger generation? You constantly have to reinvent yourself to attract a younger audience but at the same time you don't want to lose your existing loyal clients. Backstage is a dynamic environment, so I came up with the concept of a backstage line. I'm very proud to not just work on the product itself, but also on the total concept and story. All the things that I learnt in Brussels still come in handy. I mean, I've been reinventing and relaunching Rouge Dior every three years. We work with the labs very closely to update and fine-tune the formula over and over again. I want people to wear it and be seduced by it.

Elisa De Wyngaert
Young make-up artists, I think, have to promote themselves quite a lot online and show their work. Make-up artists are not as anonymous as they have been. They're active on social media, as are you today. What is your experience of this transition towards an increasing online presence?

PETER PHILIPS

You kind of grow into it. I remember the first shows in Paris before social media, when you suddenly had *Fashion TV* and there were a camera and microphone in your face. Nobody prepared us for that. I never had media training. So, you kind of said, 'Leave me alone… the show is in five minutes, and I've got ten more girls to do.' But then you saw yourself being grumpy on a TV in a hotel somewhere, on repeat, for four months. I quickly realised I needed to be more careful not to push the media away. Then the phones and selfies came along, and the backstage became almost as important as the catwalk, just like the front row now is quite often more important than the catwalk. It's all part of image-making at the service of selling products.

Kaat Debo
Today, beauty is becoming increasingly focused on the fight against ageing. There are many tools to maintain the appearance of youthfulness. How do you deal with ageing?

PETER PHILIPS

In a way, everything that I do is based on fakeness. Foundation is the illusion of great skin. So it's fake. Mascara is the illusion of longer lashes. So it's fake. It is part of a routine, of a ritual. It's a very acceptable fake. New treatments like fillers and Botox are like everything else in the beginning: they seem extreme, but soon become mainstream. I remember, ten years ago, people turned their heads if they saw someone with pink hair. It was a fashion statement, such as Kate Moss with pink hair in Italian *Vogue*. Nobody else dared to wear it. Now, people go to job interviews with pink hair. That would not have been imaginable ten years ago. Tattoos went through the same transition period. They used to be very edgy or punk. Now, everywhere you go, anybody can have a tattoo. There's no problem with that because it's accepted. People need a bit of time to adapt their eyes and their perspective. Botox and facelifts are accepted now. I don't judge anybody. Sometimes I am just a bit worried about people's health. When you go too far with Ozempic, for example, to achieve a younger silhouette. You don't know what the consequences are going to be if you combine this with a lot of fillers. I'm not going to push my opinion onto anybody. I can advise them if they want advice. I can share my experience and my expertise. With my friends or people that I know and care for, when I see a bit too much Botox, I tell them 'be careful'. Or if they try fillers, I advise them to be careful because if you go on a diet, you lose your natural fat and the face underneath your fillers will still be ageing. And then before you know it, you start to show deformations that you cannot fix. This is the only advice I will give.

Kaat Debo
Do you follow the medical evolutions in this field as well?

PETER PHILIPS

I've done Botox myself. I'm very happy with that. After my first Botox I looked like the shiniest Easter egg. I could not move anything. Nobody knew if I was happy or mad or dead. It taught me that I needed to do the research and take small steps. Don't forget the face you had and where you came from. Since then, I've learnt how to balance it out. I've found that the key is to remain critical enough towards yourself, to keep an objective eye on the mirror and at a particular point to accept that there's nothing wrong with ageing. We're lucky if we hit a certain age. I know models that are of a certain age who have had work done and they look fantastic, and they feel fantastic. But I also know women and models that have had nothing done at all and they truly look as great as the others. It's just a different approach to beauty.

**Peter Philips make-up for Alexander McQueen
Spring-Summer 2010 *Plato's Atlantis* (Left)**

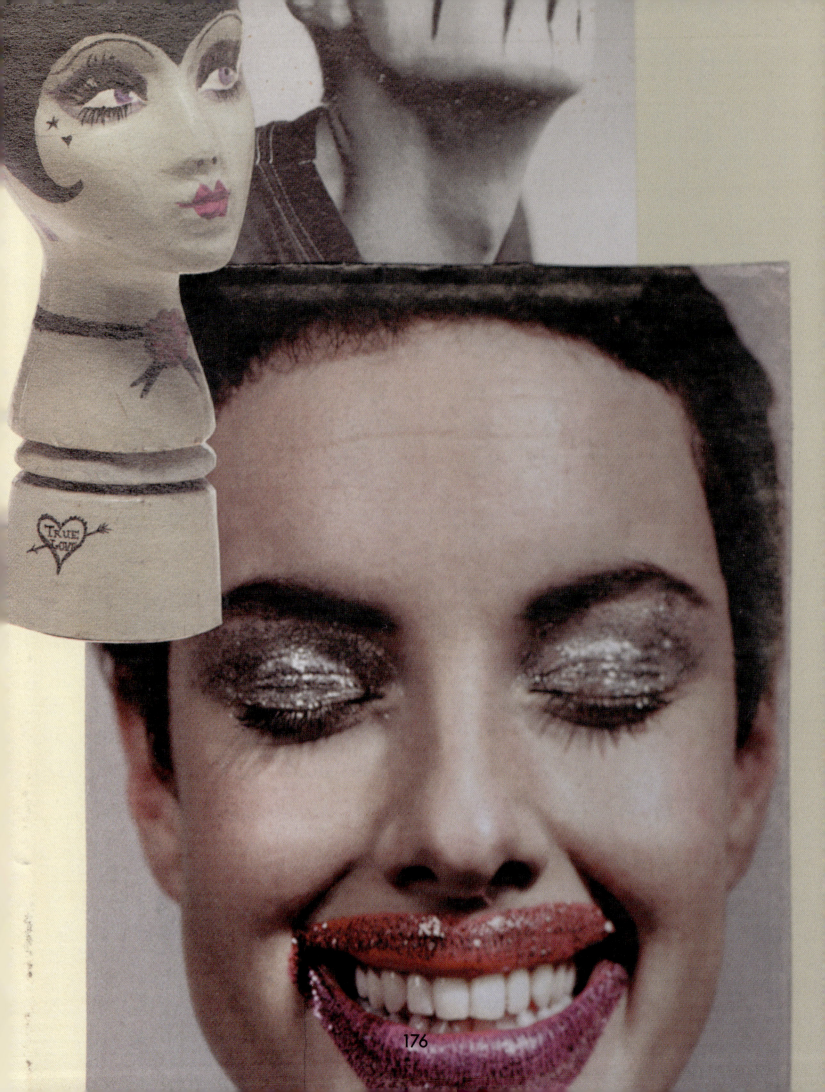

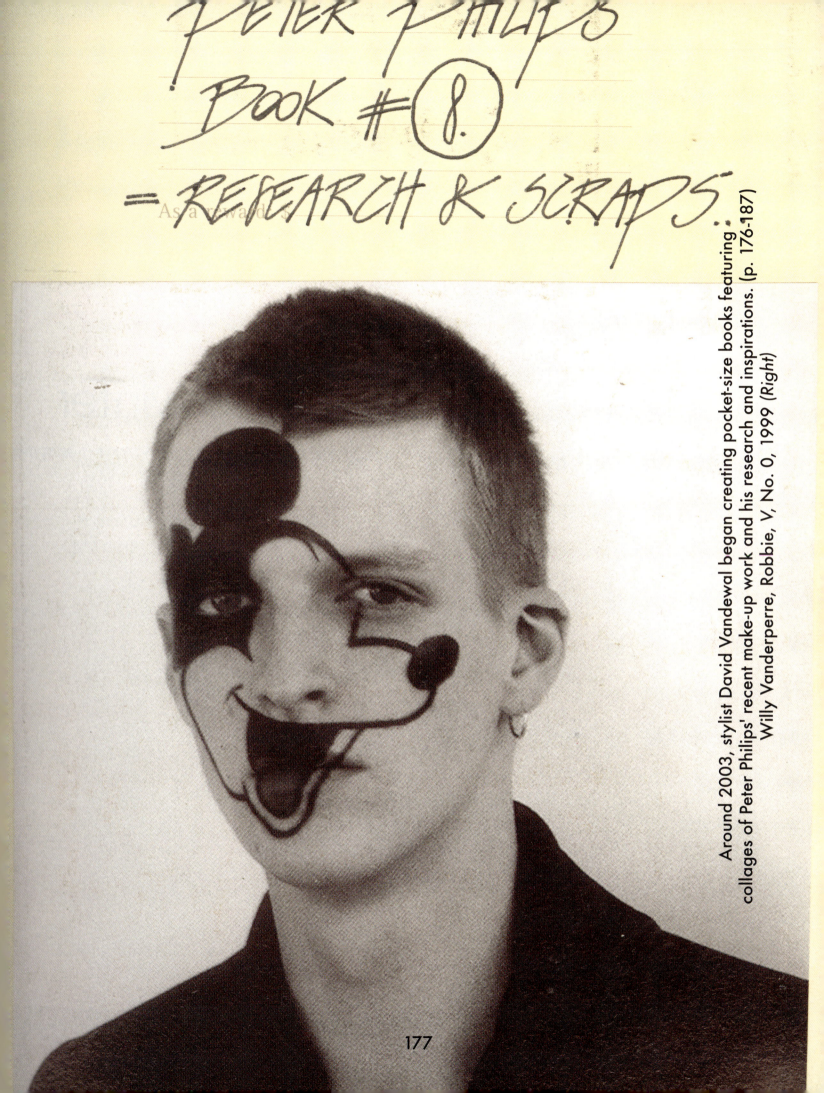

PETER PHILIPS
BOOK # (8.)
= RESEARCH & SCRAPS.

Around 2003, stylist David Vandewal began creating pocket-size books featuring collages of Peter Philips' recent make-up work and his research and inspirations. (p. 176-187)
Willy Vanderperre, Robbie, V, No. 0, 1999 (Right)

177

MA[...]
by fa[...]
-Fluor[...]
-Brig[...]
-Whit[...]
-Rub[...]
-Elec[...]

For autumn look to
makeup -wonderful, bright colors worn
ion designer Yazbukey
scent Pink eye and lip pencil
Fuschia pigment
Frost eyeshadow
Woo lipstick
ic Eel Satin eyeshadow
For inf
www.m tics.com

KS457-

179

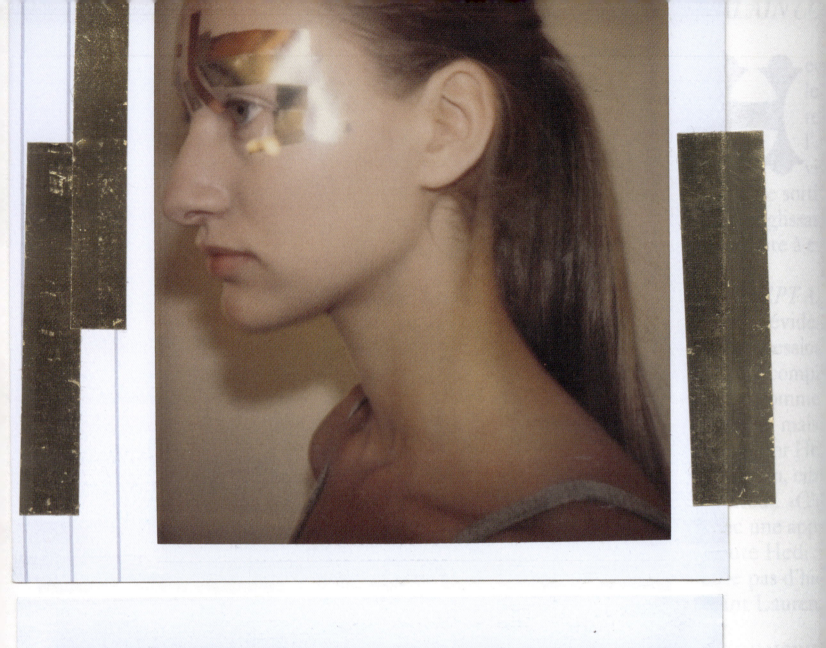

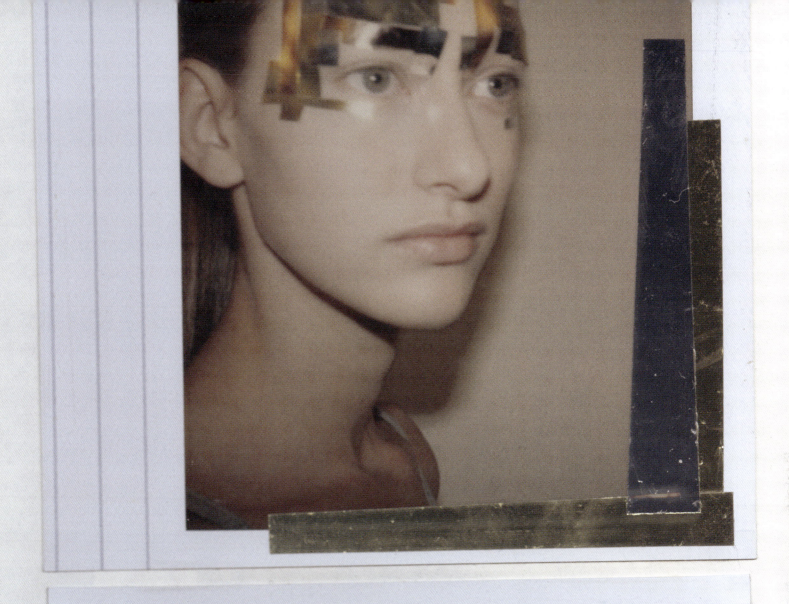

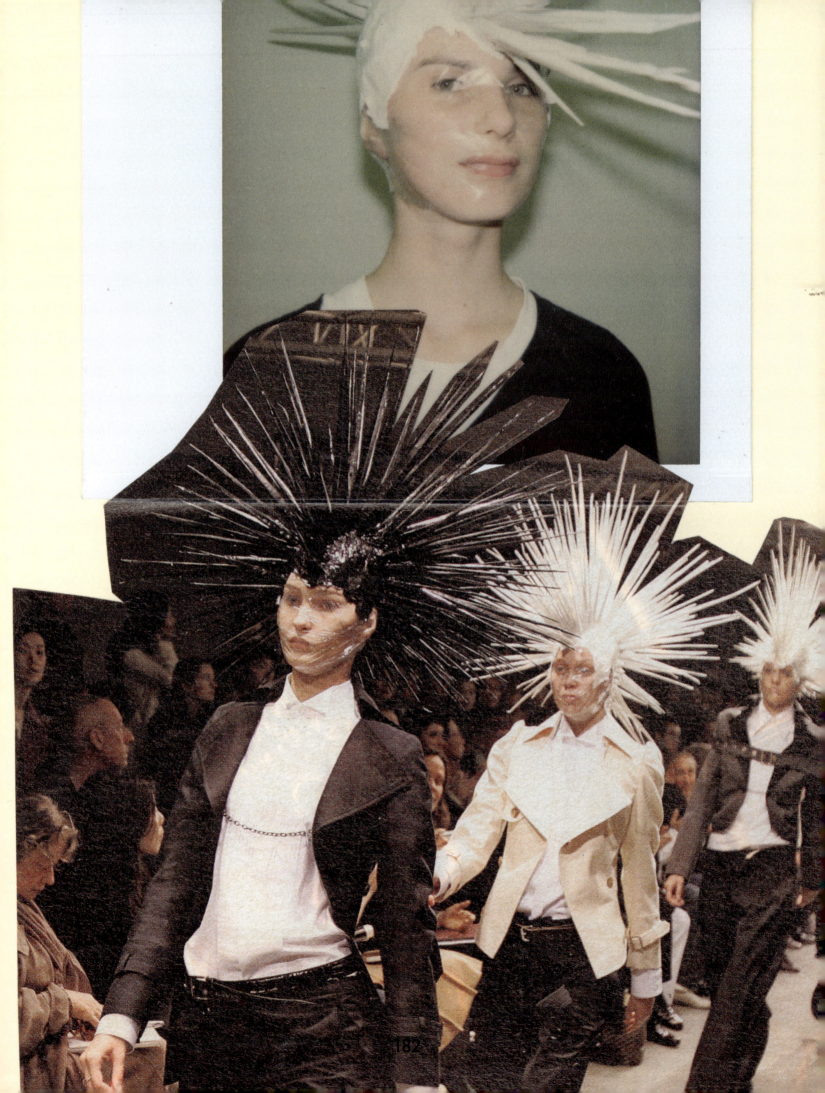

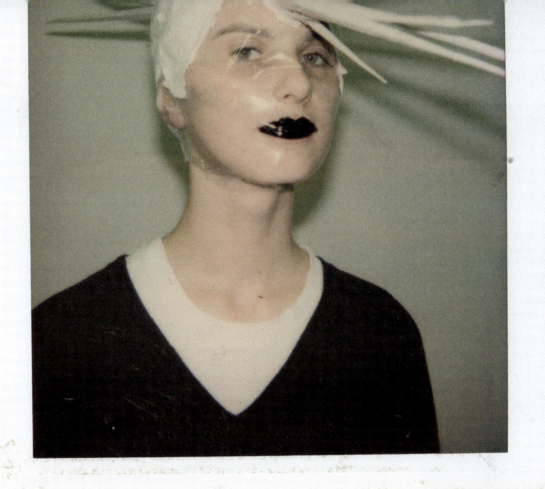

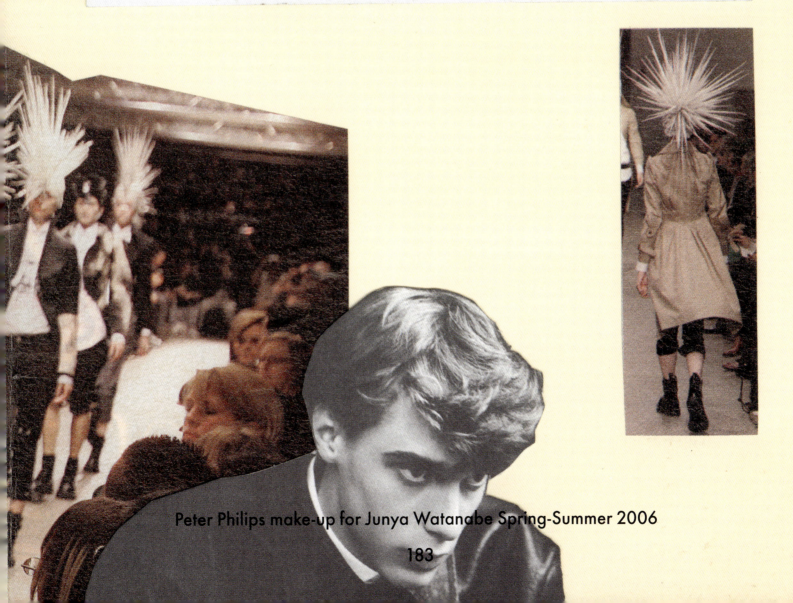

Peter Philips make-up for Junya Watanabe Spring-Summer 2006

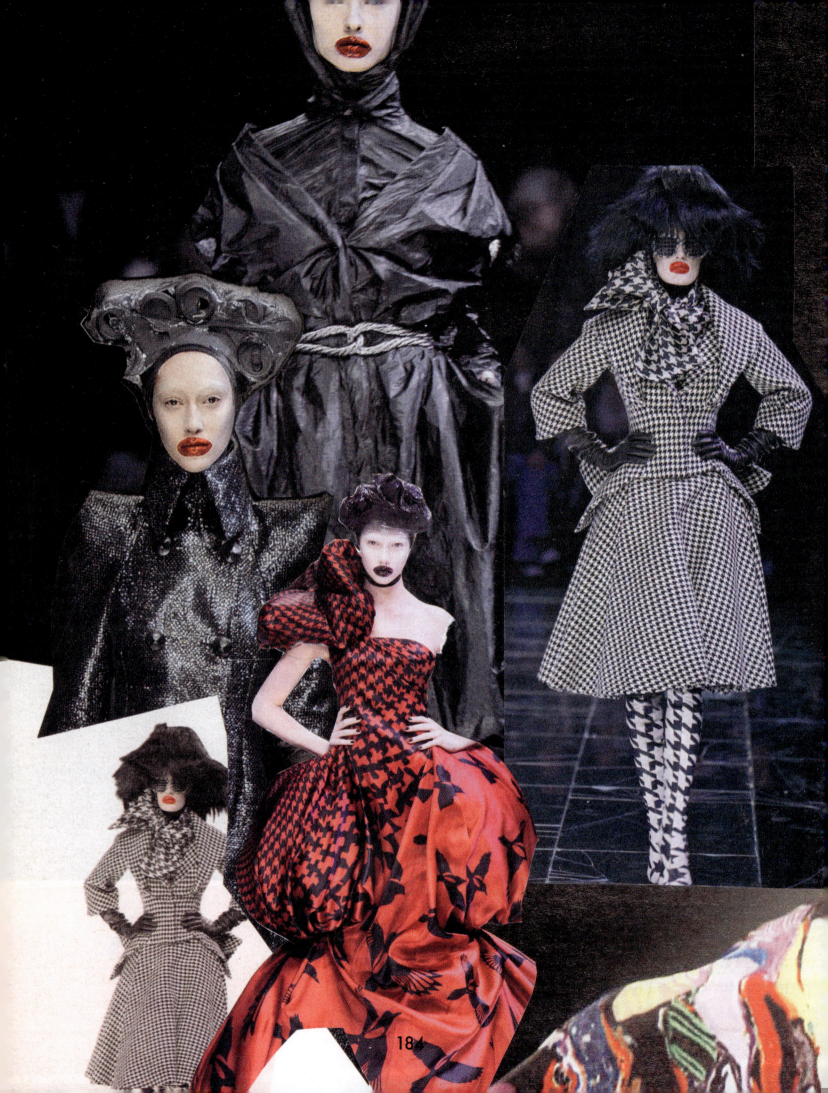

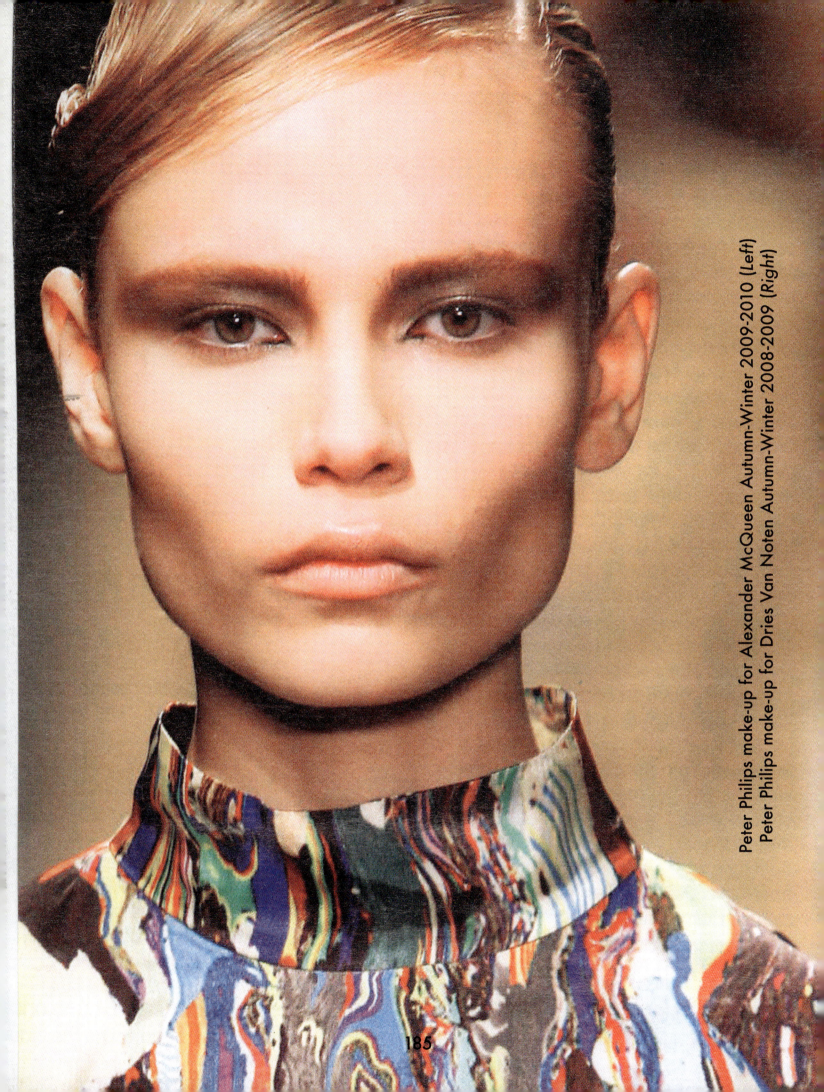

Peter Philips make-up for Alexander McQueen Autumn-Winter 2009-2010 (Left)
Peter Philips make-up for Dries Van Noten Autumn-Winter 2008-2009 (Right)

Peter Philips make-up for Veronique Branquinho Spring-Summer 1999

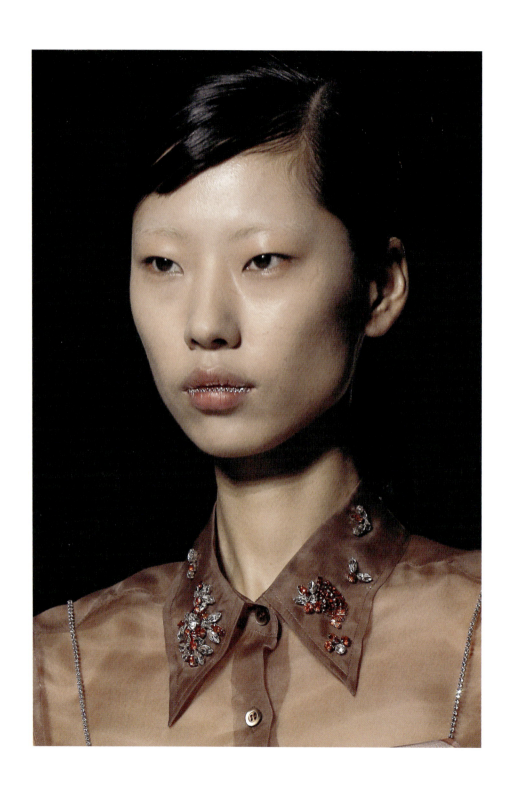

Peter Philips make-up for Dries Van Noten
Spring-Summer 2018

THERE IS BEAUTY IN DEFYING THE IDEAL

Genieve Figgis in conversation with Elisa De Wyngaert

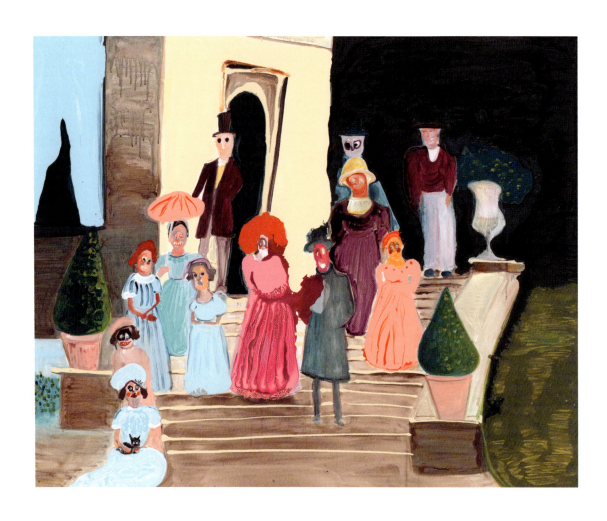

Genieve Figgis, *Family outdoors*, 2021

Genieve Figgis was born in 1972 in Dublin, Ireland, and currently lives and works in County Wicklow, Ireland.

Elisa De Wyngaert
The starting point of the exhibition is the 'Theatre of Artifice'. We explore the link between make-up and masks through different themes and stories. Interestingly, James Ensor's masks weren't there for his characters to hide behind. On the contrary, the masks revealed their true nature, their coquettishness, anger, jealousy, fear or cruelty. Does your characters' make-up reveal something about who they are or about their mental state?

GENIEVE FIGGIS

I find people fascinating and enjoy watching how they interact with their surrounding environment; the choices they make in these unusual environments we inhabit. I have always seen life as a kind of performance, especially women's role in society and what was expected of them. When I was a young girl, I observed what was expected of women and understood it to be a false narrative that was laid out before me. I know now that it was the influence of the Catholic church and the patriarchy. They were enforcing all the rules. In history, the female body was constrained in a tight corset, then it was high heels unsteadying the movement and forcing her to walk slowly behind. Currently it is the media's programming of youthful minds, repeating the mantra of unworthiness. People wear make-up in compliance with current beauty standards. I search for freedom and fantasy as I create my work, which I hope will undermine this current narrative. Some people find this part of my work unnerving and I hope that my Irish sense of humour slightly levels it out.

Elisa De Wyngaert
There is a darker tone to Ensor's work. Your work feels different, more emphatic. How would you describe the relationship you have with the characters you paint?

GENIEVE FIGGIS

I really enjoy the work of James Ensor. There is a theatricality. Like him, I observe. I hope that I would look upon the characters empathetically. We are all the same. We all are performing together. Where there are people, there is drama. I watch from afar and with a sense of humour. I hope there can be kindness. The characters portrayed in my work are rendered freely in the paint, and the surface I enjoy working with allows a certain exaggeration and a freer interpretation. I set them free.

Elisa De Wyngaert
Are you interested in people playing a role, keeping up appearances?

GENIEVE FIGGIS

I am interested in the idea of performing perfection. It is a fantasy that is constantly aimed for, but it can never be achieved. The breaking down of perfection can be beautiful. The women are more disobedient as they strive for beauty but fail, and the failure is brave and a more creative way of depicting a portrait. 'Normal' and 'traditional' are very tedious and I would like to show the joy in working against that idea.

Elisa De Wyngaert
Growing up, what did beauty mean to you?

GENIEVE FIGGIS

I guess I never really identified with supermodels or media-type beauties. The women I really admired and who were influential were my grandmother, great-aunts and aunties. They showed me leadership in how to exist in the world and how to be independent. They were beautiful to me. The magazine ladies were unattainable and from a young age I understood this. Since then, I have always gravitated toward the unconventional.

Elisa De Wyngaert
Your work magnifies the close relationship between make-up and paint. Rather than being blended to become one with the skin and canvas, your painterly strokes sit on the surface. Your lips are comprised of overt dabs; your blush playfully contends with traditional requirements of subtlety. It seems that you are breaking down beauty standards by exaggerating the use of make-up beyond its traditional purpose. How do you see this?

GENIEVE FIGGIS

My goal is usually to obtain a more progressive way of perceiving beauty. Idyllic Thomas Gainsborough portraits show ladies of perfection, and yet you can find beauty in the portraits of Otto Dix, and Lucas Cranach too. There is a fascination with the grotesque. Perfection is the new phantastic. I am not laughing at anyone or judging, but the charade of life has gotten out of hand. We need to sit back and take a look at what's important. Just like the artist Pieter Breughel the Elder who made an observation of our contemporary way of life without directly painting from life. I am not over-rationalising the portrait as I paint; it is always open for those twists and turns. There is a fluidity and innocence as I make it up as I go along, allowing myself and the characters to be free. There is a danger of failure always and somehow it kind of comes together. I am looking at my own reflection and laughing. I have a dark sense of humour and it is not directly responding to anyone personally. Women can be seen as both grotesque and beautiful. There is beauty in the abject and in defying the ideal.

Elisa De Wyngaert
Your characters remind me of doing your make-up in a dimly lit room and stepping out into the world, unknowingly looking somehow out of place. Does the idea of shame play a role in your work?

GENIEVE FIGGIS

There is no shame in trying to obtain these goals and beauty ideals. I have an understanding as a 50-year-old woman myself. We all want to blend in and seem normal. What I see today is going beyond that. There is a violence against women's bodies as they are under the media's scrutiny in obtaining a false idea of perfection. What is wrong with being imperfect?

Elisa De Wyngaert
You like to use watered-down acrylic paint and I've read how you enjoy the way it becomes a difficult and messy process with no guarantee of success. Is there a performative element to this process?

Genieve Figgis, *Moschino Dress*, 2019

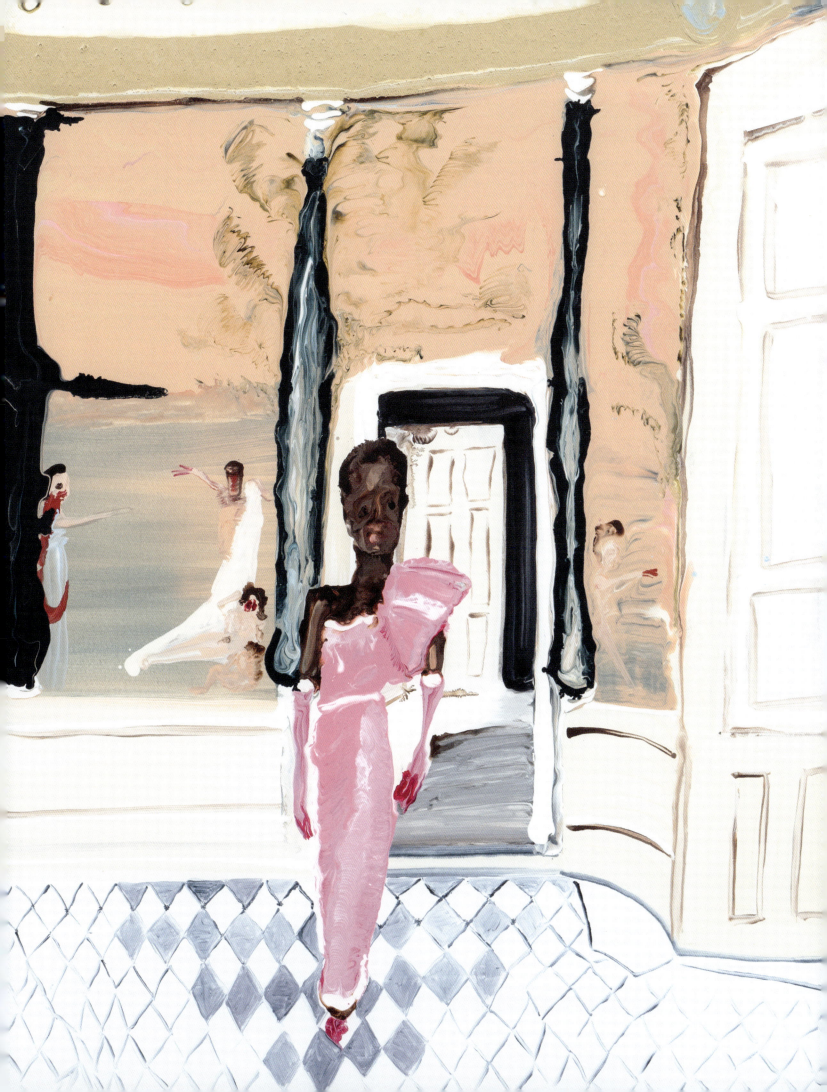

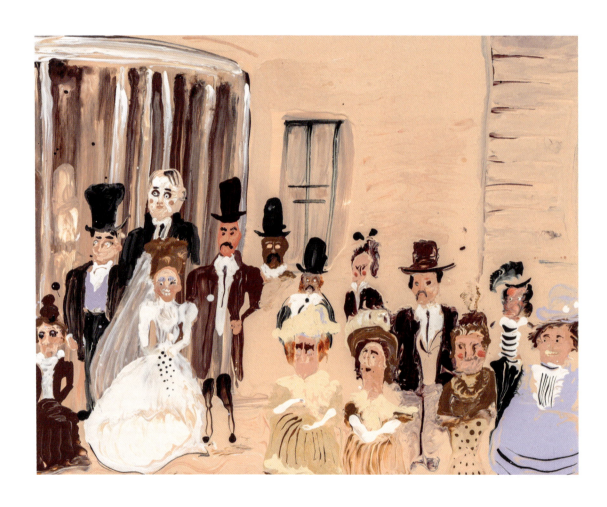

Genieve Figgis, *Wedding*, 2022

GENIEVE FIGGIS

Make-up is an artistic practice and performance. The before and after makeovers are something we obsess over. I feel paint is like make-up. I never aim for reality in the paintings, but reality is an influential factor. The mirror selfie is everywhere, and we have become too obsessed. There is also safety in looking at the past. There is more truth to be explored during the process of making a portrait. The paint can lead in many directions. In that unconscious process magical things can happen.

Elisa De Wyngaert
Growing up in Ireland in the 1970s and 1980s, what influenced your love for clothing?

GENIEVE FIGGIS

We had the glitz and glamour of the disco and then the grunge of the 1980s punk and new wave music. My parents weren't very musical, but my mother loved fashion: she took great pride in her shoes, dresses and bags. I learnt to use clothing to make myself heard. I found my own way of dressing and wore my dad's clothes. I became more rocker chic in the 1980s as heavy metal was the path I took to express myself. I altered clothing and invented a way of achieving a look that was my own. When I was 11 my father brought home a sewing machine for me. I was delighted and got to work exploring how to make clothes. My parents were very supportive but did not appreciate my heavy metal grunge look. They liked when I made skirts and bags and played the girly dress up. Today, when I go to clothes shops and look at the new collections, I still get so excited. It reminds me of when I dressed up as a kid and raided my mother's forbidden wardrobe.

Elisa De Wyngaert
There was a performative or protective element in dressing yourself growing up?

GENIEVE FIGGIS

Dressing was a performance and a way of surviving in the world. I never felt like a girly girl but have a fascination with how women were looked down upon and seen as the weaker sex. I never once in my life identified with that. Children were encouraged to speak only when they were spoken to, and the female voice was drowned out by the man in charge in television, radio and film. We were not encouraged to speak or have opinions in our environment.

Elisa De Wyngaert
And misogyny still persists...

GENIEVE FIGGIS

It is a pretence that women are being given equal rights now if you look at how we are allowed to participate in the world. We are encouraged to alter our flesh, hair and even skin tones. We must be flawless and obey the rules. In painting anyone can be any colour, they can take any shape or size, they exist without judgement and do not have to play to an audience. There is a sense of safety there.

Elisa De Wyngaert
Where did your fascination for the theatre come from?

GENIEVE FIGGIS

During my childhood, it felt performative watching the Mass, the priests and bishops dressed in their purple silks, lush red velvets and performing with gold trinkets on stage. We were dressed in our finest watching this. In Catholic Ireland it felt like the most important thing, this strange theatrical performance. I grew up encouraged to admire and worship it. I did attend drama classes on the weekend, and we put on plays. My drama teacher had a real stage installed in her garden. In my spare time, I wrote stories on my typewriter.

Elisa De Wyngaert
The closing part of the exhibition is about 'Vanitas' and people's longing for rejuvenation and the universal fear of time passing. As an artist, how do you feel about ageing?

GENIEVE FIGGIS

Ageing is a privilege. Focusing on health and well-being is much more important. That said, I'm not happy about ageing as I feel like I took my youth for granted now. I do take better care of what I eat, and keep up fitness more than trying to obtain any idea of perfection. I would rather focus on colour and nice fabrics.

Genieve Figgis, *Royal Friends*, 2014

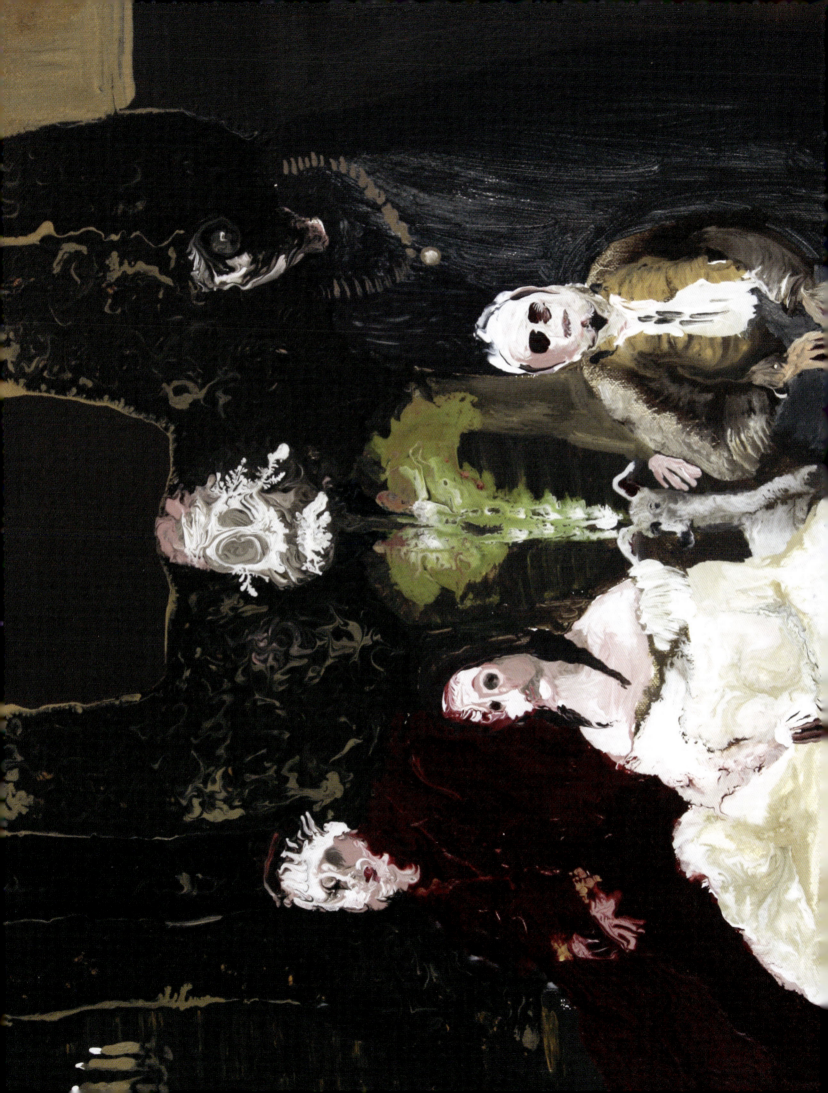

Genieve Figgis, *Ensor & Friends*, 2017

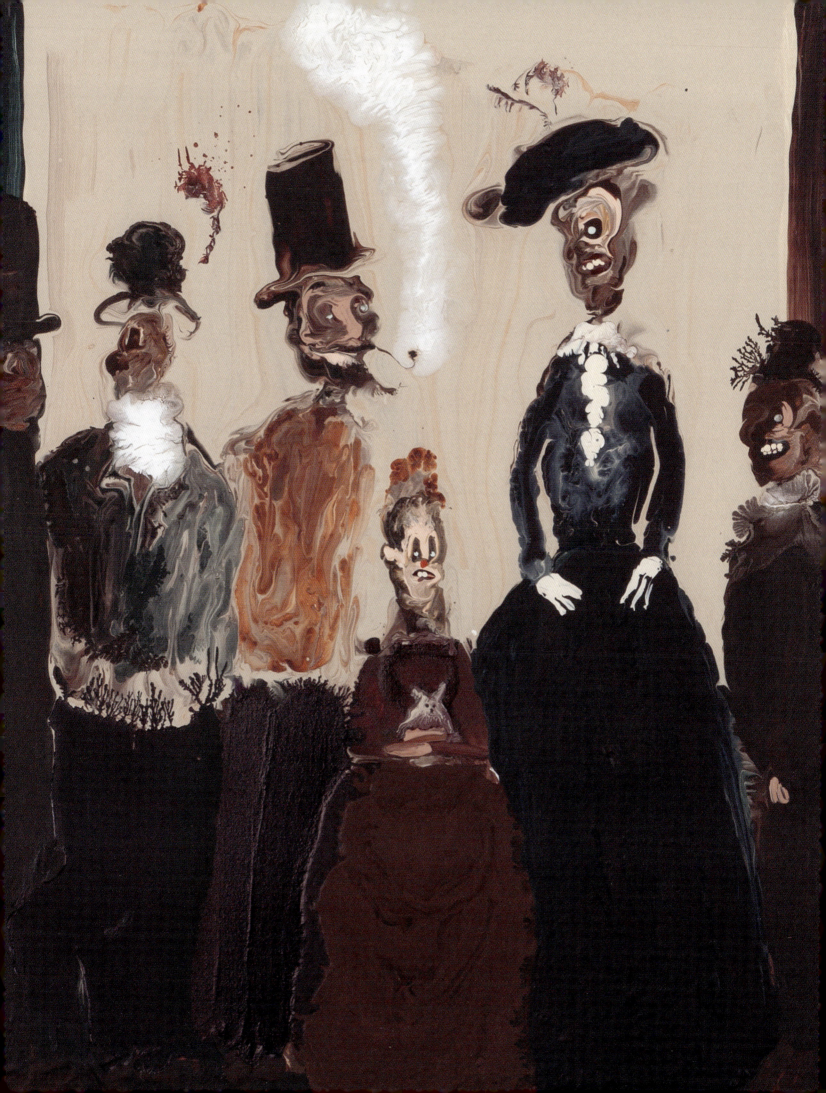

Genieve Figgis, *Fashion shoot*, 2021

I DON'T SELL PRODUCTS, I SELL IDEAS

Inge Grognard in conversation with Kaat Debo & Elisa De Wyngaert

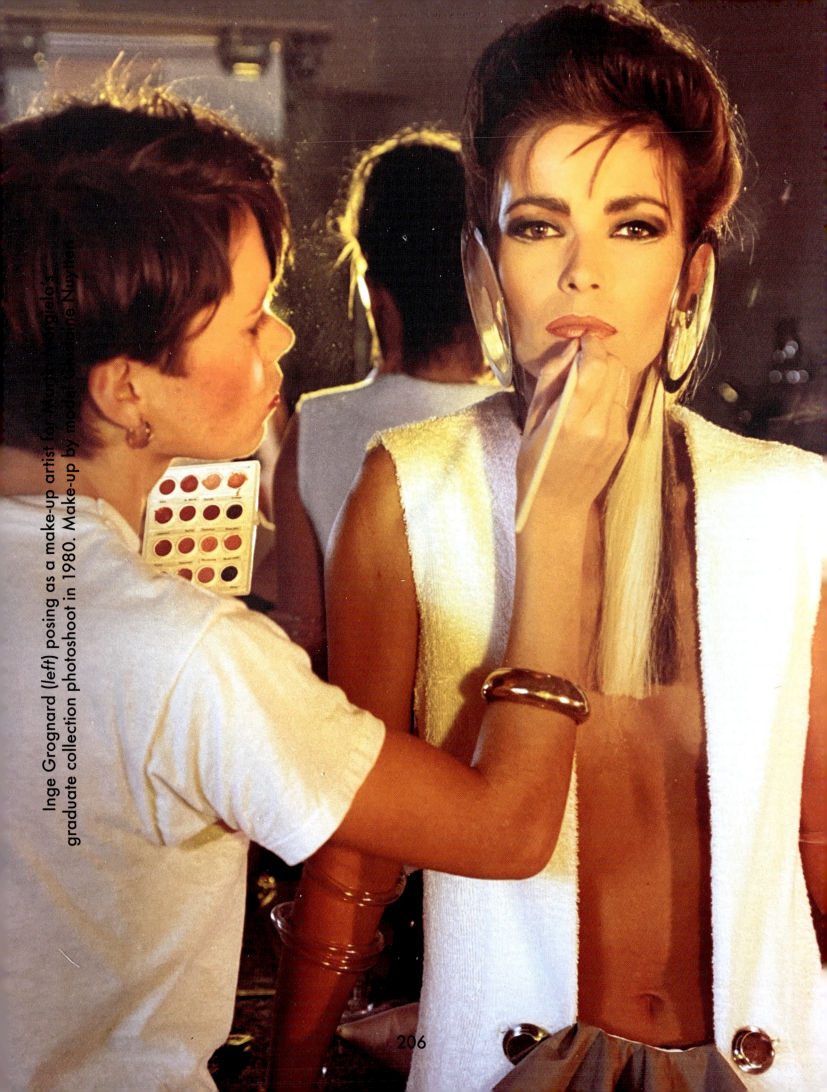

Inge Grognard (left) posing as a make-up artist for Martin Margiela's graduate collection photoshoot in 1980. Make-up by model Germaine Nuytten.

206

Kaat Debo
Where does your interest in make-up
and fashion come from?

INGE GROGNARD

Even as a child, my mother says I was really into clothes. Twice a year we got new outfits and my mother would say, 'You always manage to pick out the most expensive ones.' I wasn't easy; I had a thing for clothes and for the beauty of appearance. I was 12 when I met Josiane, Martin Margiela's cousin. We went to the same school for girls where uniforms were compulsory. Through her, I was introduced to Martin. When we were 16, the three of us went to Paris, mainly for the flea markets. We saved drastically on food and spent our entire budget on second-hand clothes. In the evening we paraded down the Champs-Élysées in them, wearing sunglasses and loose-fitting coats. We had pancakes, drank cheap red wine and went home with a suitcase full of nice things.

Kaat Debo
Why did you ultimately choose to train
in make-up and not fashion?

INGE GROGNARD

I felt that my drawing skills fell just a little bit short. I was hard on myself and always felt I had to be able to really excel at something, to turn it into my craft. My love for clothing did lead me to something closely related: make-up. And I wanted to leave home. Together with Josiane, I enrolled in a beauty school that offered theoretical courses and also basic make-up training. The advantage was that we had few classes. Martin went to study fashion and we were always there when there were shows at the Fashion Department of the Royal Academy of Fine Arts in Antwerp.

Elisa De Wyngaert
You could say that today you practice the
opposite of what is taught in traditional beauty schools.
What did you get out of your training?

INGE GROGNARD

Mainly a wonderful sense of freedom. During those three years, we went to the cinema every week and bought second-hand clothes that we adjusted to our liking. It was during that time that I met Walter Van Beirendonck, who was also good friends with Martin. When there were themed parties, they would come to our place in Berchem with props, such as a bag full of feathers. We were happy to help them dress up and transform themselves.

Elisa De Wyngaert
Can you tell us about the first shoot you were involved in?

INGE GROGNARD

The first time I was involved in a photo shoot was for Martin's graduation collection. The photos were taken at the hair salon where I worked for a year. I didn't have enough experience to do Ghislaine Nuytten's make-up, which she did beautifully herself. I was present as a prop rather. I have fond memories of that day.

Elisa De Wyngaert
There were designers you looked up to at the time, such
as Claude Montana, Thierry Mugler and Jean Paul Gaultier,
but were there any role models for you in the world of make-up?

INGE GROGNARD

I didn't really have a role model. I do remember how special it was for me to discover Linda Mason's work. She was the first one to write something on a face; a revelation. Martin had

shown me her work. Serge Lutens was also a great inspiration during his time, working for Dior and then Shiseido. He had a very personal signature and did everything himself: hair, make-up, set, photography… incredible.

Kaat Debo
What about later in your career? Have there been people
in the make-up world that you have found inspiring?

INGE GROGNARD

I find inspiration in films, theatre, music and things that stand out rather than in other make-up artists.

Kaat Debo
What was your first professional experience after
working as a student in the hair salon?

INGE GROGNARD

After that year in the hair salon, I went back to school, in Antwerp, to train to be a secondary school teacher for science. I was good at science, but soon realised I could no longer follow a traditional curriculum. I switched to secondary school teacher training in Ghent. By then, I had already married Ronald [Stoops], in 1981. From 1981 to 1983, I commuted to Ghent every day and finished the course. It took some getting used to, because the other students were much younger than me and sometimes commented on my style or appearance. Before launching myself as a freelance, I went back to work in the hair salon. By that time, the owners had opened a salon for men and they wanted me to run it. I agreed, but on condition that I could combine my work with shoots. By now, I was collaborating with magazines such as *Mode. Dit is Belgisch, Bam, Flair, Knack*… I was still doing both hair *and* make-up. There was a lot of freedom and room for experimentation, and that was my training ground. I was able to train in those years, through trial and error.

Kaat Debo
What products did you use back then?

INGE GROGNARD

I bought most of them myself. Sponsorship didn't exist at the time, or at least I didn't know how it worked. I often went to theatre shops because they had brighter colours, and I mixed products to get the colours I wanted.

Elisa De Wyngaert
You first job abroad was for Martin Margiela's first show in Paris.
How did you experience that show backstage?

INGE GROGNARD

It was pretty chaotic because there was very little light backstage. I was supposed to model in the show too. My silhouette was hanging on a coat stand, ready for me, but in the end I didn't have time. The make-up consisted of panda eyes, longer bangs for some models, a red mouth. I did have some assistants to help me, but they didn't have much experience backstage either.

Elisa De Wyngaert
When they hear your name, most people immediately
think of your collaboration with Martin Margiela, but you have
actually worked for many Belgian designers.

INGE GROGNARD

For almost all of them, and always with great dedication. I learnt a lot from them and it was a real pleasure to immerse myself in their worlds. It started with the Antwerp Six. Then came the second generation, with Raf Simons, Veronique Branquinho, Jurgi Persoons, Haider Ackermann, A.F.Vandevorst and Wim Neels. Today, there are also younger alumni from the

Inge Grognard make-up for Maison Martin Margiela
Spring-Summer 1993 lookbook

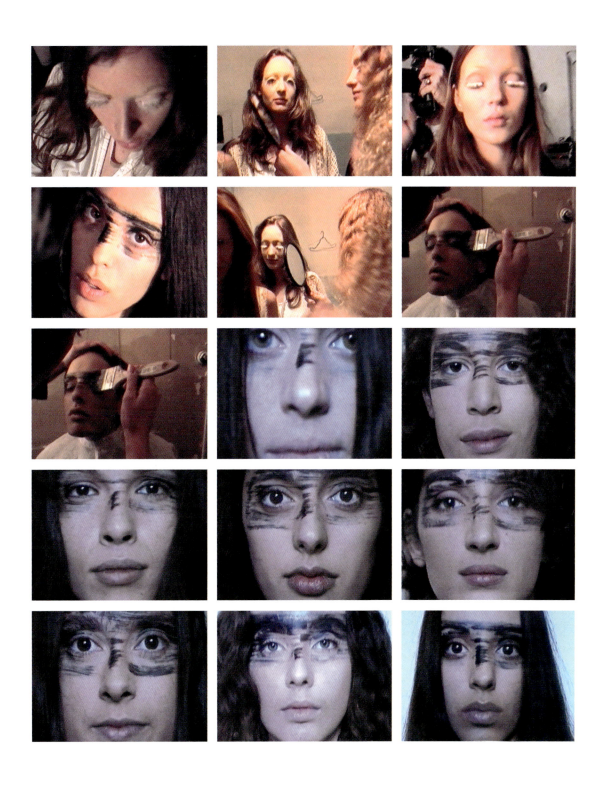

Inge Grognard make-up for Maison Martin Margiela
Spring-Summer 1993, backstage film by Bridget Yorke

A 'no-make-up' look by Inge Grognard
for A.F. Vandevorst Spring-Summer 1999

Fashion Department in Antwerp, such as Demna and Glenn Martens. Collaborations like these are very dear to me; you build something together. Martin and I, of course, have known each other the longest because we grew up together. That is why his aesthetic is so in line with mine.

Kaat Debo
Your collaborations have also been very decisive for your signature.

INGE GROGNARD
Thanks to Martin, I learnt to experiment, especially on myself in the beginning. That was even before I moved to Antwerp. He gives me a lot of energy. After an evening spent chatting with Martin, you feel energised to make something.

Kaat Debo
How important is your personal work with your partner, photographer Ronald Stoops, which has also been a constant throughout your career?

INGE GROGNARD
Hugely important, and Ronald's role in that is essential. He is my sounding board. For us, our personal work starts with an emotion. There was a period when we produced a lot from a feeling we shared. We both need a certain fervour and friction to produce. If everything just chugged along quietly, I would get rather lazy.

Elisa De Wyngaert
You are a vocal activist on social media. Is the freedom to make your voice heard important to you? And is it therefore also a conscious decision not to attach yourself to the big fashion houses?

INGE GROGNARD
I want to be free. I have been headhunted on occasion, but at the end of the day, my freedom is priceless. I don't sell products, I sell ideas.

Kaat Debo
Make-up is often described as a mask behind which mainly women hide. But a mask can also make a person anonymous and as such can stand for the ultimate freedom. What is your take on that?

INGE GROGNARD
I once made a series of masks as personal work. This came to me from a growing feeling that things in the world are often times not fair, that people are not given a voice. One mask incorporated newsprint with articles that touched me at the time. My work is a reflection on the world and a reaction to the world, and also to people around me.

Elisa De Wyngaert
Is your work a way of channelling your emotions?

INGE GROGNARD
Yes, that was an intense period, the end of the 1990s. I remember looking for an agent to represent me internationally at the time. In 1998 I made a small book, my first portfolio, together with Paul Boudens and Ronald. That little book shows the dark side of my work, but always with a touch of romance.

Elisa De Wyngaert
The idea of freedom is linked with another important aspect of your career, namely your refusal to work with celebrities or big names. Why have you always held onto that?

INGE GROGNARD
Celebrities usually have their own glam team with them and already have a specific idea of how they look good. As a make-up artist, such jobs involve playing a psychological game, which I admire, but which I am not so keen on myself.

Elisa De Wyngaert
Your work has evolved in line with changing ideals of beauty. Your recent work, for instance, refers more often to plastic surgery. Is this a commentary, a reflection or an obsession?

INGE GROGNARD
It is a reflection. I worked on the *Hood by Air* show for Spring-Summer 2016 where we used contouring techniques, but without actually blending the products. That way you could see how much product was used to get the flawless faces, moulded and sculpted. In fact, it was also a bit of a critique. It has to do with the difference between Europe and the United States. A 'natural' look for us is something completely different there. To them, 'natural' equals full make-up. What they mean by natural make-up is absolutely not natural to me. I am a European, so for me natural make-up is raw. I want to see the skin underneath. I also don't like seeing make-up that is fresh. I like to see make-up that has been on for several hours. Then it comes alive.

Kaat Debo
That idea can sometimes be quite extreme in your work. I think the most extreme make-up may have been what you created for A.F.Vandevorst's first show, the Spring-Summer 1999 collection.

INGE GROGNARD
That show was early in the morning. It was very pure and was about the ritual of facial care without any make-up. It was essential for the models to be comfortable. Showing someone's skin has always been essential for me. I personally hate applying foundation all over my face. I only use a little of it, which I mix with day cream. The skin needs to breathe. Today, fortunately, there are more shades and textures of foundation available on the market.

Elisa De Wyngaert
In your work, the skin itself also becomes make-up, taking the form of prints and marks. How did you come to manipulate the skin?

INGE GROGNARD
I recognised such manipulations in Lucio Fontana's canvases, among others. I love that radical take. I look for something sharp, something disruptive. I look for the right tools, like a palette knife, with which to draw a sharp line.

Kaat Debo
There is something very artisanal about that approach. Your tools are not part of the traditional range.

INGE GROGNARD
I even used to cut my own brushes. I first did the brushstrokes for Martin. We bought cheap brushes and cut them. Today, you can buy such brushes. I do tests to determine the right amount of paint and then I move across the face in a single gesture.

Elisa De Wyngaert
That finishing touch and your freehand gestures are an important part of your signature. How do you find working in a team at fashion shows?

INGE GROGNARD
Usually the team lays a foundation, like at the Autumn-Winter 2023-2024 show with Junya Watanabe. The finishing

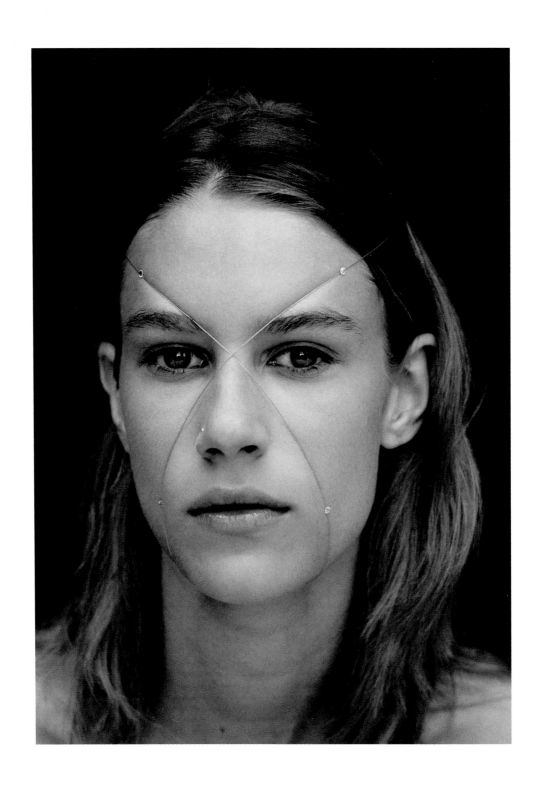

Inge Grognard in collaboration with Ronald Stoops,
V Magazine, 2001

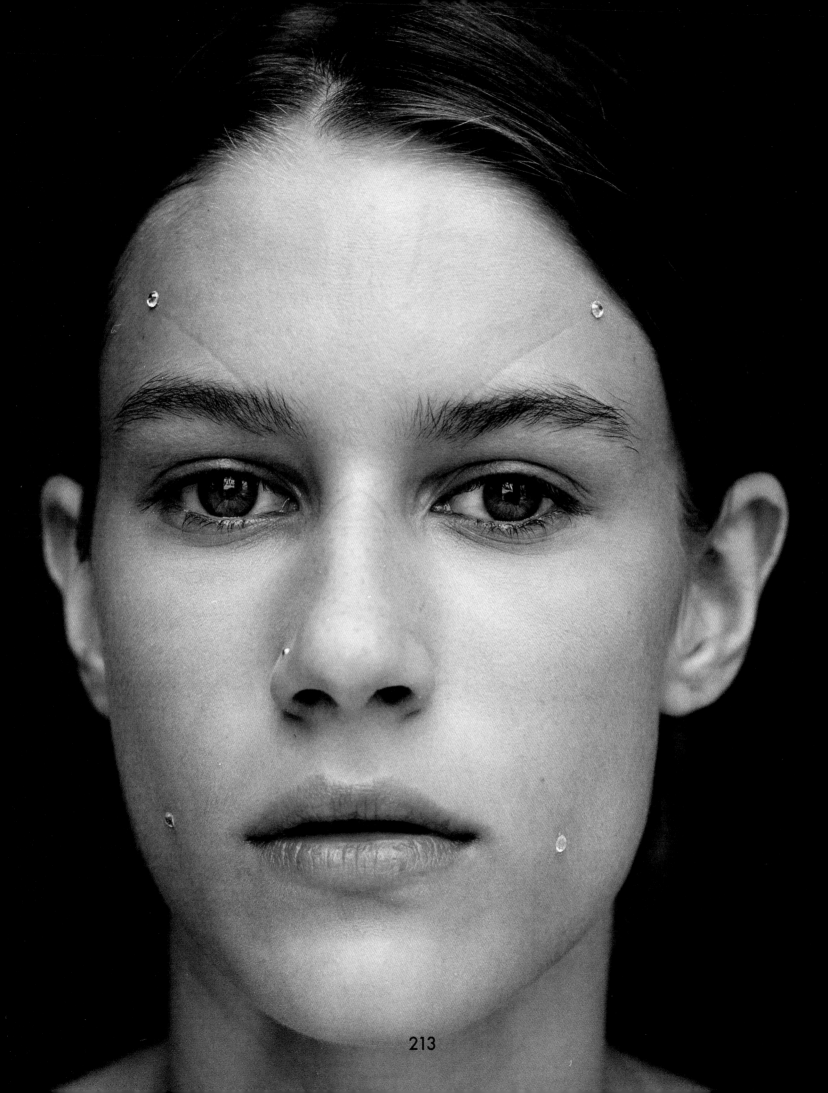

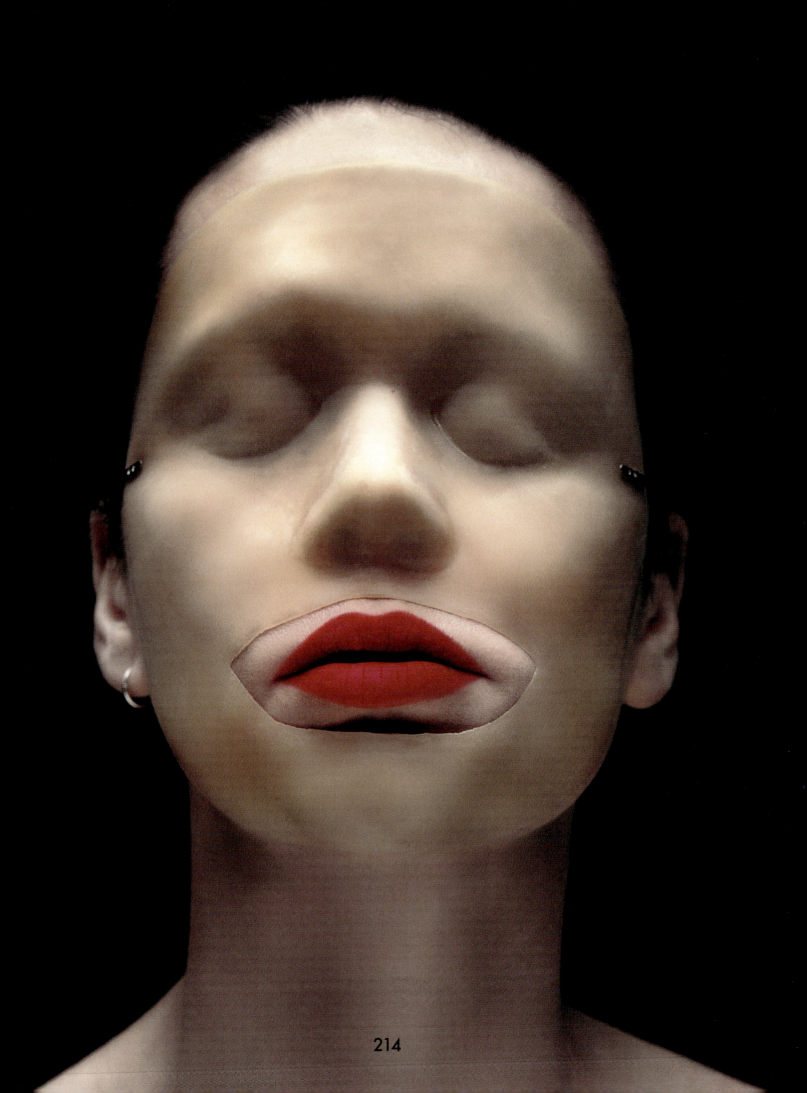

Inge Grognard in collaboration with Ronald Stoops, 2001
Inge Grognard in collaboration with Ronald Stoops, *Belgian Beauty*,
(B)Eople Magazine, 2001 *(Next Page)*

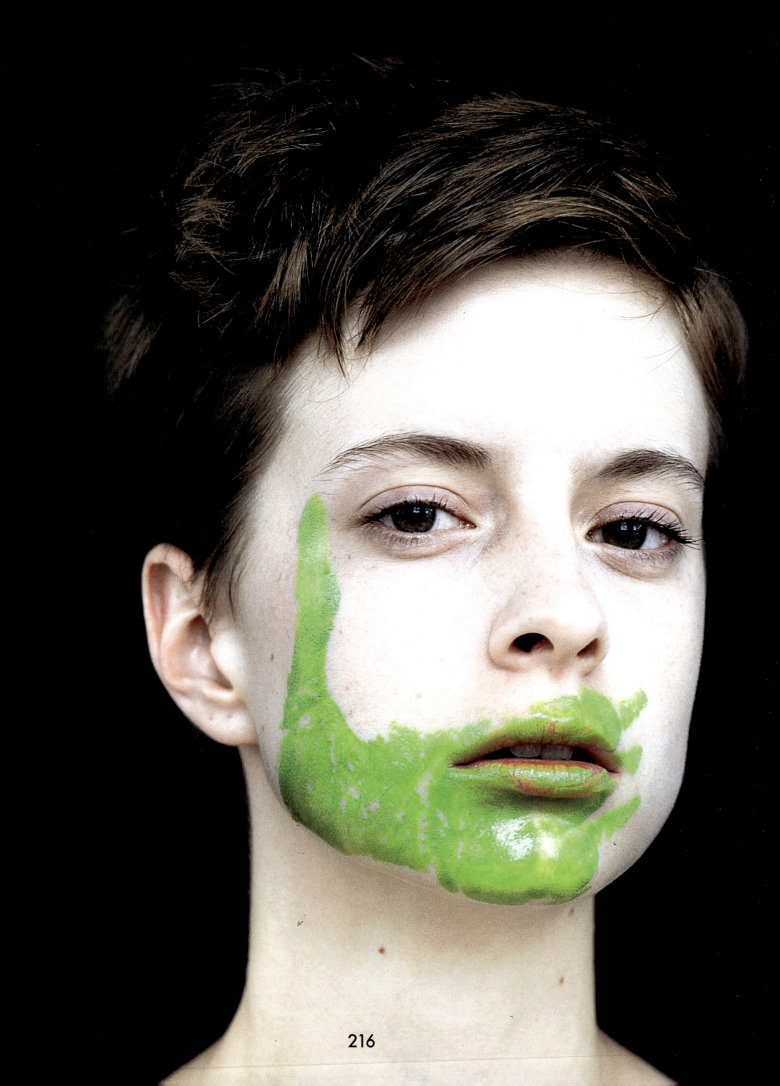

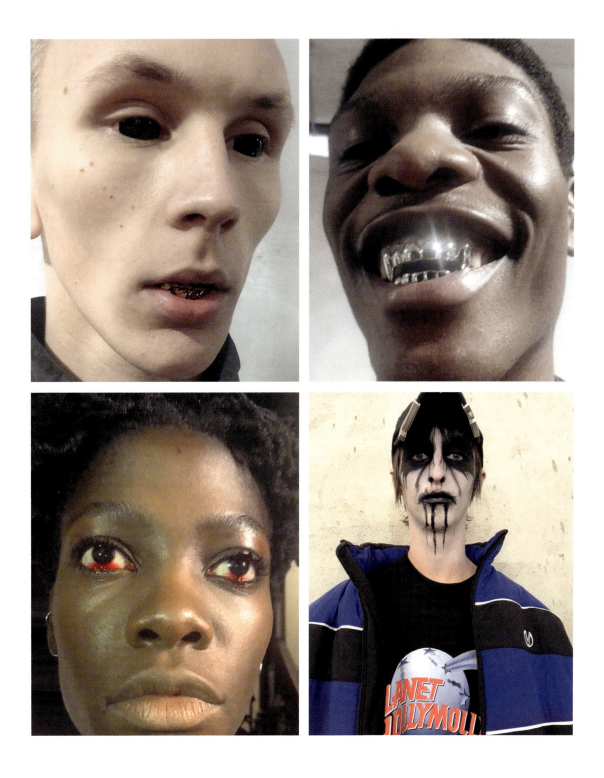

Inge Grognard make-up for Balenciaga Autumn-Winter 2020-2021 *(Above)*, Section 8 Spring-Summer 2020 *(Bottom left)* and Vetements Spring-Summer 2020 *(Bottom right)*

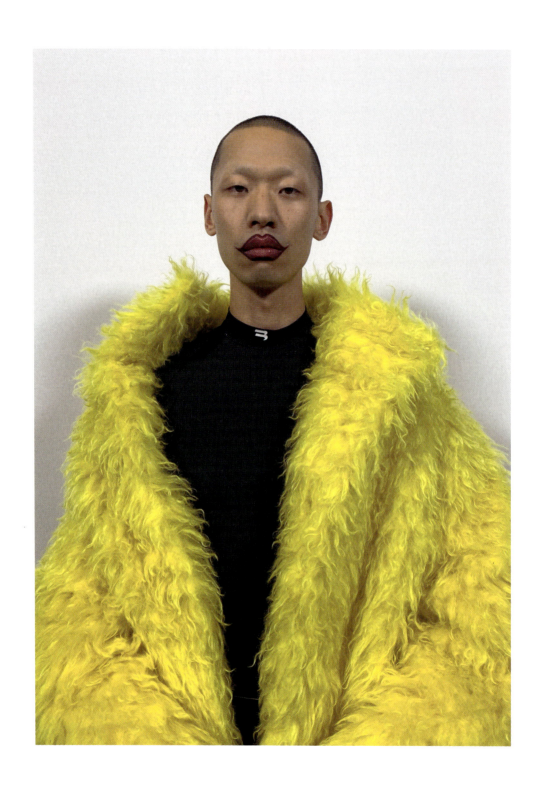

Inge Grognard make-up for Balenciaga *Video Game*,
Autumn-Winter 2021-2022

touch is often difficult, because you have to be able to do it in a single gesture. Above all, you can't be afraid. Anything that has to be technically perfect, I have it done by my assistants. If there is any freehand work involved, I do it.

Elisa De Wyngaert
Does it feel natural for you to take on the role of mentor?

INGE GROGNARD

I come from a family of teachers. That is all I have ever known. I went to a teacher training college and also did internships in schools. Mentorship is in me somewhere. I hate people who shout. If something goes wrong, I give the person a chance to keep working on it. Only when I see that things are taking too long do I move the assistant to another model for a while. Models can become anxious when things take too long. They sense such things. So only then I take over. But I do that subtly and with respect.

Kaat Debo
In some of your early creations, the idea of the 'frame' is very present. Is it a deliberate diversion from the essence of the face, from the nose, eyes and mouth?

INGE GROGNARD

The frame is very important. That is why, for example, I made the neck darker, as with Dirk Van Saene for his Spring-Summer 1998 collection. I use the frame to give everything in it just a bit more emphasis. I can also evoke emotion in the eyes through eye drops, for example.

Kaat Debo
During the first part of your career, in the 1990s, Photoshop was suddenly introduced. How did you react to that transition?

INGE GROGNARD

In the first few years, Photoshop didn't exist. Back then, people still retouched the photo or negative, and we had to make sure everything was as perfect as possible. Those early days of Photoshop were really intense. Everything got erased and there was nothing beautiful about it anymore. Models became cartoon characters. Today, if Photoshop is used properly, you can still feel the texture of the skin. You can see the pores again, even in campaigns for big brands. I like that.

Elisa De Wyngaert
You test out all the make-up on your own face. Is it sometimes challenging to work with your own face?

INGE GROGNARD

Yes, it is sometimes challenging, because I am getting older and I would prefer that some things were different. But I keep experimenting on myself. In my self-portraits, I can play with how the images are cropped. I am critical of myself.

Elisa De Wyngaert
The exhibition addresses the universal fear of ageing. Everyone deals with it in their own way. Also, there are always new remedies on the market. What do you think of the developments in anti-ageing products?

INGE GROGNARD

I think it is wonderful. I can't tell you all the things I have lying around here. I have LED masks, infrared face masks, an electric pulse machine, all sorts of devices and creams. A part of me knows they don't help, but maybe they

could… so I order something and use it for a few days and then think, God, it's not having that much of an effect.

Kaat Debo
You are quite fascinated by innovation and what products are available on the market. Have you ever thought of developing a product yourself?

INGE GROGNARD

Yes, absolutely. But the time when you could market your own products like that is gone, I think. I could have done that 25 years ago, when there was still a shortage of, say, foundations of the right texture. But who would I have asked? For one thing, my name wasn't big enough and I was in Belgium. There were lots of gaps in the market at the time. There have been so many instances when I have thought to myself, 'I should have done that 25, 30 years ago'.

Kaat Debo
Although you have never launched your own product, you recently collaborated with Dries Van Noten on a range of lipsticks.

INGE GROGNARD

I worked with my assistant, Florence Teerlinck, on the texture and colours for the launch of the lipsticks. Developing the lipsticks during the Covid pandemic was a challenge because we couldn't go to the factory. The pigments we experimented with were sent to us by post at our request. There was a room in my house that we completely taped off and set up for the process. We carried out very secure and extensive testing with different textures and pigments, which was rather unique and challenging without the expertise and guidance of a manufacturer. In a sense, it made our process artisanal and quite intimate. There were certain colours in the range that I had to be as faithful to as possible, but we also created some more unexpected lipstick colours, like a beautiful lilac and green. My dream, and the biggest challenge, was creating the perfect red lipstick. I gave it the working title 'Favorite Red' because it is my ultimate red, the red I had been searching for all my life. Today, 'Favorite Red' is the official name of that lipstick. That came as a surprise and it really moved me. It was an important moment in my career to get that confidence from Dries Van Noten.

Kaat Debo
The pandemic was an intense period for make-up artists, because what you do is something very intimate. You can't get any closer to people.

INGE GROGNARD

In my profession, feeling is important. That is what I always tell my assistants. You immediately feel who you are dealing with. It is a psychological game. Working with designers is also often a game. You have to be sufficiently persuasive and confident about the idea you have in mind. You have to be able to convince them to such an extent that they trust you.

Kaat Debo
I remember Stephen Jones telling me that the last thing you can change are the hats and make-up. I guess you have to learn to deal with that?

INGE GROGNARD

If something doesn't work, I am the first to leave things out or change things. I am open to that. It is about the designer, not me. I have enough experience by now. I have learnt how to intervene in the moment. Improvising with what you know is something I do well.

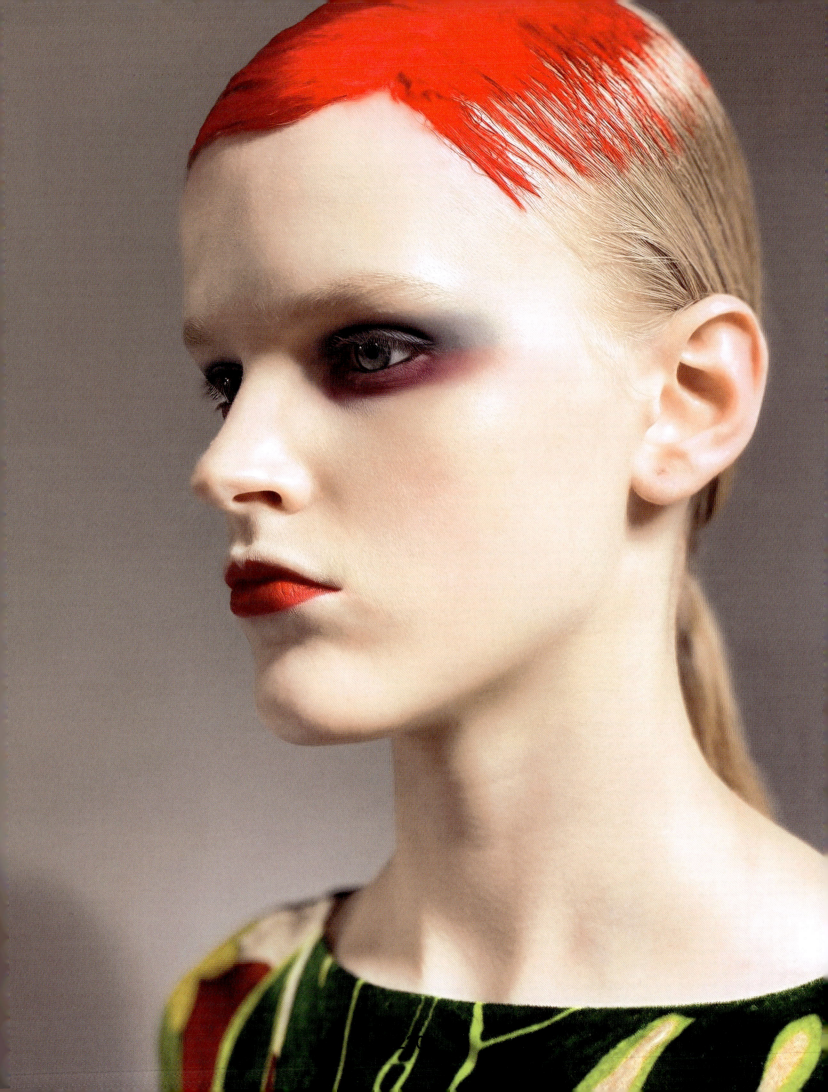

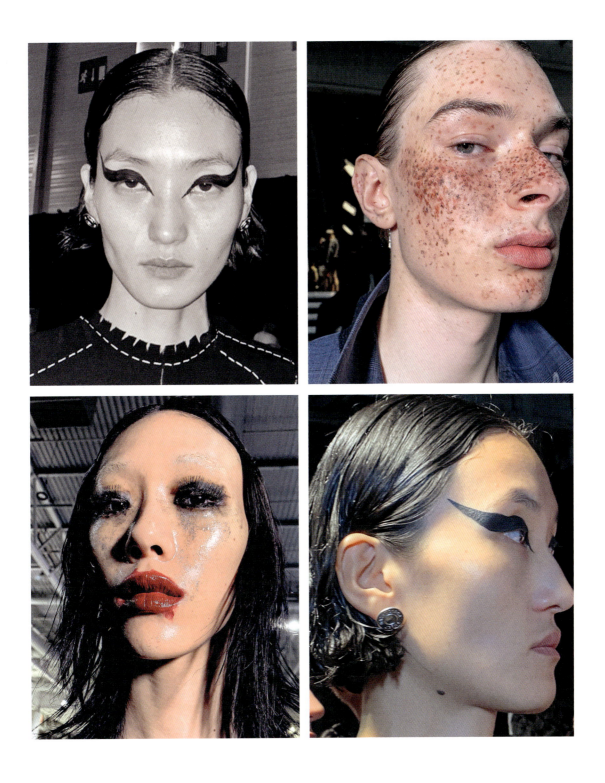

Inge Grognard make-up for Balenciaga Spring-Summer 2023
Inge Grognard make-up for Dries Van Noten Autumn-Winter 2020-2021 *(Left)*

Inge Grognard's first inspiration book (p. 222-232)

MISERY. 1980. 95 x 158 in. 241 x 401 cm.

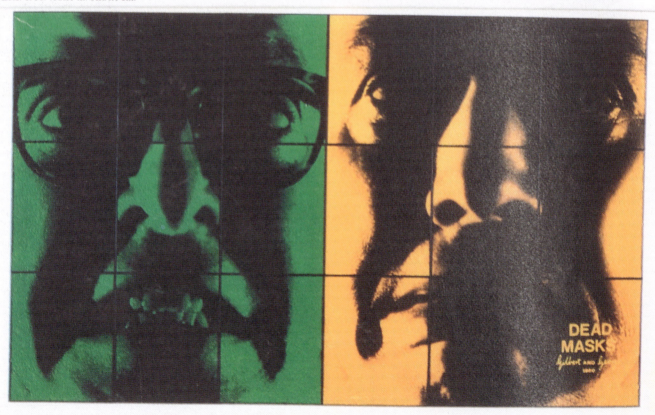

DEAD MASKS. 1980. 71 x 119 in. 181 x 301 cm.

225

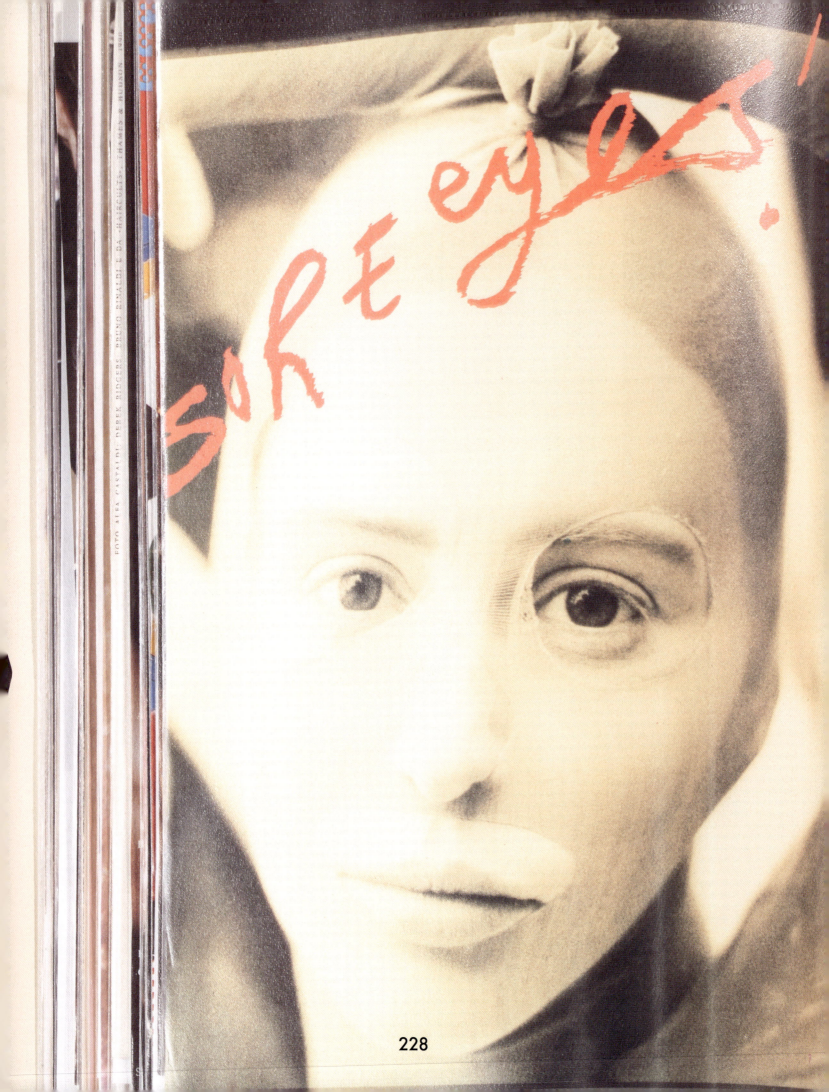

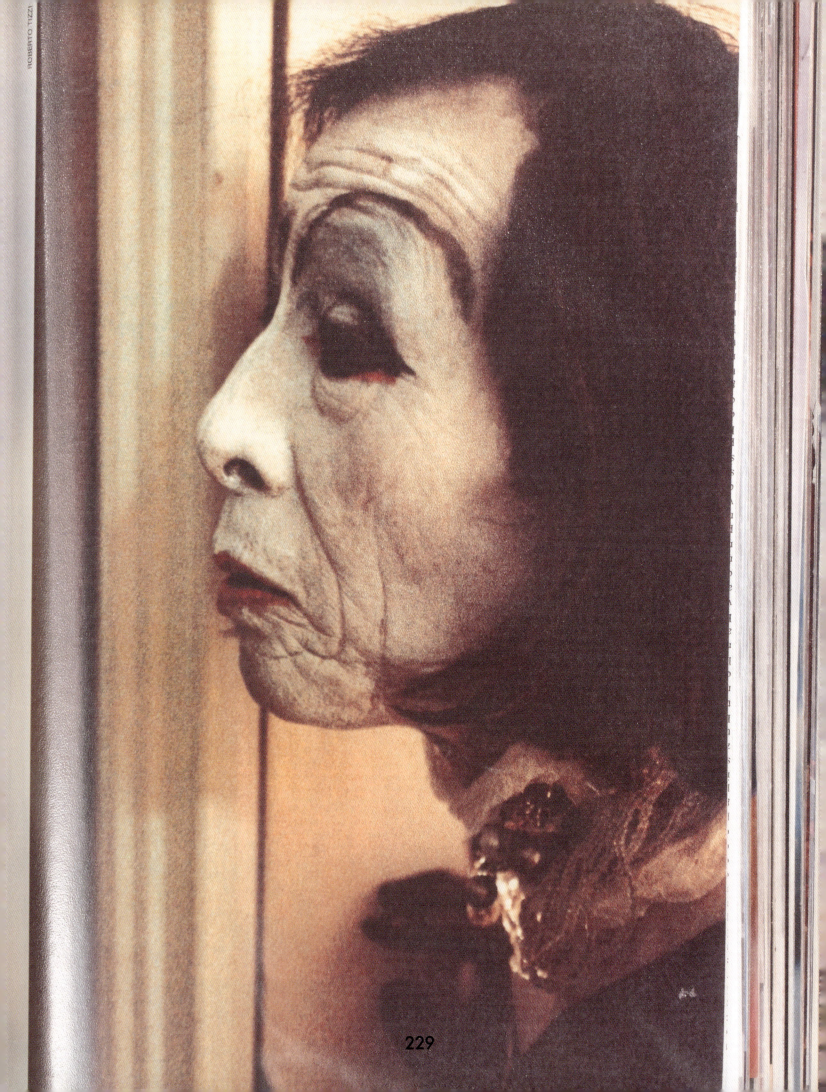

229

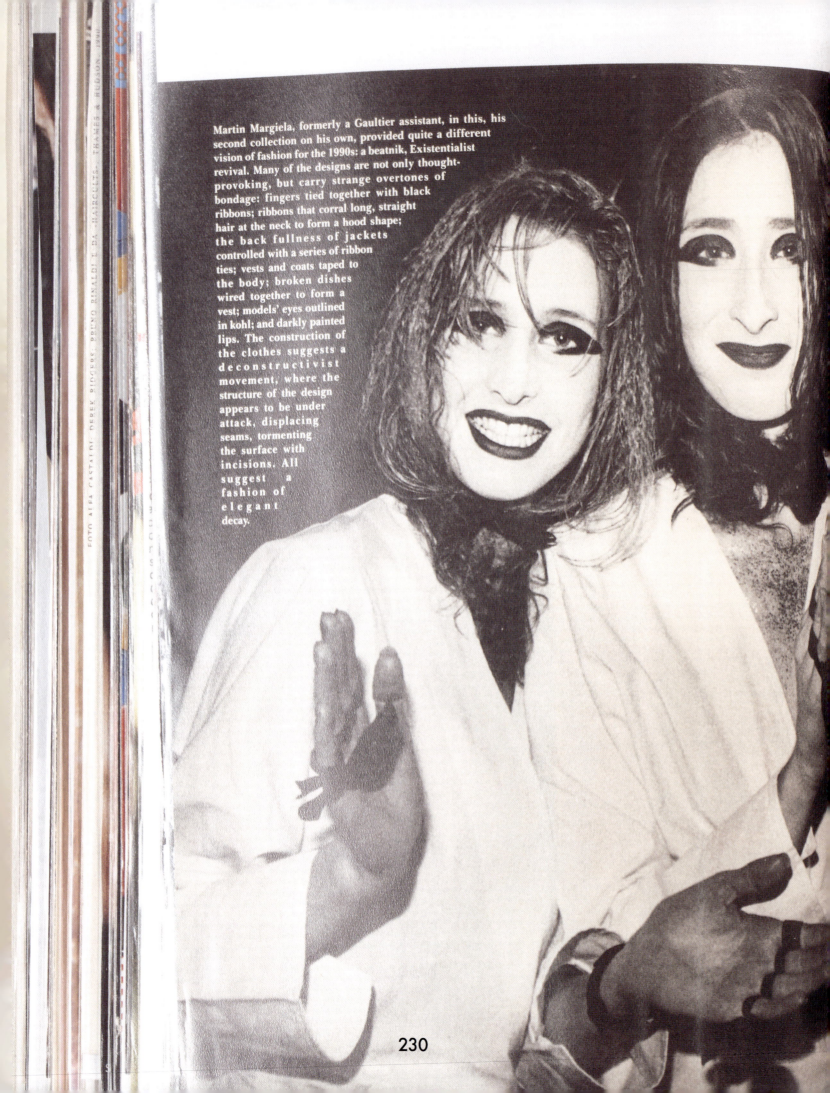

Martin Margiela, formerly a Gaultier assistant, in this, his second collection on his own, provided quite a different vision of fashion for the 1990s: a beatnik, Existentialist revival. Many of the designs are not only thought-provoking, but carry strange overtones of bondage: fingers tied together with black ribbons; ribbons that corral long, straight hair at the neck to form a hood shape; the back fullness of jackets controlled with a series of ribbon ties; vests and coats taped to the body; broken dishes wired together to form a vest; models' eyes outlined in kohl; and darkly painted lips. The construction of the clothes suggests a deconstructivist movement, where the structure of the design appears to be under attack, displacing seams, tormenting the surface with incisions. All suggest a fashion of elegant decay.

FOTO ALFA CASTALDI. DEREK RIDGERS. BRUNO RINALDI E DA HAIRCUTS. THAMES & HUDSON, 1990

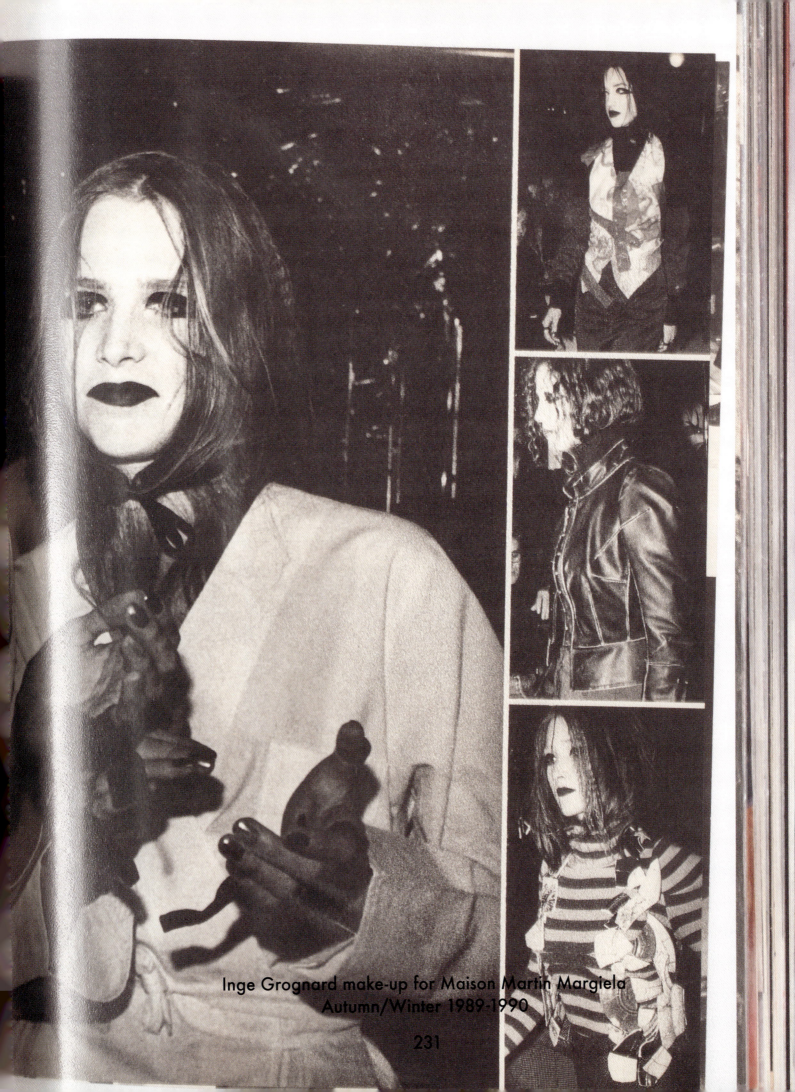

Inge Grognard make-up for Maison Martin Margiela
Autumn/Winter 1989-1990

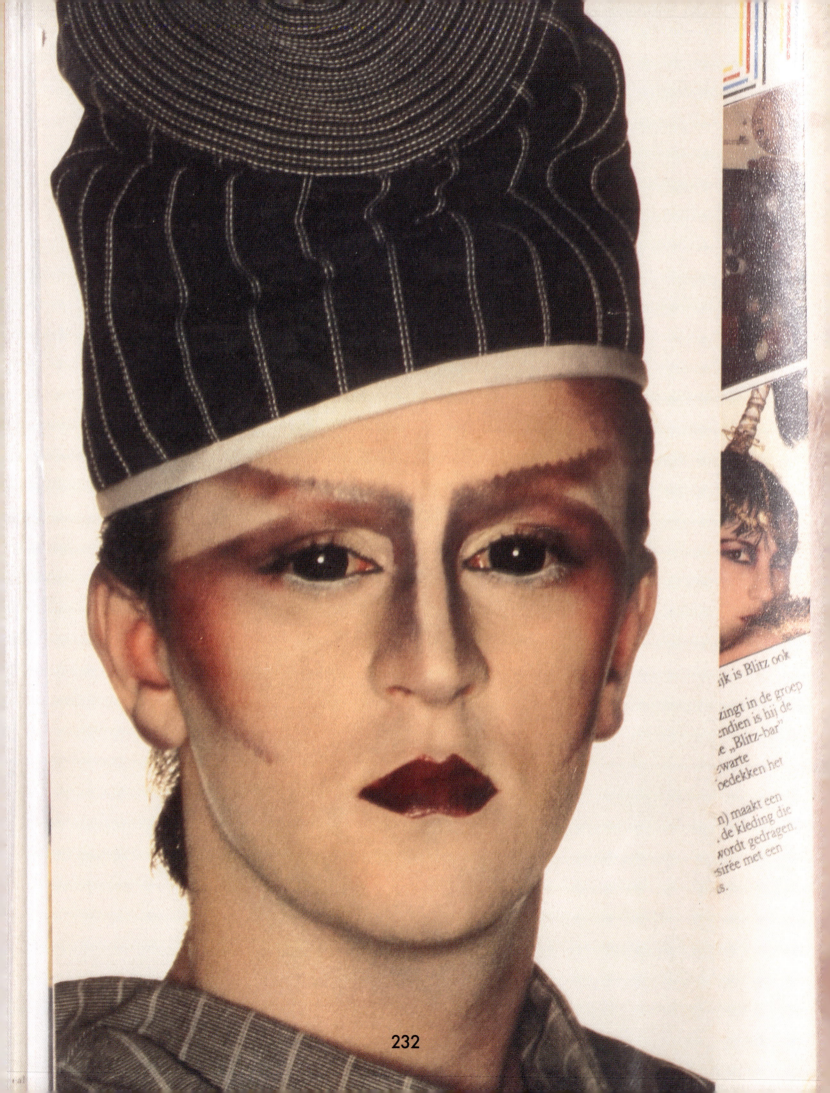

Rejuvenating, Janice Li

Many religious depictions, for example in Judeo-Christian beliefs, whether it be the Virgin Mary or angels sent from God, associate youthfulness and beauty with both the representation of and proximity to the divine. One could interpret these as clear examples for believers to follow. Yet when women began pursuing techniques to turn back the traces of time, they were mocked as vain.

Vanitas, Latin for vanity, refers to a genre of artworks that convey the inevitability of death and the emptiness of worldly pursuits, notably beauty. In the form of etchings, sculptures and decorative collectibles, they make overt moral judgement on the quest for beauty and wealth. The genre is reflective of conflicting beliefs in Europe during the Baroque period (sixteenth to mid-eighteenth century), when beauty was seen as the outward expression of a virtuous character but cultivating personal beauty was condemned as hollow vanity.

European visual culture has historically linked ageing in women with diminishing beauty by juxtaposing their maturing features with symbols of youthfulness and fertility, such as fresh blooms and feathers. This tacit connection between 'reproductive value' and attractiveness continues today. The intended message of a typical image of a woman donning make-up was likely to one of mocking the figure as a 'lustful old woman', inappropriately concerned with her appearance.

While James Ensor's characters are not strictly represented in the traditional form of *Vanitas*, apparent traces of ageing in the illustrations of facial wrinkles, unevenly flushed skin tones and sagging skin – in addition to the use of skulls and other motifs of *memento mori* – feature heavily in his extensive oeuvre. His characters seldom exuberate youthfulness, as if those who are truly youthful need not to mask.

In the world of make-up, most make-up artists agree that the best anti-ageing make-up technique is not to add more colour products but to concentrate on skin rejuvenation. This shifts the focus from concealment, coquetry, display and deception through mastering colours and forms to the adaptation of scientific technology.

Many anti-ageing beauty devices have their origins in medicine. Electrotherapy targeting wrinkles and pimple prevention was first

used to treat tuberculosis. Oxygen therapy to promote younger-looking skin was originally an asthma treatment. Devices were redesigned and rescaled, first to fit into salons, then into domestic spaces. Face masks with LED lights that have become popular in recent years have their roots in technology promoting wound healing by stimulating cell growth, first used on NASA astronauts in the 1990s. Although the legitimacy of these products is sometimes complicated by untruthful marketing claims, many of these technologies are themselves tested and effective.

Is it not fascinating that in order to mask (through make-up) and unmask (through skincare) it requires the mastery of both art and science, that is, the foundations of humans' interaction with the world? If our never-ending endeavours in pursuit of eternal beauty will never succeed, is our lesson from Ensor one of play and ridicule, in the hope that we will reach the realisation that we are as much our masked selves as our unmasked selves?

'Beauty is eternity

gazing at itself in a mirror.

But you are eternity

and you are the mirror.'

Khalil Gibran,
The Prophet, 1923

CATHÉRINE VERLEYSEN

OLD LADY WITH MASKS, JAMES ENSOR

In *Old Lady with Masks* (1889, p. 240), James Ensor portrays an elderly woman. She wears a garland of flowers on her head and stares before her unperturbed, as if she were looking at herself in a mirror. Mocking masks and grinning figures crowd around her face; a skull appears at the top right. The close-up perspective and the accumulation of motifs heighten the dramatic tension, while the powerful brushwork and contrasted colour palette – bright red, blue and green – underline the sense of menace inherent to the scene. Whether the elderly lady is being taunted or whether she herself is part of the masked scene is not unambiguous. However, she shows a certain resemblance to the figures surrounding her, in both her slightly ironic expression and her gaudy make-up.

'Mon occupation préférée:
Illustrer les autres, les enlaidir, les enrichir.'

James Ensor, 1921[1]

Ensor was originally commissioned to paint a portrait. After the client rejected the end result, Ensor transformed the work in 1889 into a crowded masquerade, a *Théâtre des masques ou bouquet d'artifice* (Theatre of masks or Bouquet d'Artifice), as the artist would entitle the reworked painting[2]. Whoever is hiding behind the old lady – possibly Dutch poet Neel 'Keetje Tippel' Doff (1858–1942)[3] – loses some of their importance given this expressive, layered title. Such reworkings were in any case not exceptional in Ensor's practice. In 1888–89, he regularly added fantastical creatures to realistic-looking paintings produced earlier. In doing so, the artist altered the substance and gave the imagination the upper hand. The best-known example is his *Self-Portrait with Flower Hat* (1883–88, p. 22), in which he reworked not only the painting but also himself.

Old Lady with Masks can in the first place be related to numerous representations Ensor realised during the second half of the 1880s of women from his immediate environment in Ostend, an environment perceived as oppressive: his resident grandmother and aunt, his mother, his younger sister Mitche and her daughter Mariette. Since the death in 1887 of Ensor's father – an event that was a great shock to the artist – he had been surrounded at home by those women only. Although he rarely allowed them to pose, he did spy on them while they were working or while they were resting or sleeping in their chairs. He portrayed them from a distance, as it were, and rather unflatteringly, often surrounded here too by monstrous and satirical creatures (p. 240), as if he wanted to secretly underline the sullen, dismissive attitude of his housemates. James Ensor also felt less and less accepted in his own artistic milieu

1
'My favourite occupation: Rendering others illustrious, making them ugly, embellishing them.' James Ensor, 'Interview' (1921), in *Écrits de James Ensor de 1921 à 1926, avec un autographe d'Ensor et un dessin inédit original* (Ostend and Bruges: Éditions de 'La Flandre littéraire', 1926), p. 5.

2
Les Vingt. Catalogue de la huitième exposition annuelle (Brussels, February 1891), cat. No. 6 (James Ensor).

3
Xavier Tricot, *Leven en werk. Oeuvrecatalogus van de schilderijen* (Brussels and Brasschaat: Mercatorfonds and Pandora Publishers, 2009), p. 302.

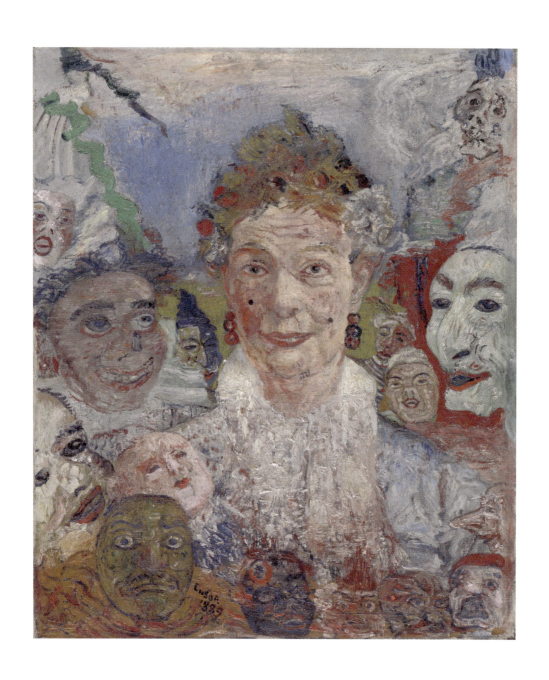

James Ensor, *Old Lady With Masks*, 1889.

during this period. As he realised his waning role as leader of the avant-garde, he denounced that environment.

He was guided in this by a sense of misunderstanding and isolation, which he translated into bold and caustic compositions, even raging against his own earlier work. The mask and the skeleton became his allies. Just as there was no limit to how he could imagine them, nor was there any restriction on how he could experiment with their visual elaboration.

Making the most of that complex repertoire, which received an unparalleled application in *Old Lady with Masks*, Ensor denounced his audience, and by extension his entire environment: 'Traqué par les suiveurs, je me suis confiné joyeusement au pays solitaire de narquoisie où règne le masque tout de violence, de lumière et d'éclat. Le masque me dit: fraîcheur de ton, décor somptueux, grands gestes inattendus, expression suraiguë, exquise turbulence.'[4]

More than twenty years later, in 1913, James Ensor would describe his *Old Lady with Masks* as 'des notes vives où parlent surtout les couleurs franches et pures'[5]. Those words weakened the sense of menace and disquiet contained in the painting. Only pictorial expression still prevailed. The artist kept the painting for a long time, integrating it several times into painted interiors of his own living and working environment (p. 242)[6]. Ensor often included in such compositions portraits, attributes or allusions to earlier paintings that were, and would remain, dearest to him.

4
'Hunted by followers, I happily confined myself to the solitary land of mockery where reigns the mask, with all its violence, light and brilliance. The mask tells me: freshness of tone, sumptuous décor, great unexpected gestures, very sharp expression, exquisite turbulence.' James Ensor, 'Discours au Kursaal d'Ostende. Ostende et ses couleurs' (1931), in James Ensor, *Mes écrits* (Liège: Éditions nationales, 1974), p. 143.

5
'Vibrant touches, with powerful, pure colours in particular coming to the fore.' Letter from James Ensor to Emma Lambotte (17 May 1913), in *James Ensor. Lettres à Emma Lambotte 1904-1914*, ed. Danielle Derrey-Capon (Brussels: Centre international pour l'Étude du XIXe siècle and La Renaissance du Livre, 1999), p. 294.

6
For instance, *Old Lady with Masks* features in *The Cardinal Points: North* (ca. 1932, private collection) and *Interior with Three Portraits* (1938, private collection).

James Ensor, *La Paresse*, 1888-1889.

James Ensor, *The Artist's Studio*, 1930.

THE POINT WOUSE WANTS TO MAKE

Masks and the iconography of the Carnival are James Ensor's most striking contribution to modern art. Around the world, masks have been used since time immemorial as everyday objects in religious or profane rituals and celebrations. While they continue to play a background role in Western painting, it was only in Ensor's work from 1888 onwards that masks really took on a leading role. The presence of masks was soon recognised by friend and foe alike as the trademark of the man who occasionally called himself 'le peintre des masques'.

Ensor's interest in festive parades and Carnival-goers first manifested itself in etchings such as *The Cathedral* (1886) and *The Infernal Cortege* (1886), the large drawing *The Bright and Radiant: The Entry of Christ into Jerusalem* (1886) from the series *The Aureoles of Christ or the Sensitivities of Light*, and *The Temptation of Saint Anthony* (1887) and the painting *Tribulations of Saint Anthony* (1887). From the outset, his masked characters were ambiguous, and it is not always easy to distinguish clearly between a crudely caricatured figure, a disguised Carnival-goer and a demonic creature of the imagination. Skeletons also crop up in Ensor's work. These belong to the iconography of Symbolism and were very popular at the end of the nineteenth century, but Ensor often combined these ghastly creatures with his unreal, hilarious masked beings.

The term 'masque' – which the French-speaking Ensor invariably used – can refer both to the masked character and to the object behind which they hide. The strange nature of the masks – which, according to Ensor's friend, the world-renowned poet and art critic Émile Verhaeren, 'are dead yet seem to be thinking, remain motionless yet chuckle' – is ambiguous anyway[1]. *The Astonishment of the Mask Wouse* (p. 246) is a fine example of how Ensor heightened this ambiguity, changing the role of the mask in his work[2]. His mask scenes are only one step away from the Expressionism of his German admirers.

To the right on the wooden floor, Ensor has piled together garments, musical instruments and some Carnival masks. This could be the staging of 'dead' objects for a still life. However, he has also included a masked character on the left who has a startled air. Two masks are visible on the right, at eye level. It is possible to tell, with the naked eye, that the two oriental masks, on the left, were later additions. They are more or less transparent, and this only heightens the unreal atmosphere of the whole composition. The central figure could be a person, male or female, with a mask in front of their face, but could just as easily be the crude caricature of a human being[3] or of a ghostly, unreal figure. The presence of the startled 'black boy' and the 'lady' alters the very nature of the masks and garments on the floor. These are no longer merely objects, but beings who have come crashing down as if drunk, or fainting, or even dead.

The setting for the scene was probably based on Ensor's attic studio. The wooden floor and blue skirting board recur in other paintings. To moderate

1
Émile Verhaeren, 'Une facette du talent d'Ensor', *James Ensor. Peintre et graveur*, Librairie de la Société Anonyme La Plume, Paris 1899, pp. 11-13.

2
Herwig Todts, 'L'Étonnement du Masque Wouse', in Thérèse Burollet and Lydia Schoonbaert (eds), James Ensor, Paris-Musées, 1990, pp. 174-5. Susan M. Canning, 'James Ensor: Carnival of the Modern', in Anna Swinbourne (ed.), James Ensor, The Museum of Modern Art, New York 2009, pp. 28-43. Xavier Tricot, 'Who Is Hiding behind the Mask in The Astonishment of the Mask Wouse?', https://jamesensor. vlaamsekunstcollectie.be/en/sources/online-publications/ who-is-hiding-behind-the-mask-in-the-astonishment- of-the-mask-wouse/, accessed 24-05-2024. Herwig Todts, 'James Ensor, Occasional Modernist: Ensor's Artistic and Social Ideas and the Interpretation of His Art, XIX Studies in Nineteenth-Century Art and Visual Culture', Brepols Publishers, Turnhout 2018, pp. 372-77. Herwig Todts, 'Verbazing van het masker Wouse', https://kmska.be/nl/meesterwerk/verbazing-van- het-masker-wouse, accessed 24-05-2024.

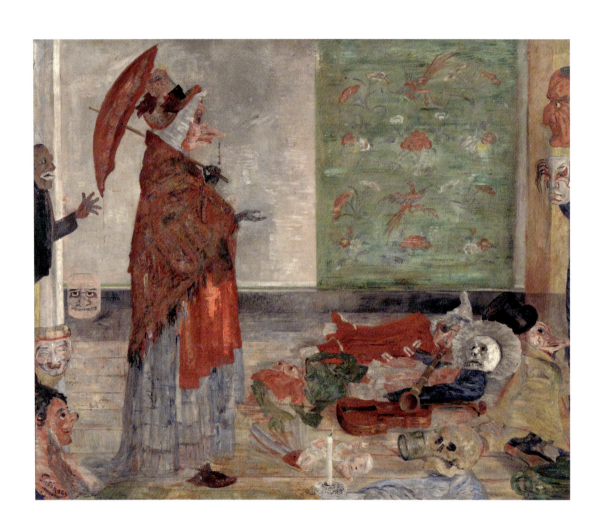

James Ensor, *The Astonishment of the Mask Wouse*, 1889.

the emptiness of the space in the background, Ensor coloured part of the floor blue as well. Most of the accessories appear in other paintings too. He could order dozens of different types of masks in Germany. While he occasionally used Japanese masks, his mask repertoire remained limited.

Ensor found in the mask a means of denouncing what he himself called 'the hypocrisy, duplicity, opportunism and deceitful malice' of his fellow human beings[3]. In some works, however, his masks appear as good-natured, funny, unfathomable creatures. The title of this painting does not help us to understand the composition. Wouse's identity is uncertain. Is it the character wearing the mask of a black African or is it the 'lady' after all? What does Wouse mean? And why is she astonished? The main character looks like an impudent parody of a coquettish femme fatale parading with her fine black leather gloves, elegant red parasol, floral hat, gossamer blue dress and expensive Indian scarf. The head of a baby emerges from that scarf. A strange globule dangles from her nose and under her hat she wears a 'folk' headpiece. Have the 'musicians' at her feet sung their swansong? Are they perhaps drunk, or the lifeless victims of her dubious charms? In the foreground, a skeleton waves a night candle meaningfully, an empty bottle behind his head. It was in the seventeenth century in particular that noblewomen were portrayed with a black servant. Was Ensor inspired by one of those portraits?

Even if the meaning escapes us, the scene nevertheless possesses an anecdotal nature: a pithy moment from an incident that may be amusing or sentimental but is in any event entertaining. The painting has thus been staged as a pseudo-literary image. For Ensor's progressive predecessors and heroes, such a thing was virtually an anathema. Since every artistic discipline had to obey its own essential rules and painting therefore had to avoid being literary, they – the 'realists' – sought to banish anecdotalism at all costs.

Ensor most probably painted the work in 1889. He had a photograph taken of himself while he appears to be working on an early version of *The Entry of Christ into Brussels in 1889*. Next to him we see an 1889 still life and *The Astonishment of the Mask Wouse*. Ensor announced the exhibition of *The Entry* in the catalogue for the salon of Les XX in February 1889. While he dated that painting 1888, he did not show it in public before 1929. In a letter to Mariette Rousseau in May 1889, Ensor reported that the painting of the masks had 'luckily succeeded' – *The Entry* was far from finished at the time. A little later, on the eve of the 1890 salon of Les XX, where he showed *Wouse*, he wrote to Rousseau again:

> 'I have made several paintings of masks, seascapes, still lifes and drawings heightened with gold and pastel. My exhibition may raise me in your esteem for a while, and you will see that the paintings will come out very beautifully and harmoniously, and that they will have a very gentle appearance, and that they will not hurt your eyes, and that they have not been made to cause a stir, and that they deserve to be looked at for the sake of painting especially and not for the sake of the subject matter'.[4]

Apparently, Rousseau regretted that her young friend had been deliberately depicting provocative subjects. Ensor, however, was asking her above all else to enjoy the pictorial qualities of paintings like *The Astonishment of the Mask Wouse*.

3
James Ensor, Lettre à Jules du Jardin, 06-10-1899, *James Ensor Lettres*, (ed. Xavier Tricot), Archives du Futur, Editions Labor, Bruxelles, 1999, p. 271: 'J'ai pu contempler philosophiquement les faces hypocrites, dissimulées, intéressées et fourbes des couards écrasés par mes méprisantes évolutions.'

4
'Avec le noble crayon'. Lettres de James Ensor à la famille Rousseau, (ed. Jean-Philippe Huys, Peter Lang, Brussels, New York, Wien), 2021, p. 280.

COLOPHON

This book is published in conjunction with the exhibition 'Maskerade, Make-up & Ensor' on view at MoMu - Fashion Museum Antwerp, from 28 September 2024 to 2 February 2025

EXHIBITION

CURATORS
Elisa De Wyngaert
Romy Cockx
Kaat Debo

CURATORIAL COMMISSIONS
Beauty Papers
Janice Li

EXHIBITION DESIGN
Janina Pedan

MOMU - FASHION MUSEUM ANTWERP

DIRECTOR
Kaat Debo

BUSINESS MANAGEMENT
Sara Joukes

CURATORS
Romy Cockx
Elisa De Wyngaert

ASSISTANT CURATOR
Juliette de Waal

PRODUCTION MANAGEMENT
Marie Vandecasteele

COLLECTION CURATOR
Wim Mertens

COLLECTION MANAGEMENT
Frédéric Boutié
Ellen Machiels
Pieter Pauwels
Wouter Pauwels
Belgiz Polat
Kim Verkens
Danicia van Glanen-Weijgel

LIBRARY & DRIES VAN NOTEN
STUDY CENTER
Birgit Ansoms
Hadewijch Bal
Ester Claes
Marguerite De Coster
Tobias Hendrickx
Dieter Suls
Michelle Suykerbuyk
Stijn Van den Bulck
Eva Van den Ende
Ykje Wildenborg

PRESS & COMMUNICATIONS
David Flamée
Lies Verboven

EDUCATION & EVENTS
Iris Adriaenssens
Leen Borgmans
Karl Kana
Klaartje Patteet

COMMUNITY BUILDING
Alex Akuete
Jana Tricot

ADMINISTRATION
Diane Van Osta

MERCHANDISING MANAGER
Annik Pirotte

HOSPITALITY MANAGER
An Teyssen

WELCOME DESK
Maaike Delsaerdt
Veronique De Man
Kristel Van den Wyngaert
Lynne Van Kerkhove

FACILITY MANAGEMENT
Justin Vanneste

MAINTENANCE
Isabel Suengue
Maria Sebastiao Viegas

SECURITY
Internal security service of AG Cultural Institutions Antwerp

LENDERS
Almine Rech, Brussels
Bonnefanten & Rijksdienst voor
 het Cultureel Erfgoed
Issy Wood, Carlos/Ishikawa, London
Christian Lacroix
Cyndia Harvey
Deutches Hygiene-Museum Dresden
Dries Van Noten
Galerie Eva Presenhuber, Zurich
Harley Weir Studio
Inge Grognard
Thomas de Kluyver
Julien d'Ys
KBC Bank NV, Brussels
Magnum/Bruce Gilden
Mario Testino
Martin Margiela
Museum Plantin Moretus
Museum of Fine Arts Ghent
Peter Philips
Royal Museum of Fine Arts Antwerp
 –Flemish Community
The Phoebus Foundation, Antwerp
Walter Van Beirendonck
Wellcome Collection, London

And all lenders who wish to remain anonymous.

PUBLICATION

AUTHORS
Romy Cockx
Susan M. Canning
Kaat Debo
Elisa De Wyngaert
Francesca Granata
Janice Li
Alistair O'Neill
Herwig Todts
Cathérine Verleysen

CONCEPT AND DESIGN
Paul Bergés & Frédéric Jaman

CREATIVE DIRECTION
Studio M Paris with Paul Bergés & Frédéric Jaman

IMAGE RESEARCH & COPYRIGHT
Birgit Ansoms
Elisa De Wyngaert
Marguerite De Coster

Thanks to Noemie Brakema for inventorying references to cosmetics in the French women's magazine *La Mode Pratique*, part of the MoMu library collection.

PROJECT MANAGEMENT
Astrid Devlaminck

TRANSLATIONS
Patrick Lennon (Dutch—English)
Robrecht Vandemeulebroecke (English—Dutch)

EDITING
Linda Schofield (English)
Sabine Humbeeck (Dutch)

PROOFREADING
Léa Teuscher (English)
Sofie Renier (Dutch)

PHOTO ENGRAVING
Steurs

PRINTING AND BINDING
Balto Print

COVER IMAGE
Make-up Linda Cantello, hair Julien d'Ys, model Kate Moss, photo Paolo Roversi/Art+Commerce. This editorial originally featured in *i-D* (February 1996)

If you have any questions or comments about the material in this book, please do not hesitate to contact our editorial team: art@lannoo.com

© Lannoo Publishers, Belgium, 2024
D/2024/45/424 - NUR 452/644
ISBN: 978-94-014-2706-7
www.lannoo.com